Inhaltsverzeichnis /
Table of Contents

Fake
Titel

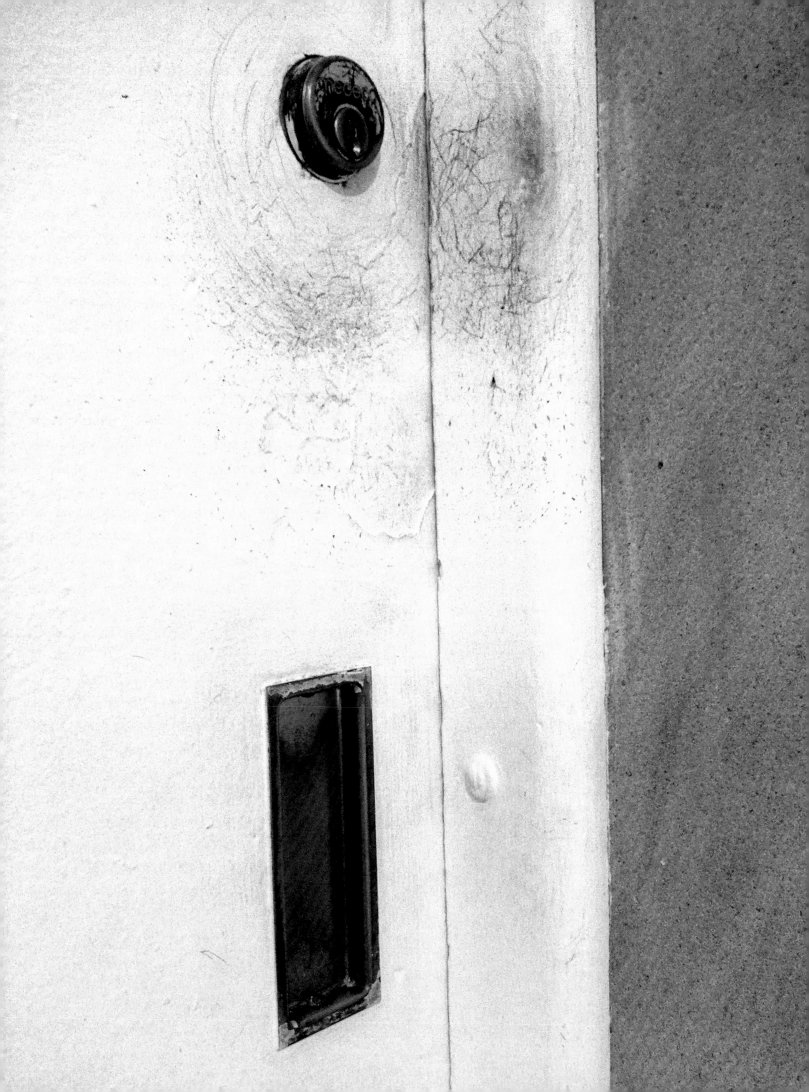

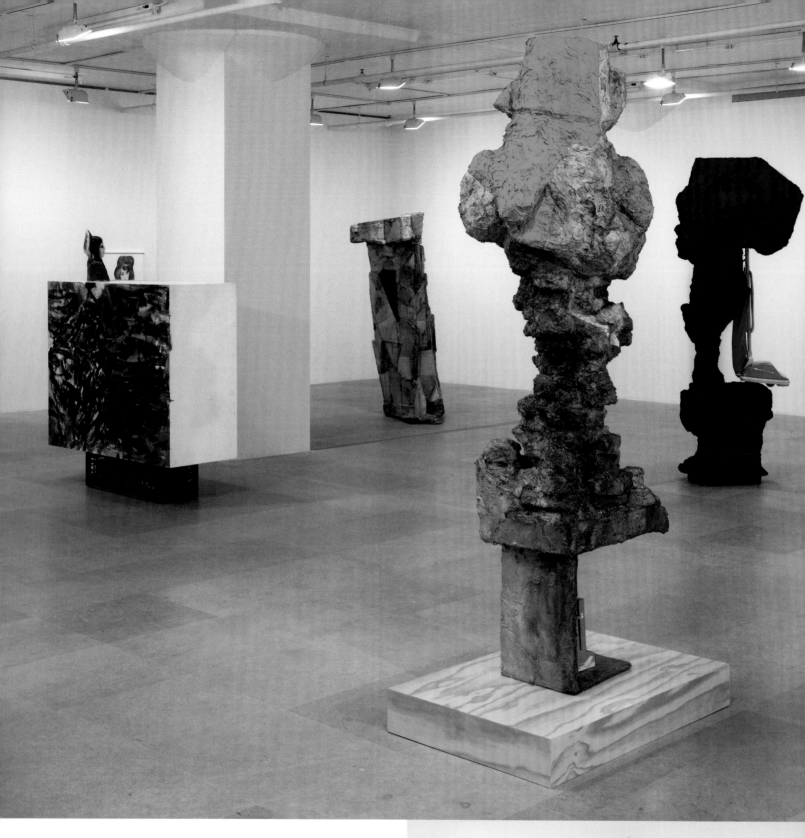

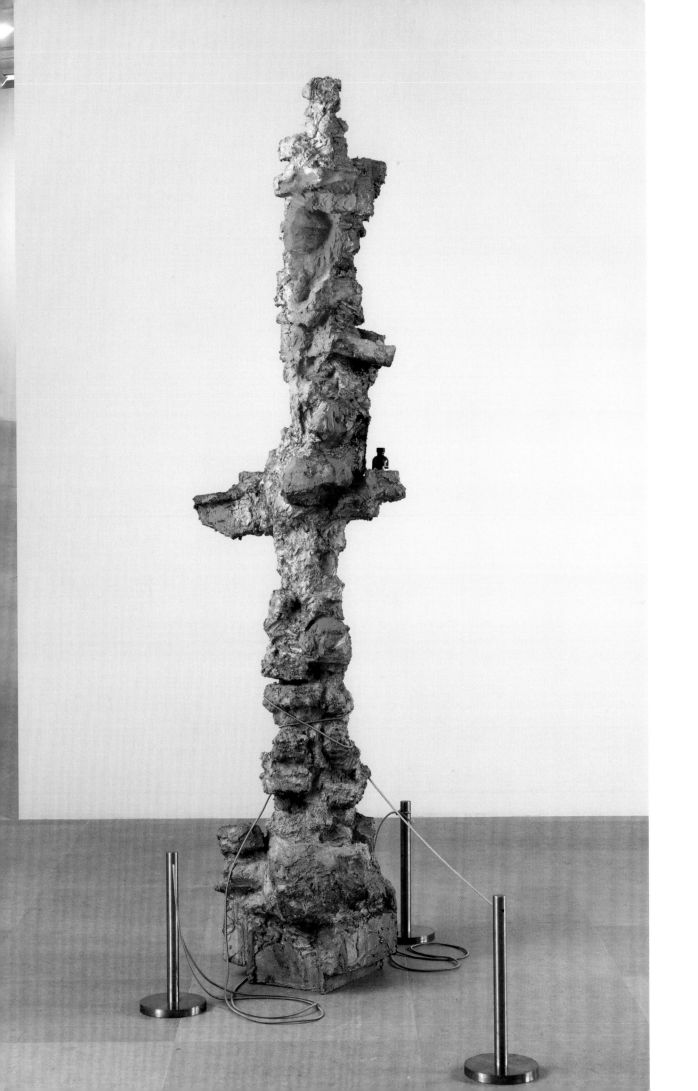

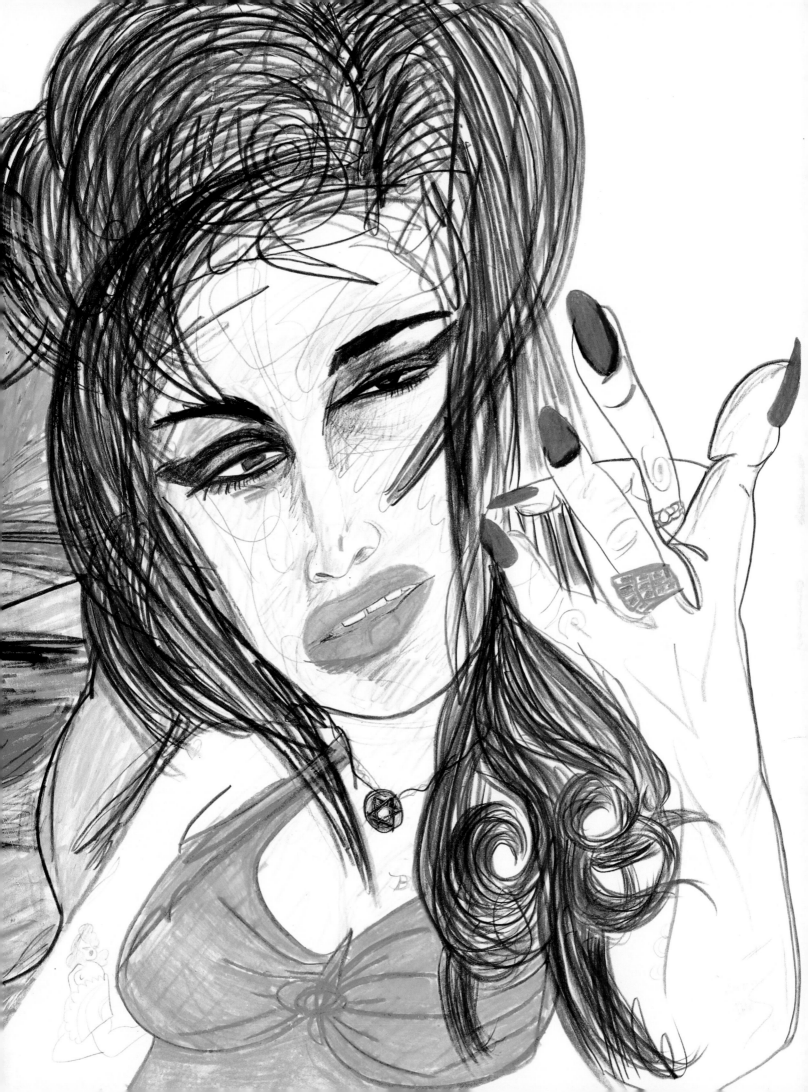

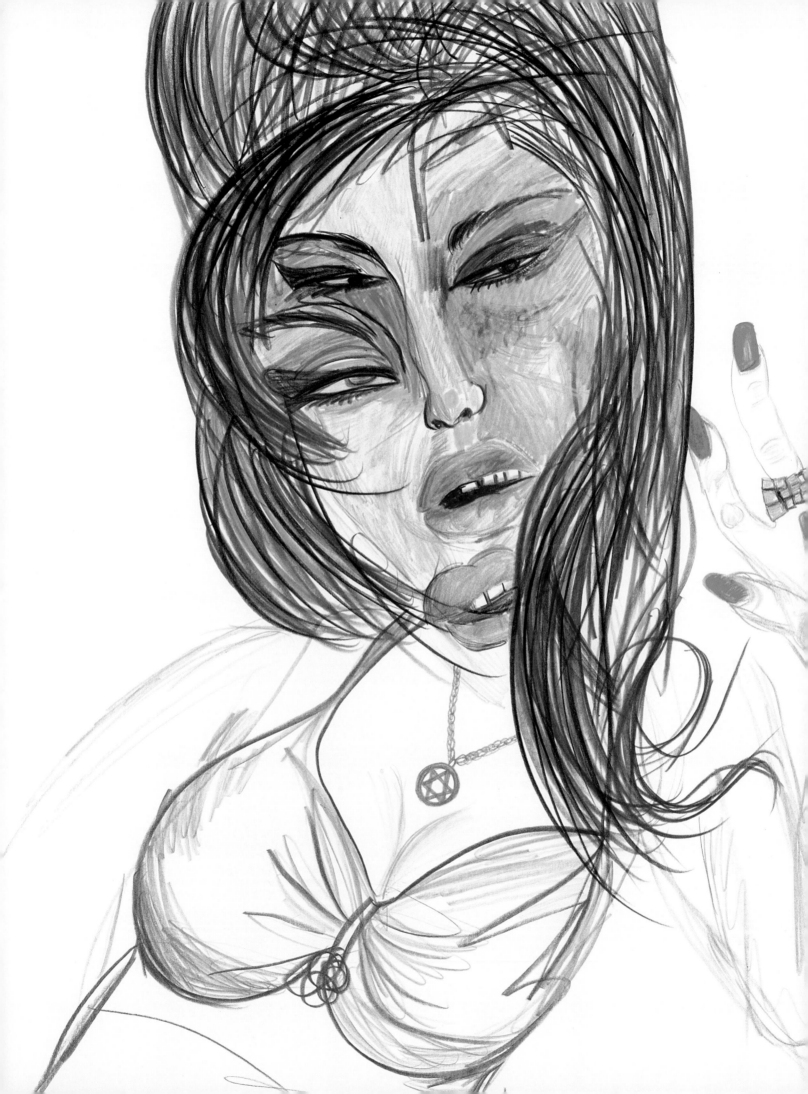

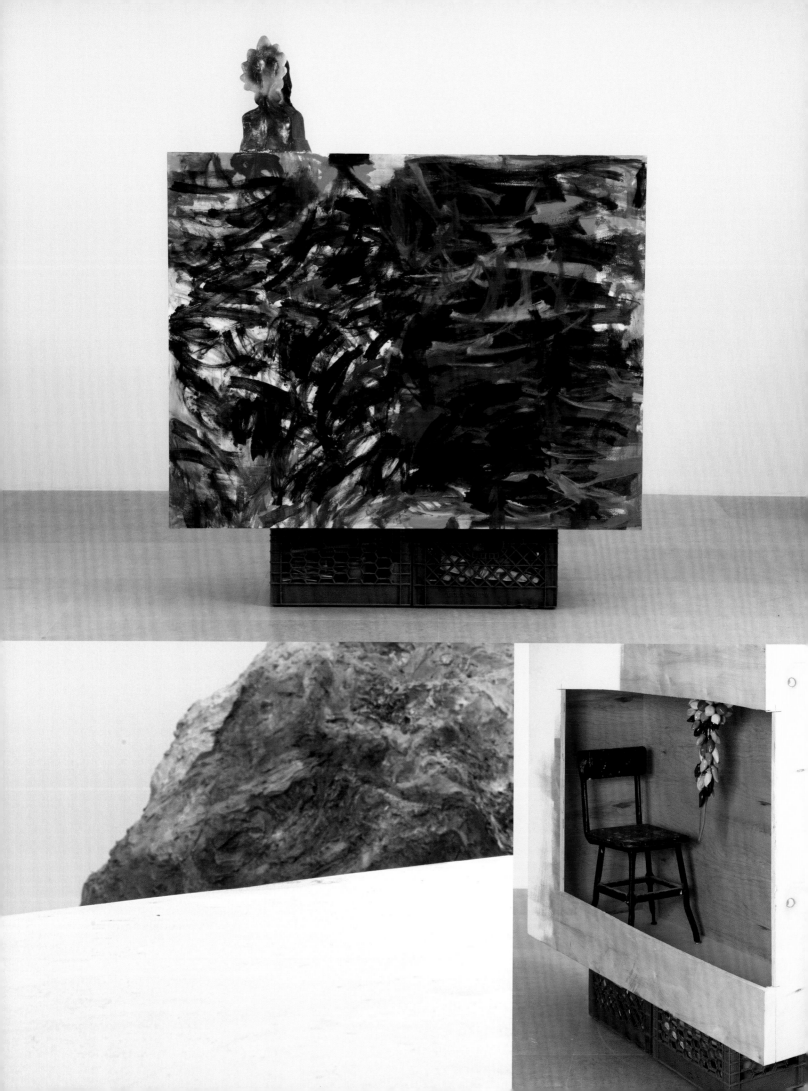

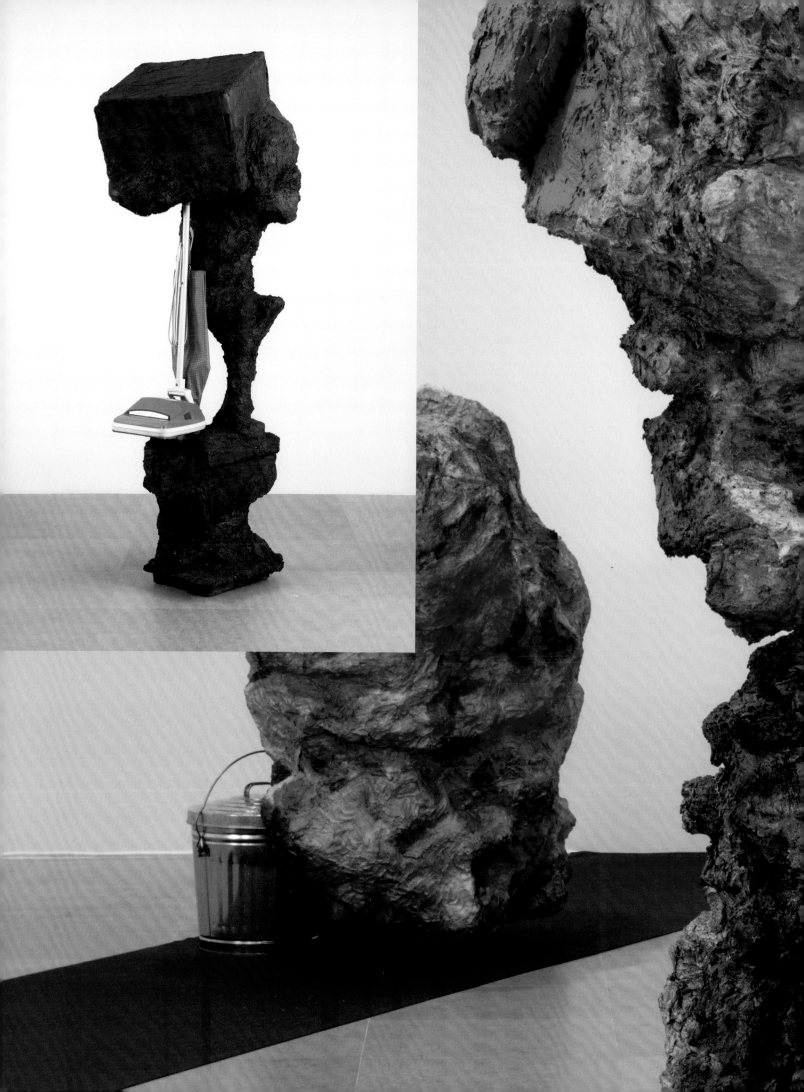

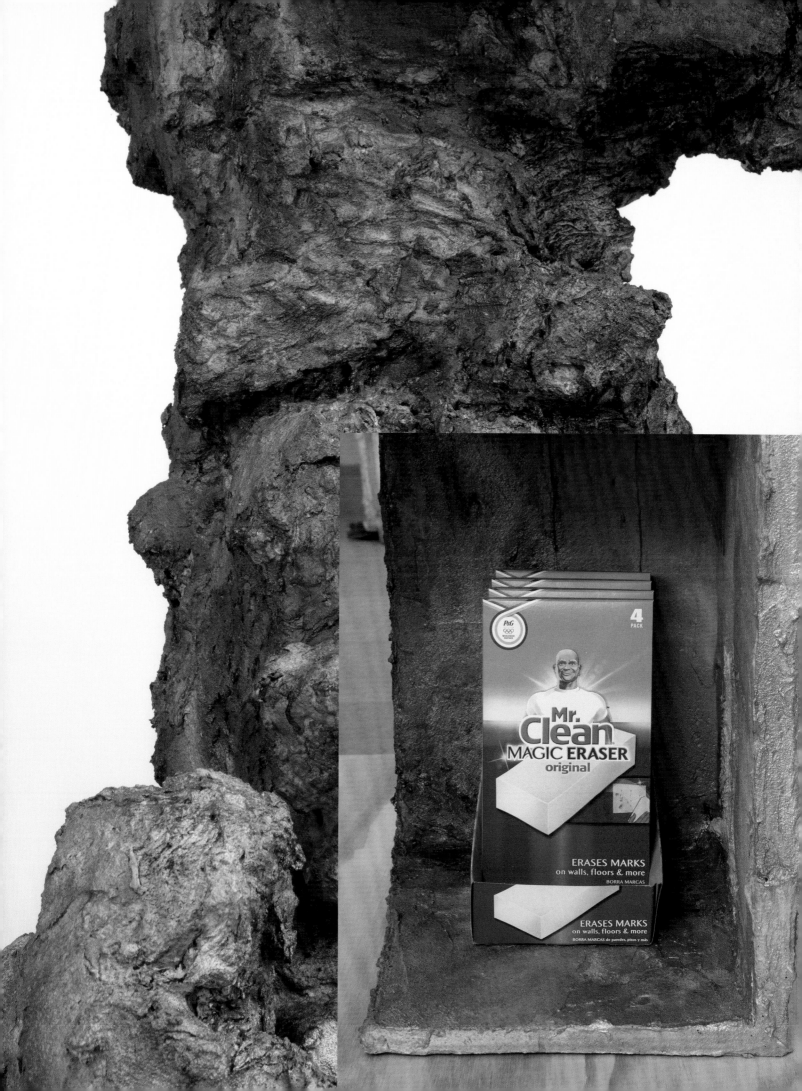

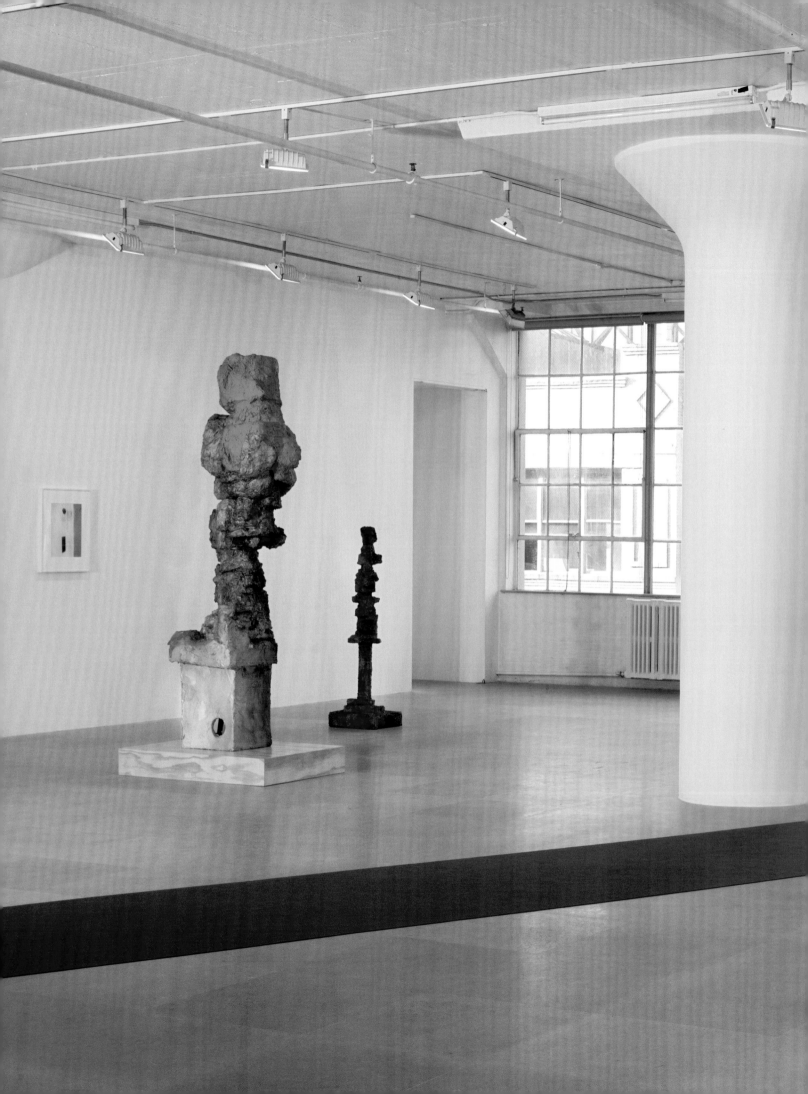

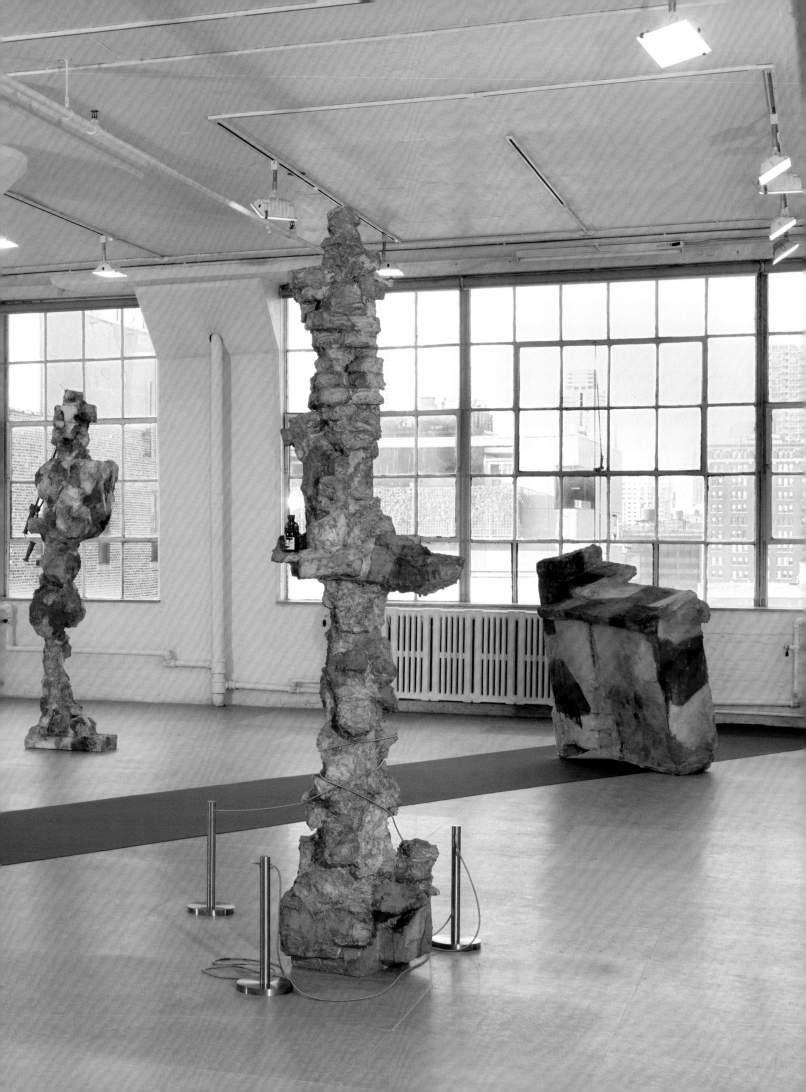

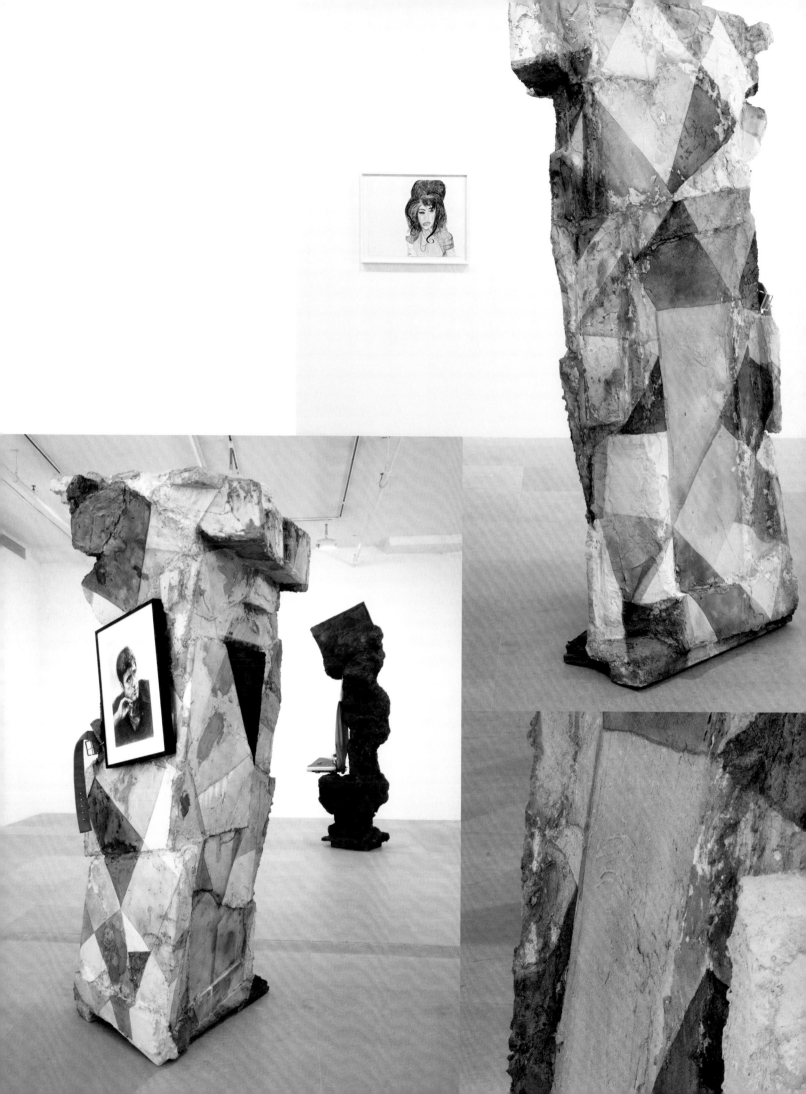

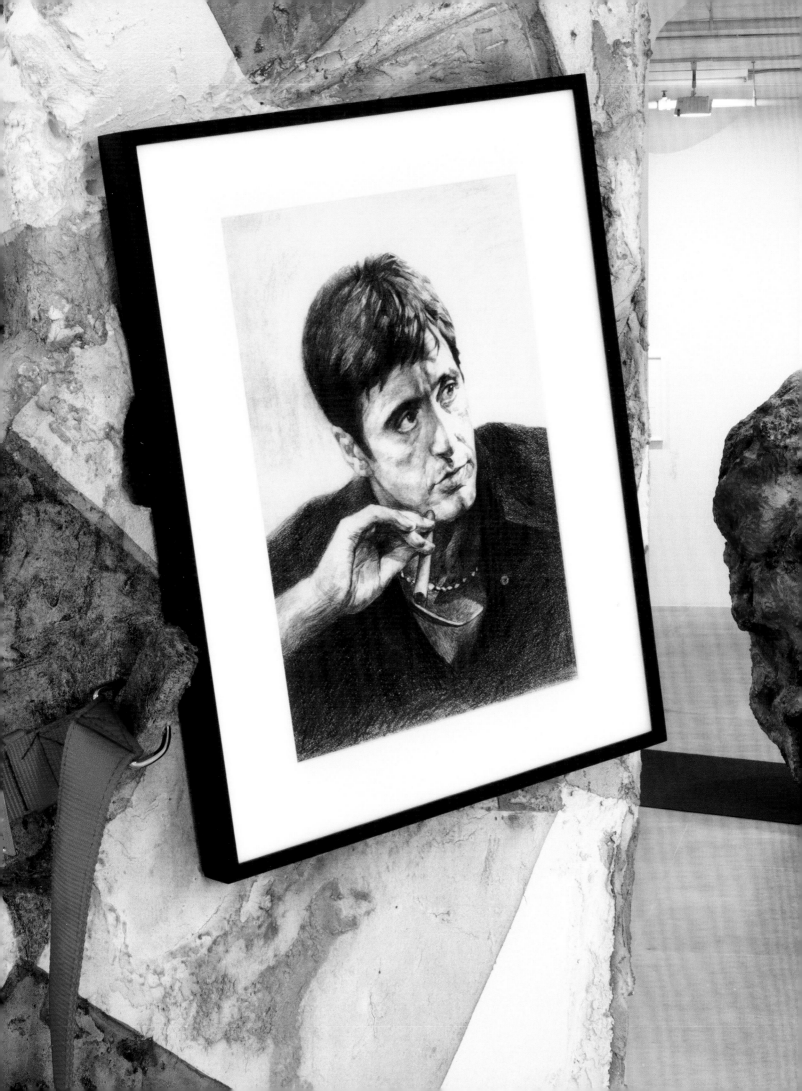

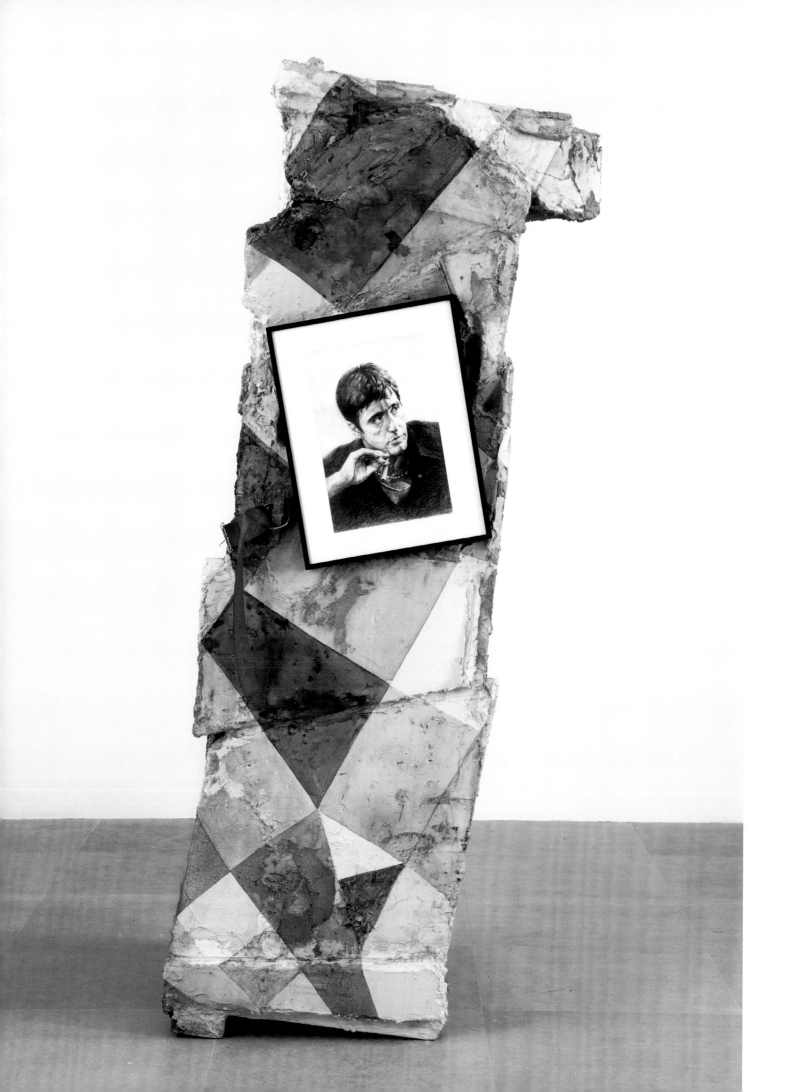

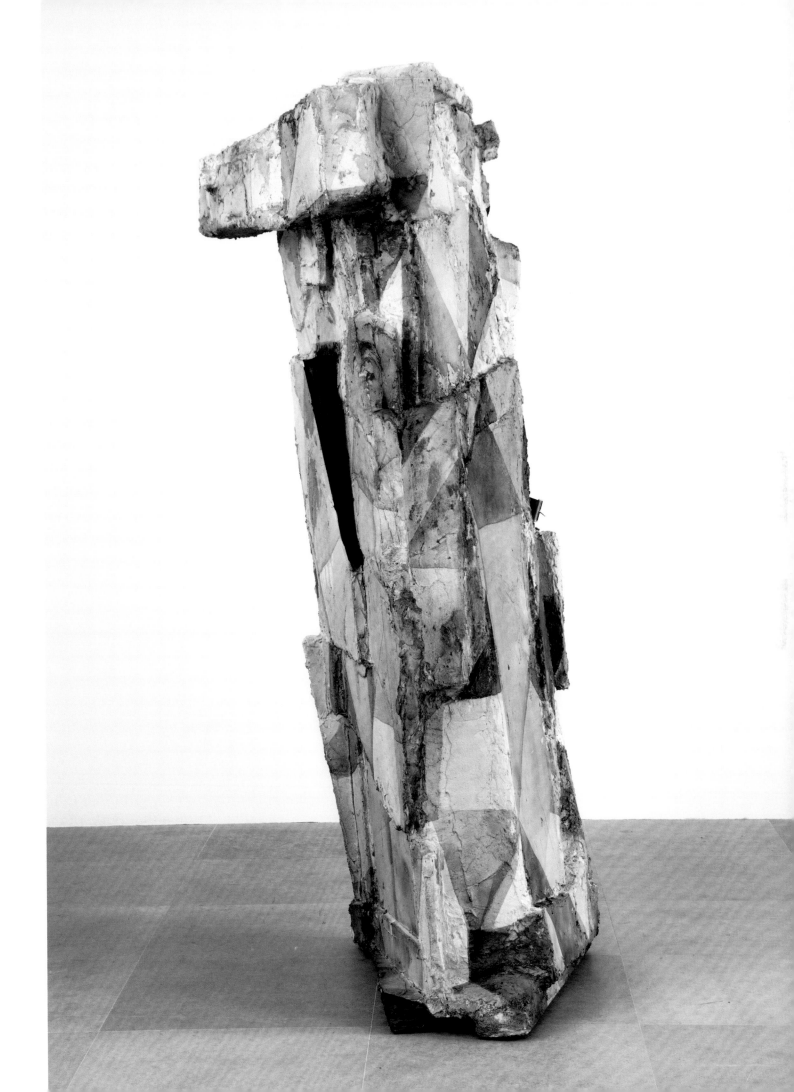

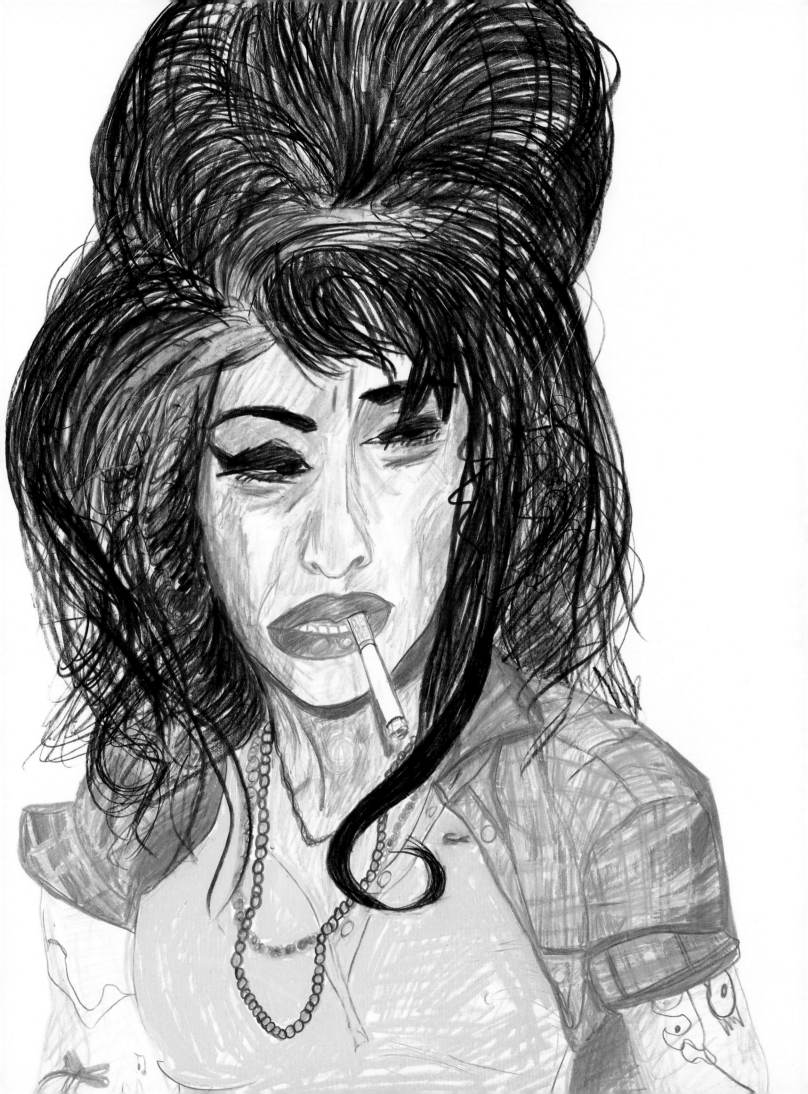

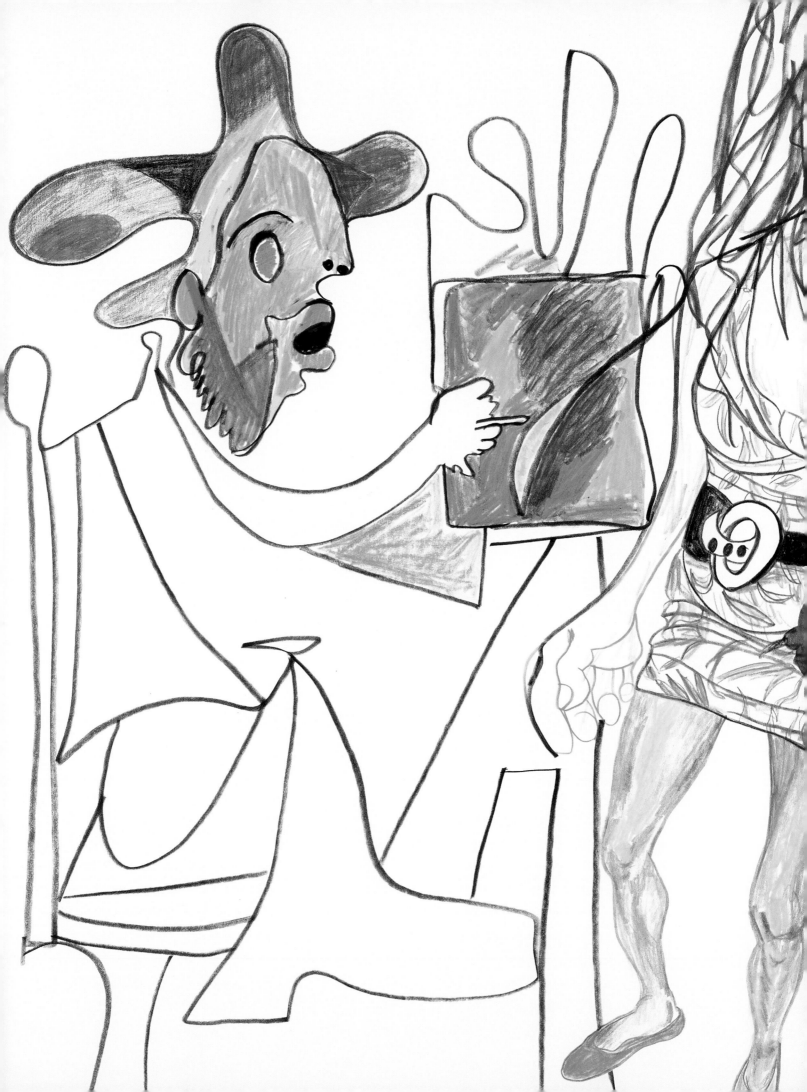

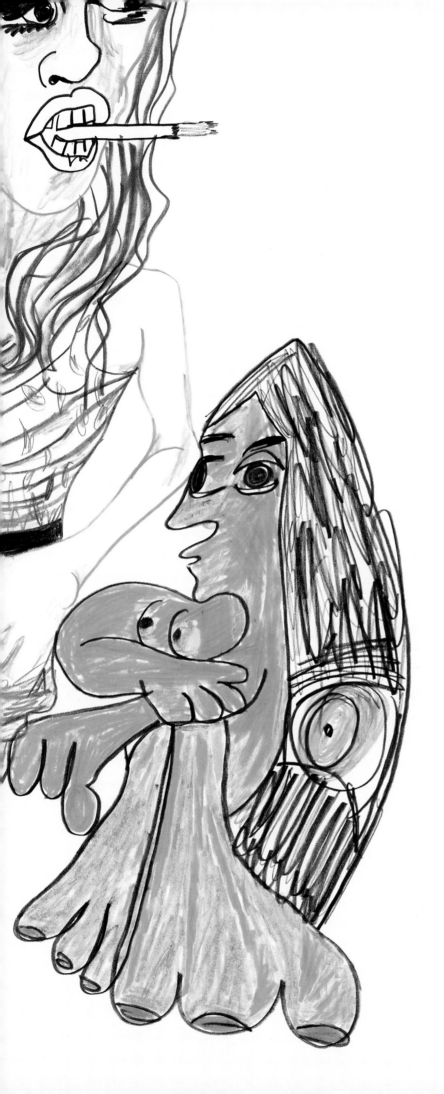

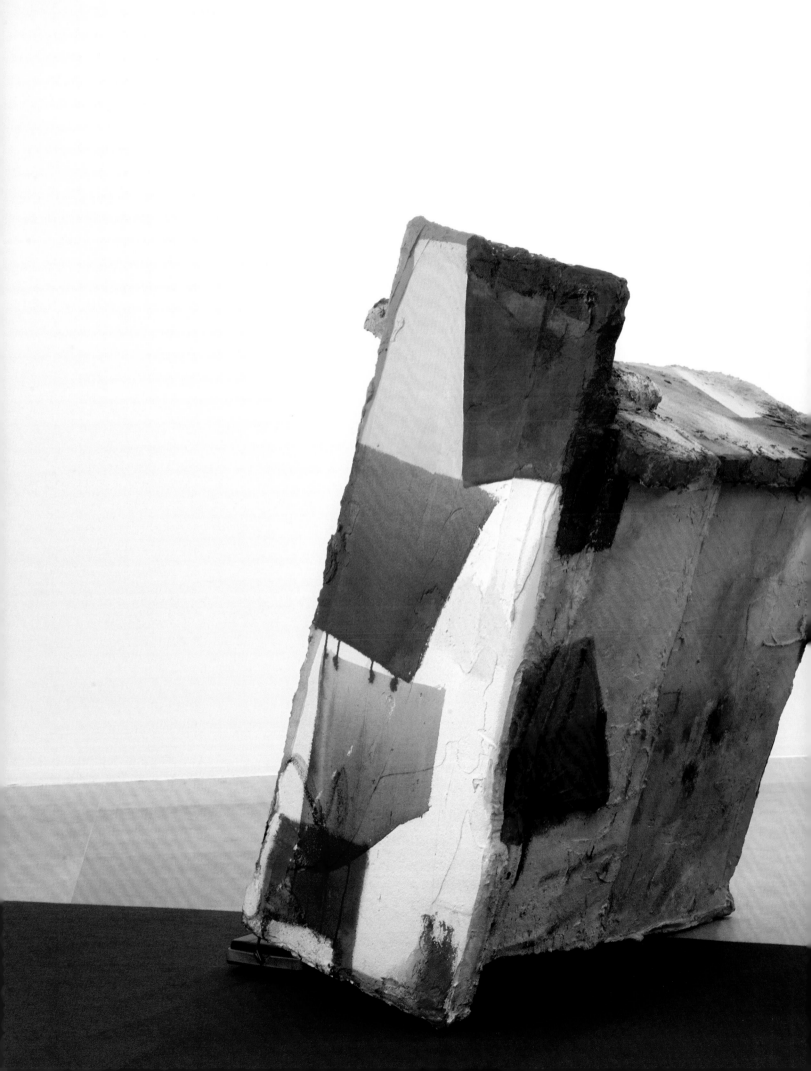

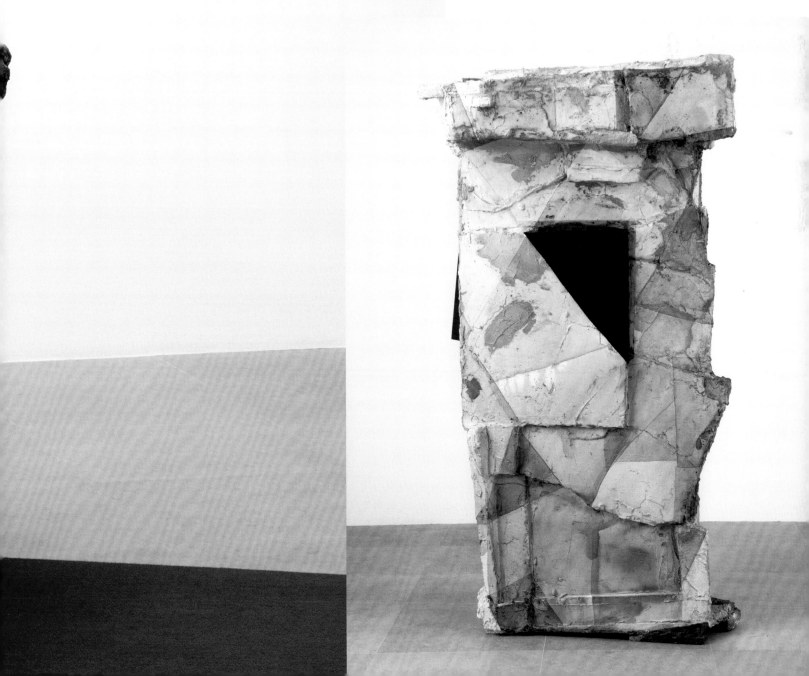

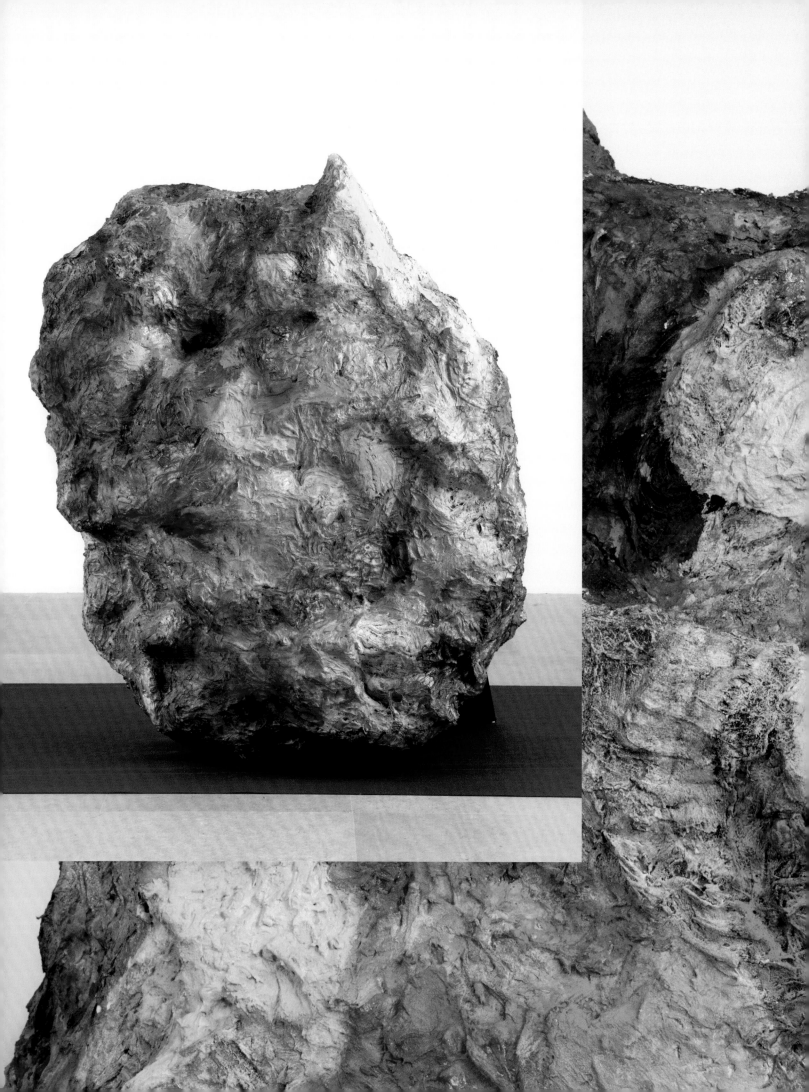

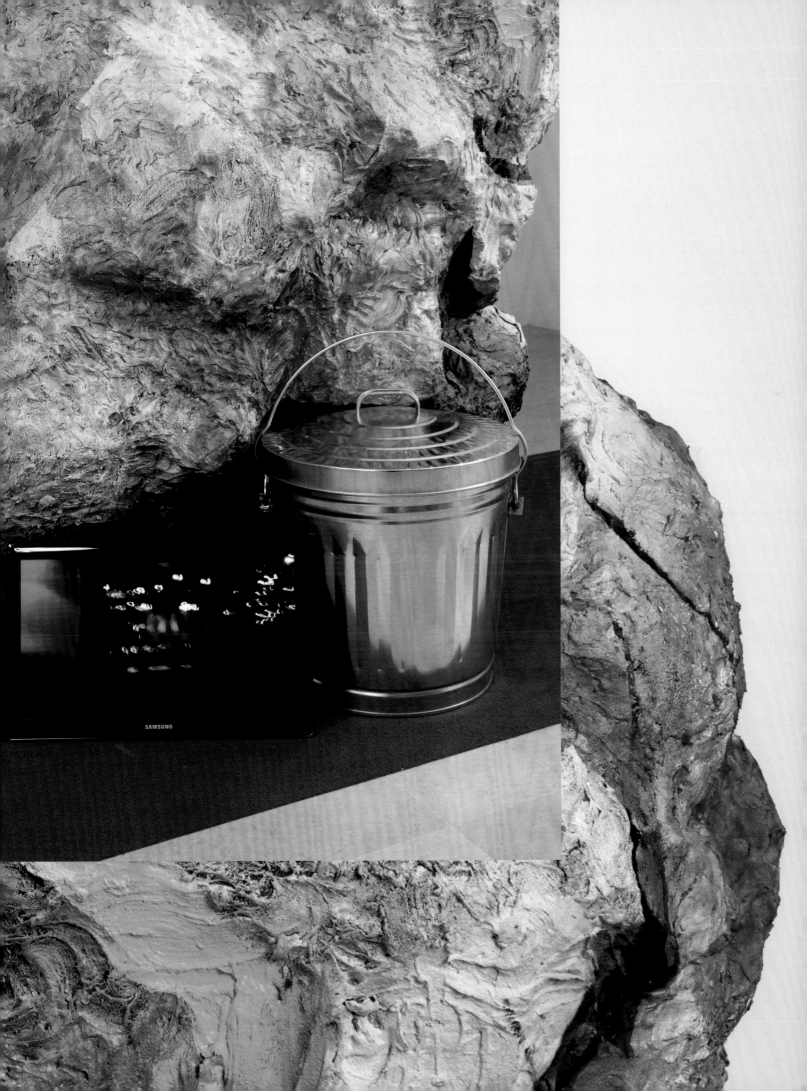

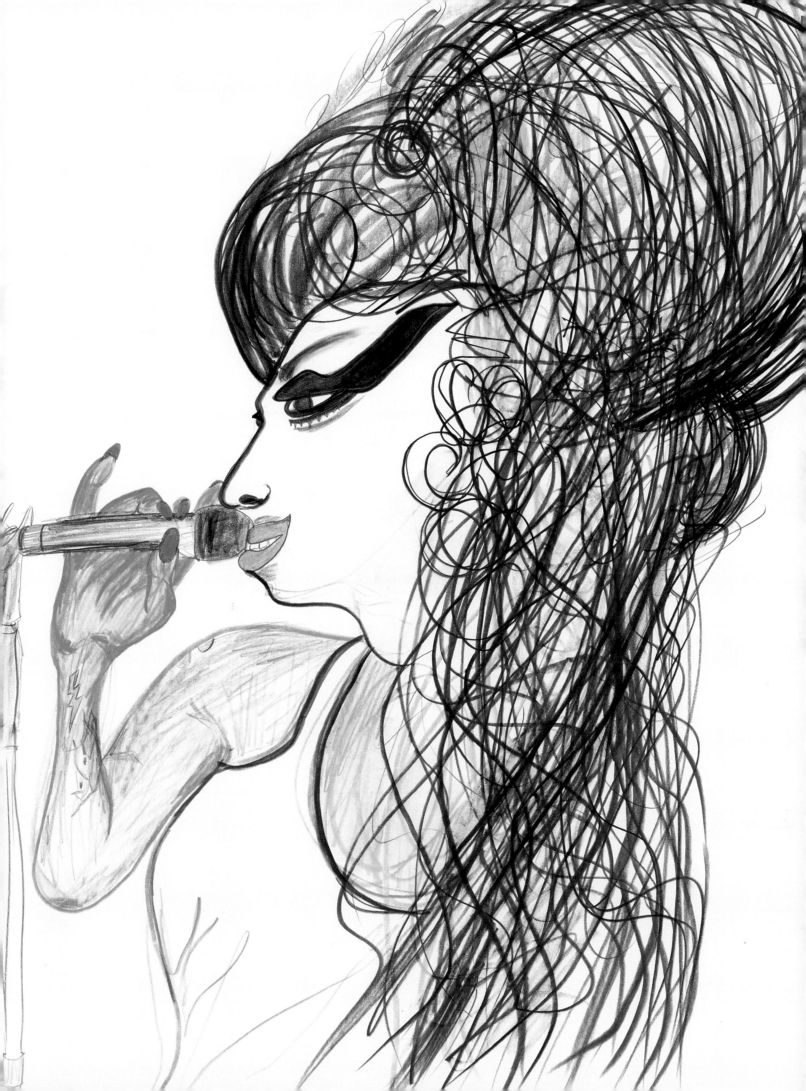

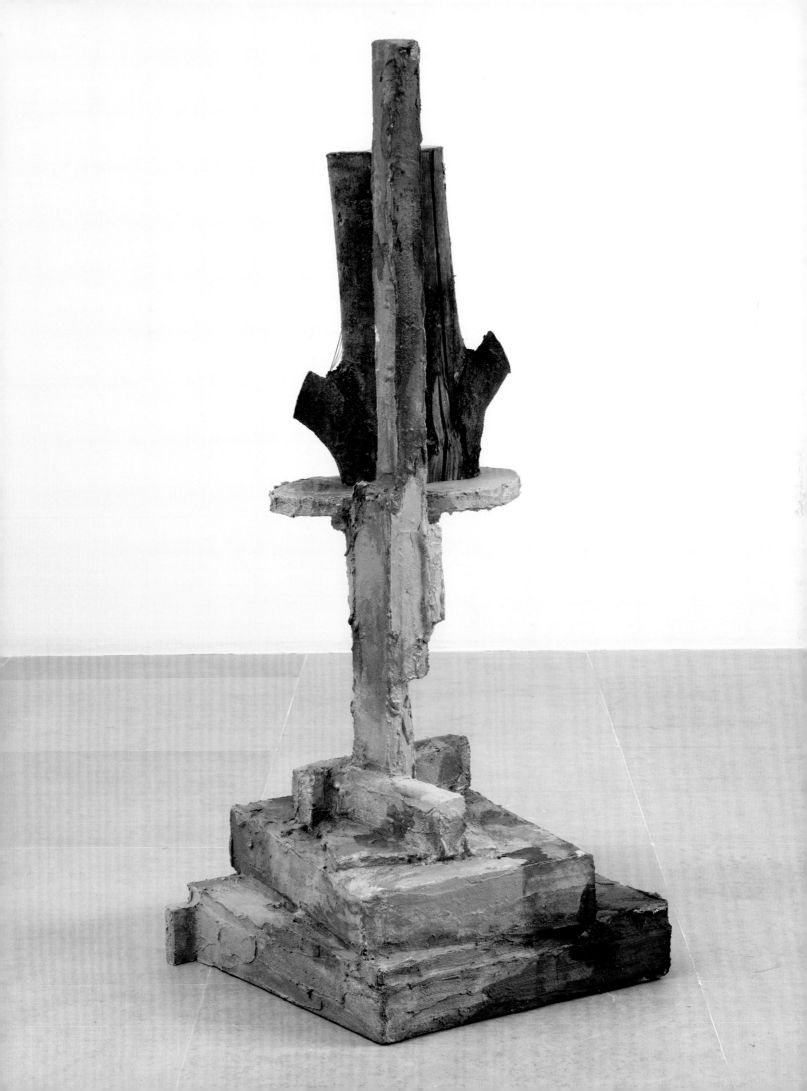

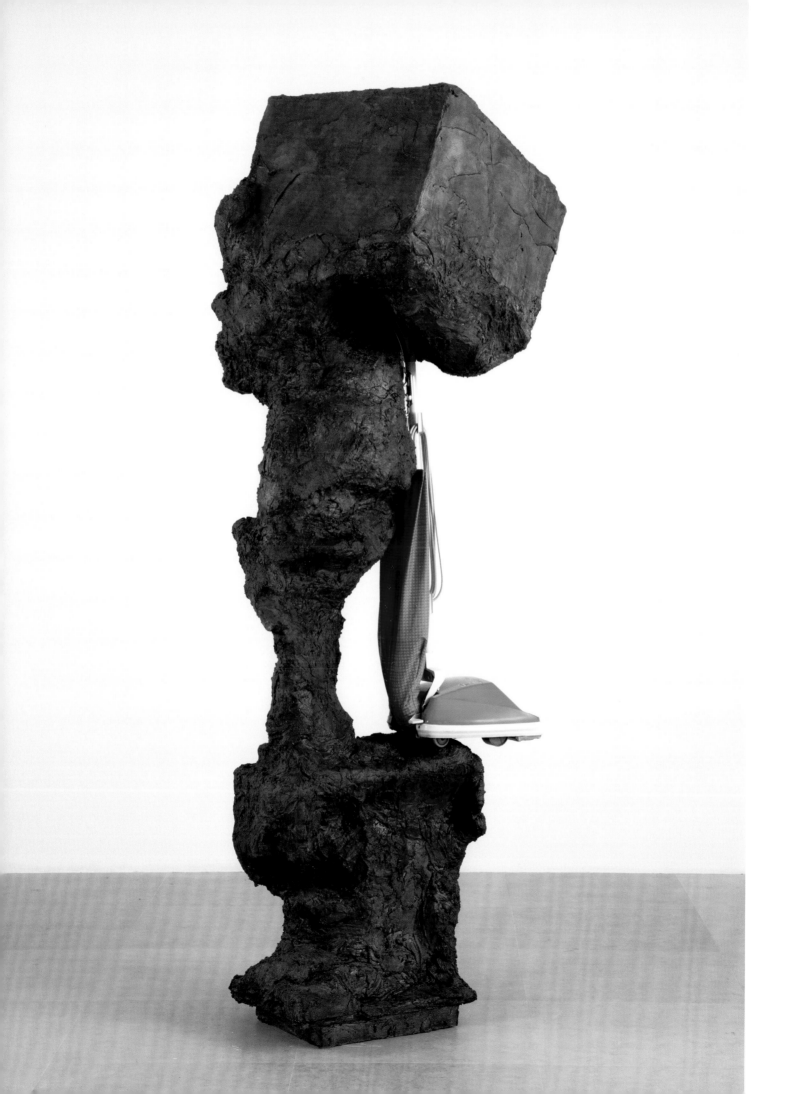

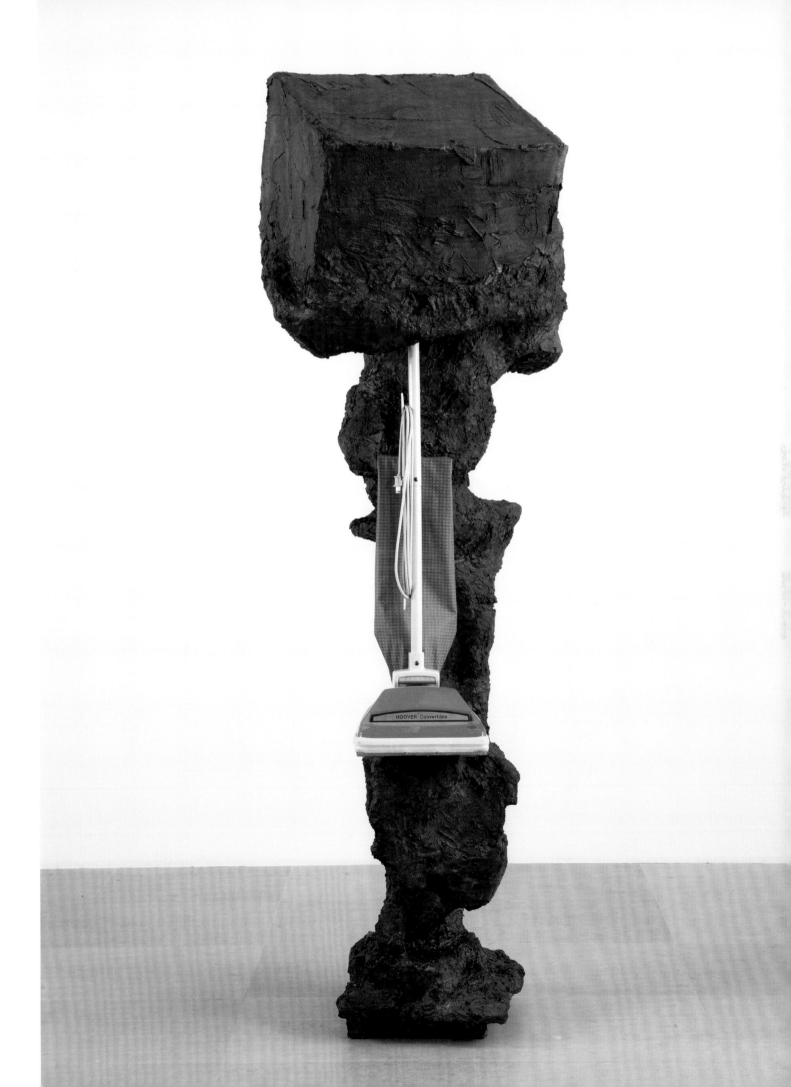

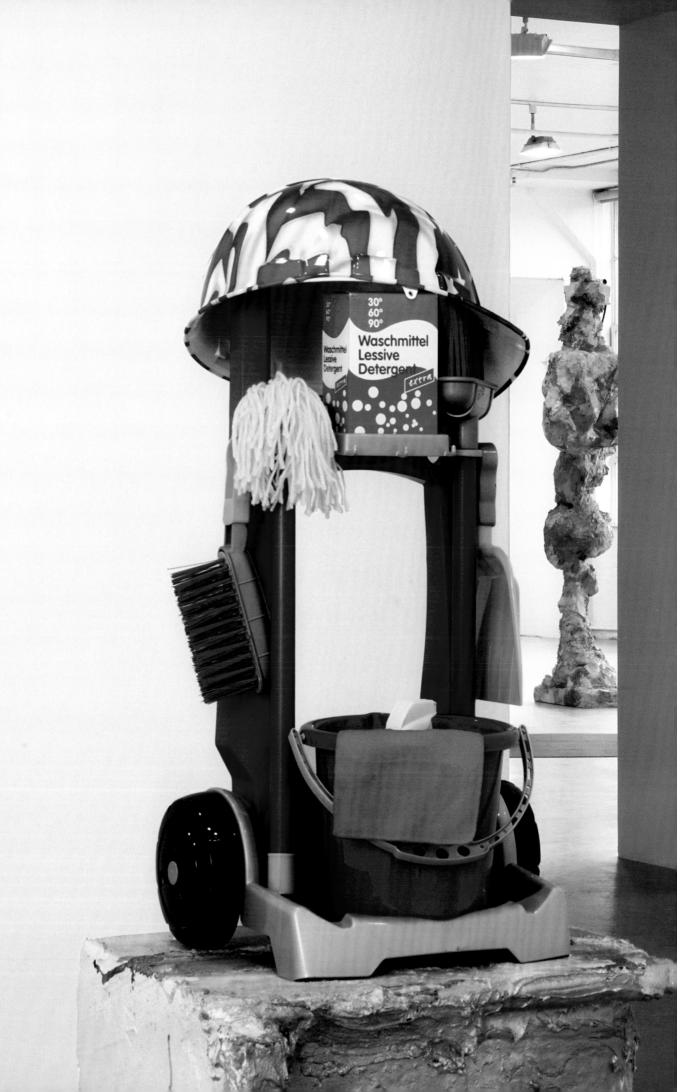

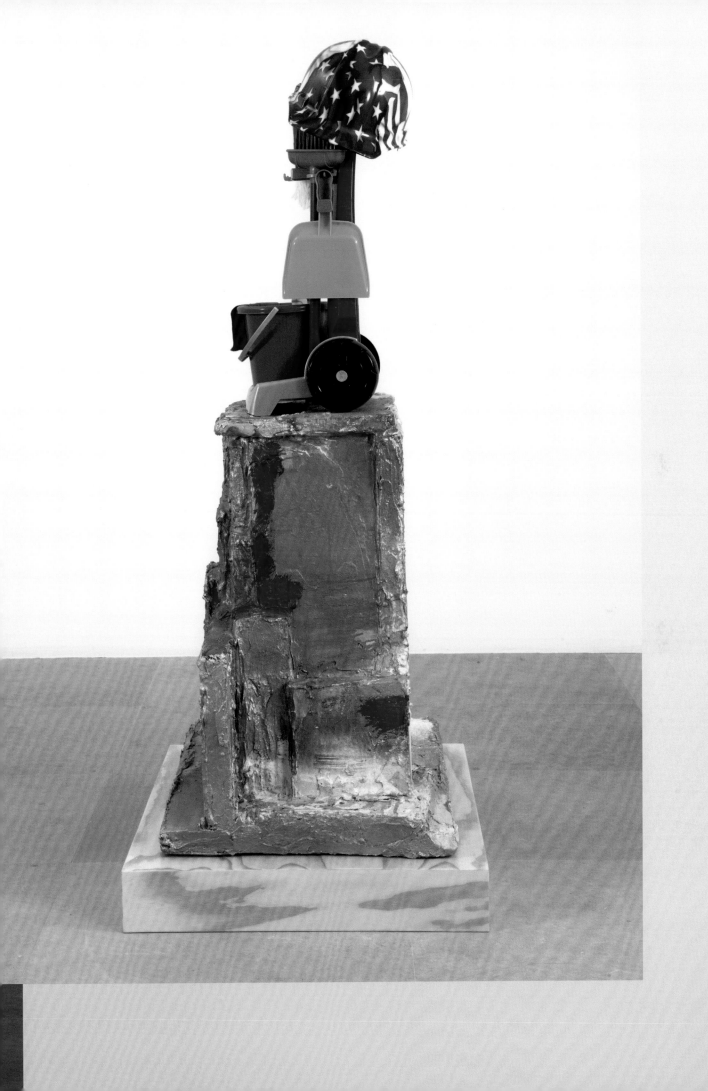

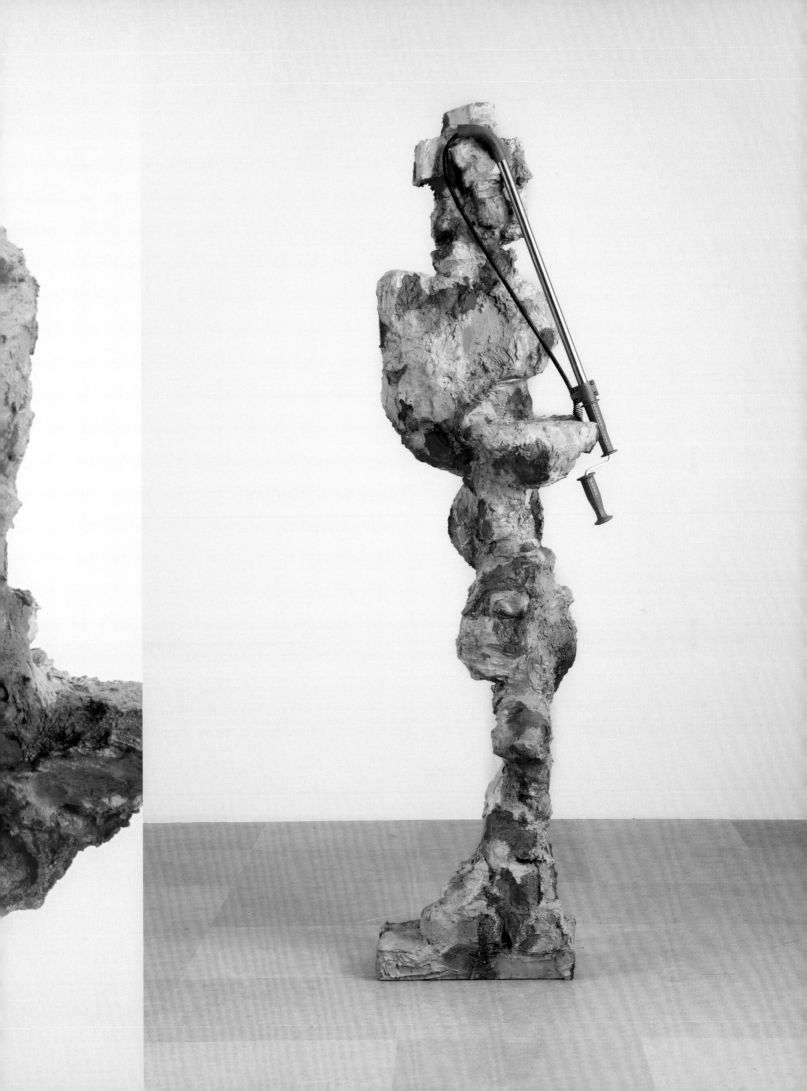

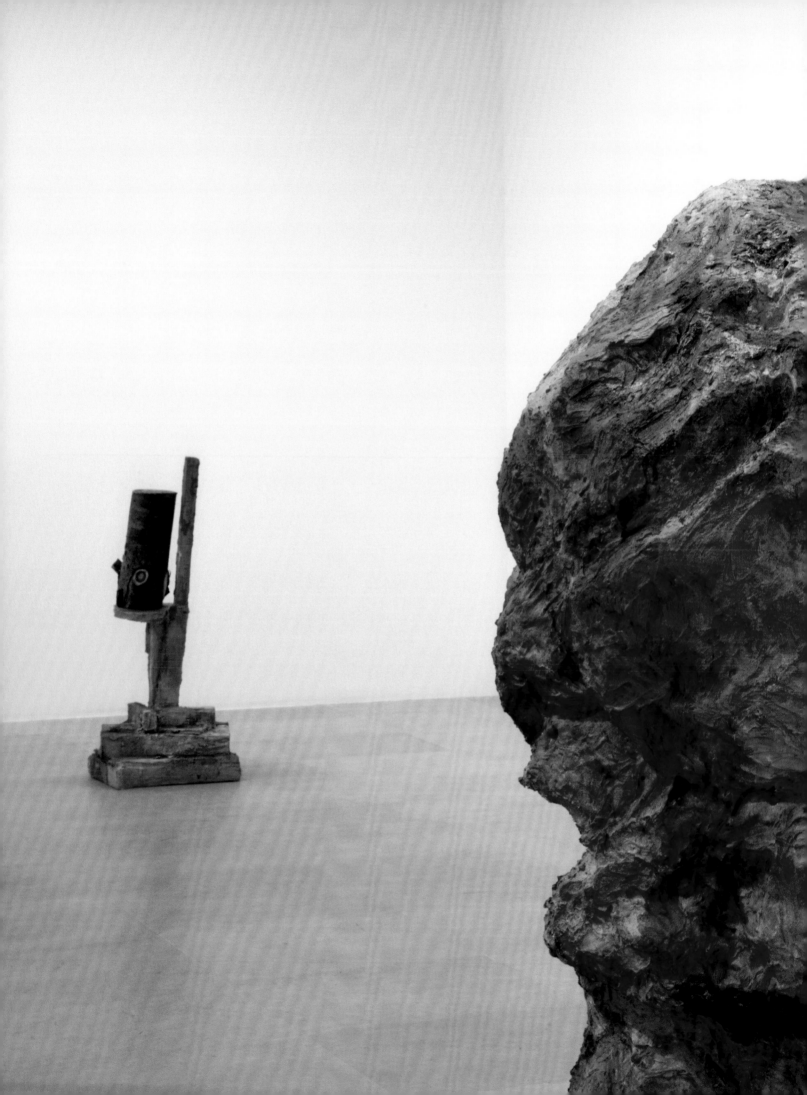

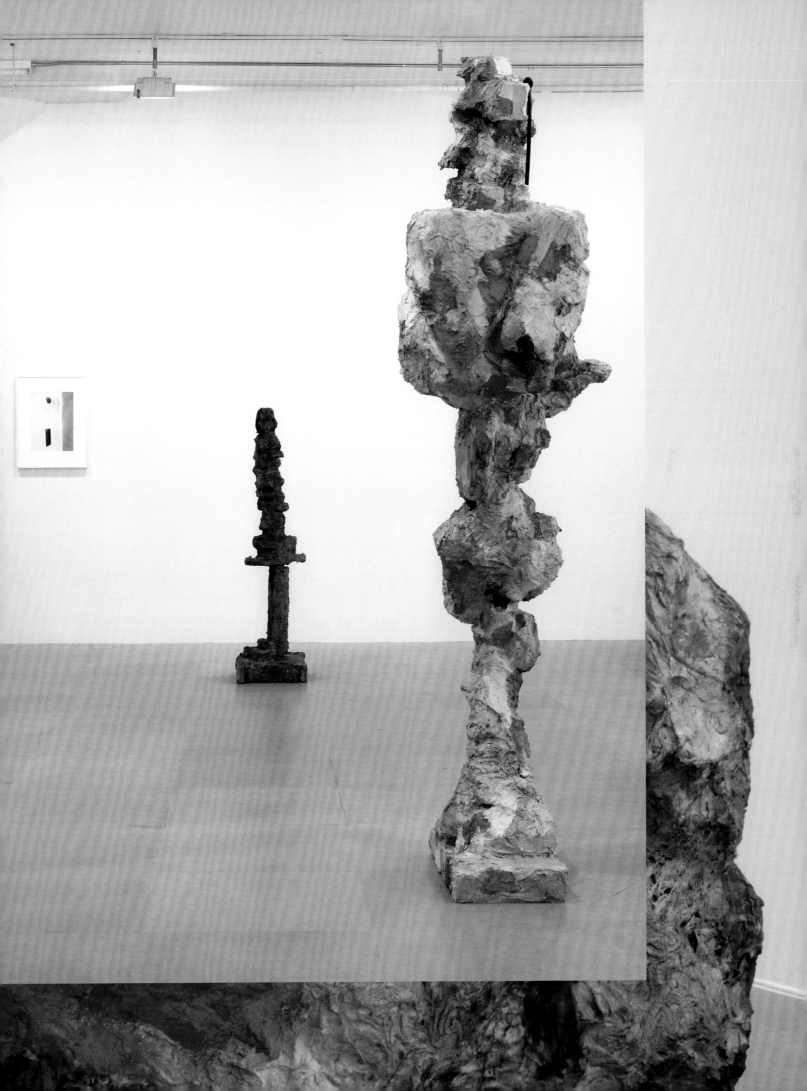

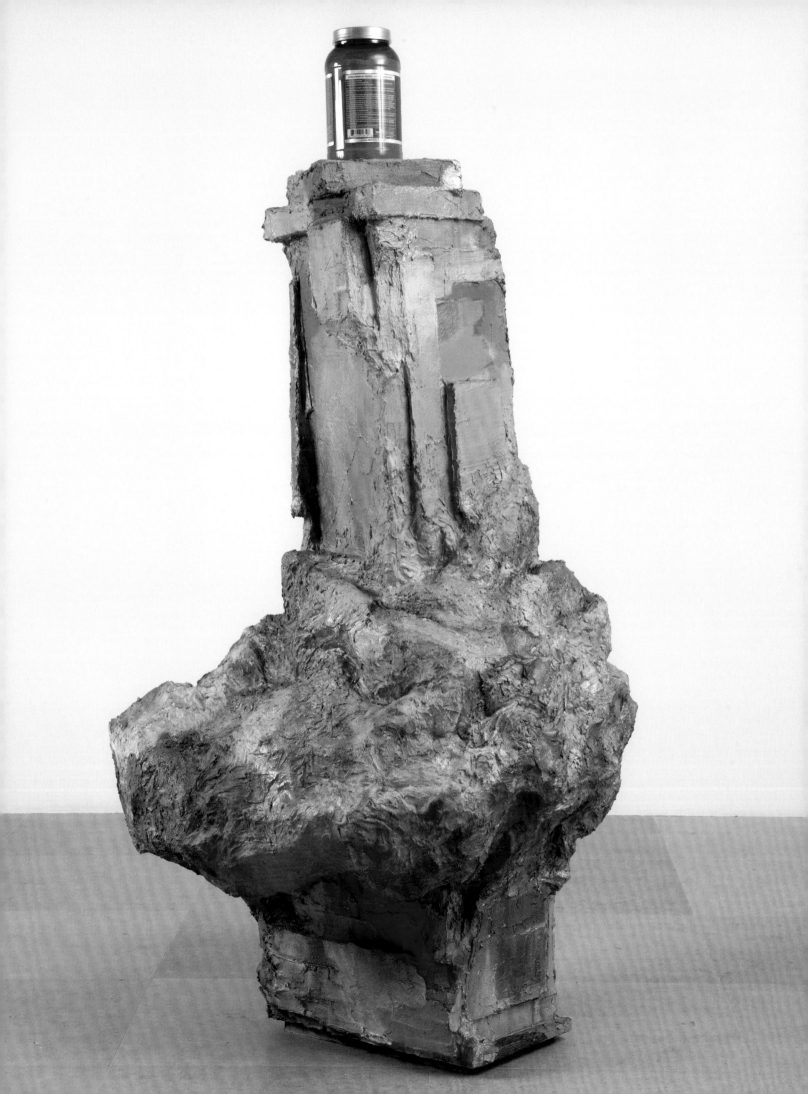

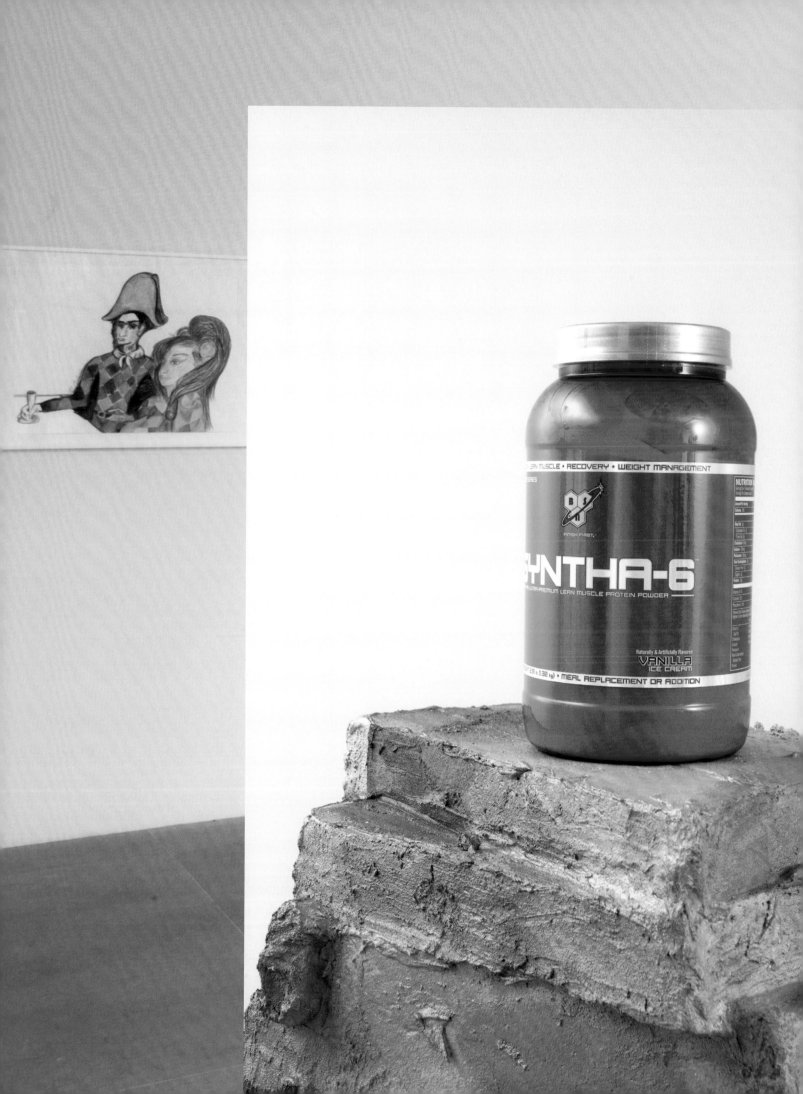

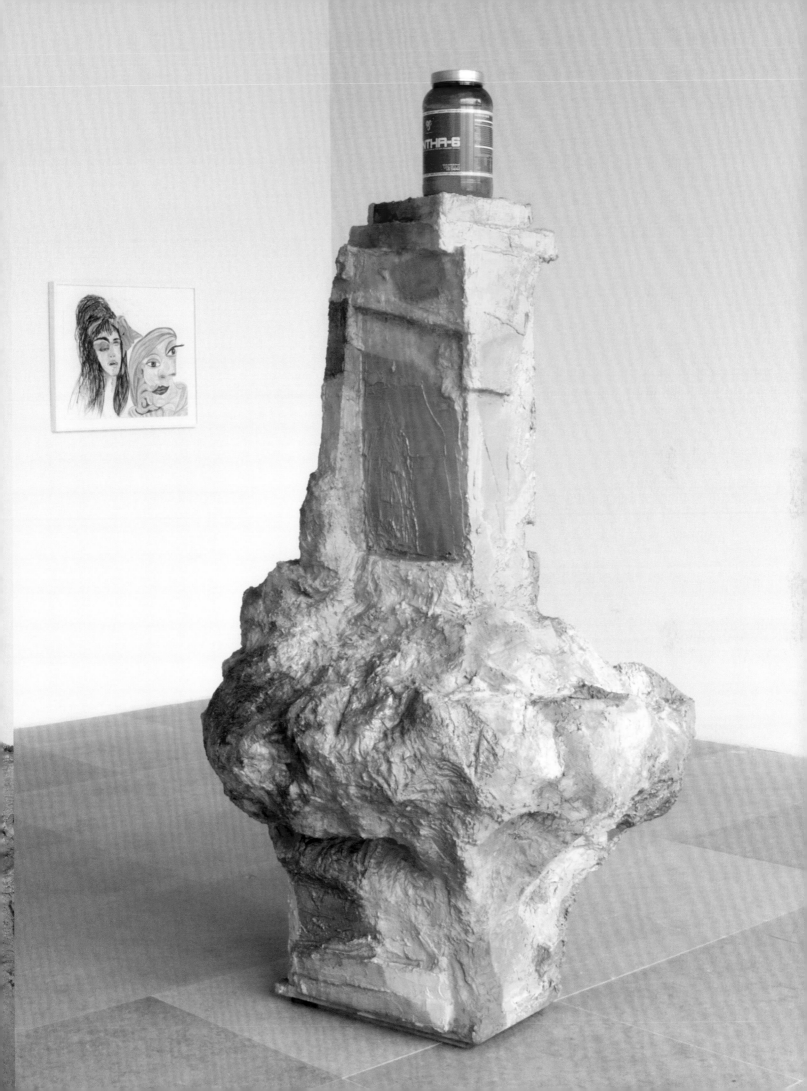

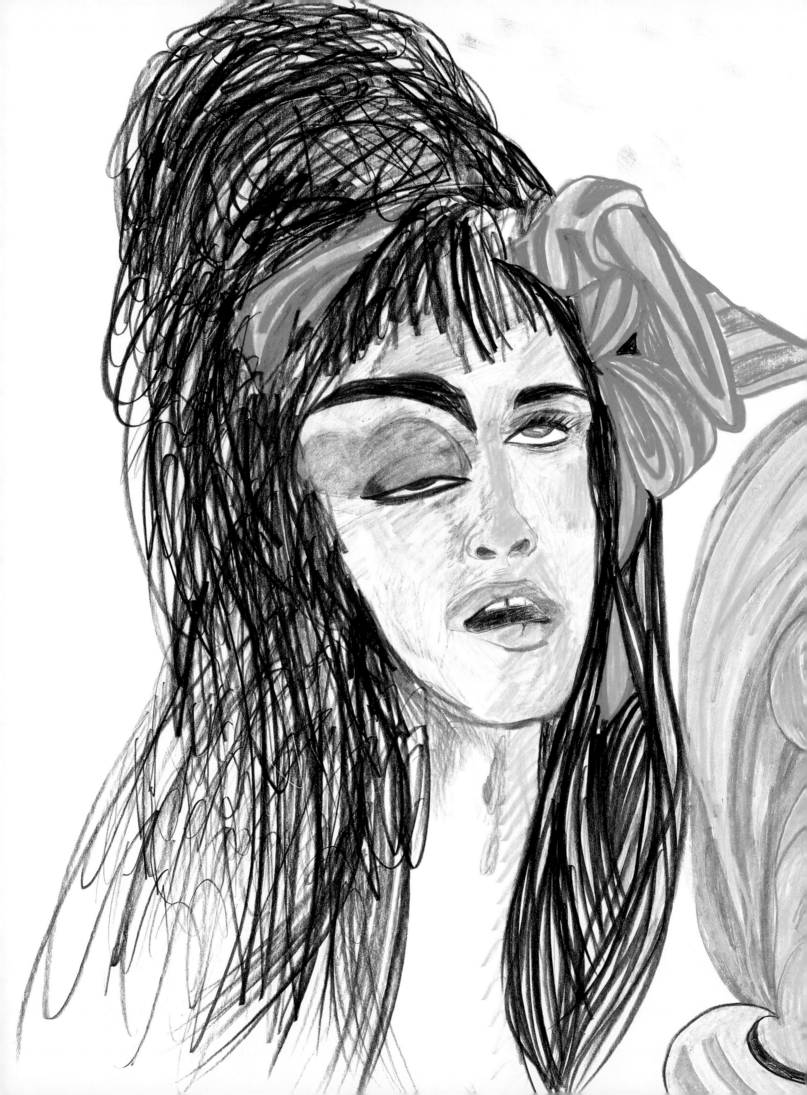

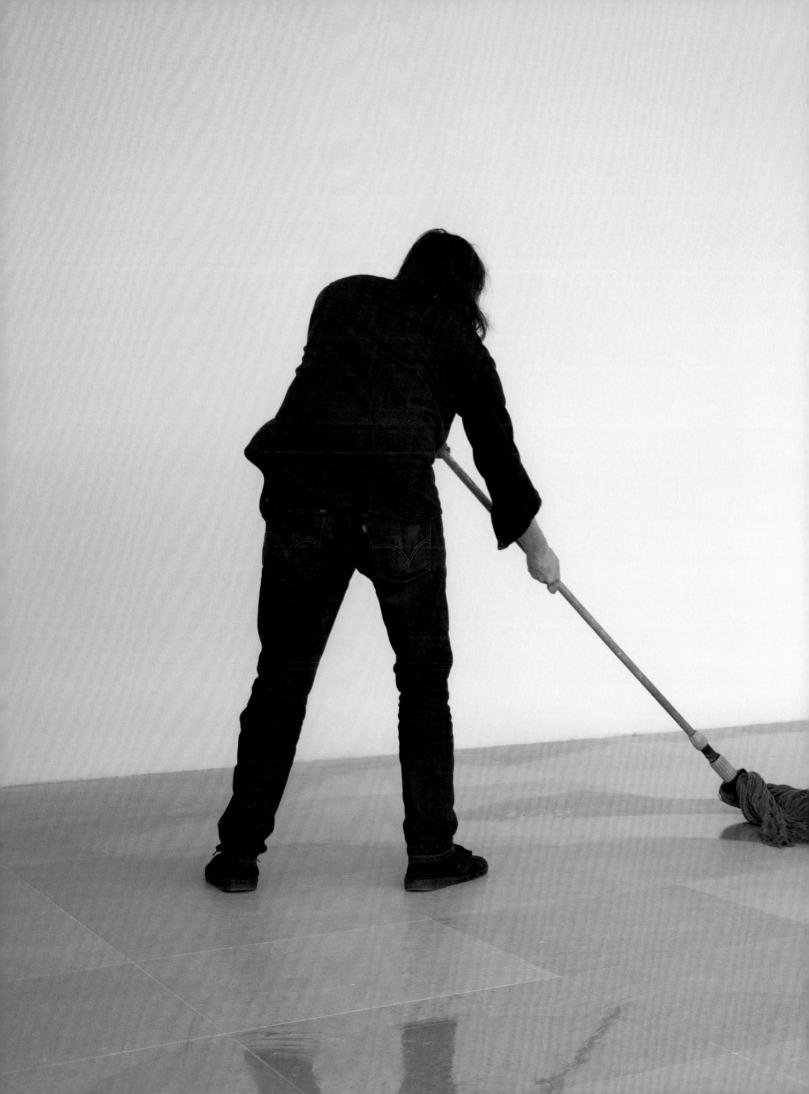

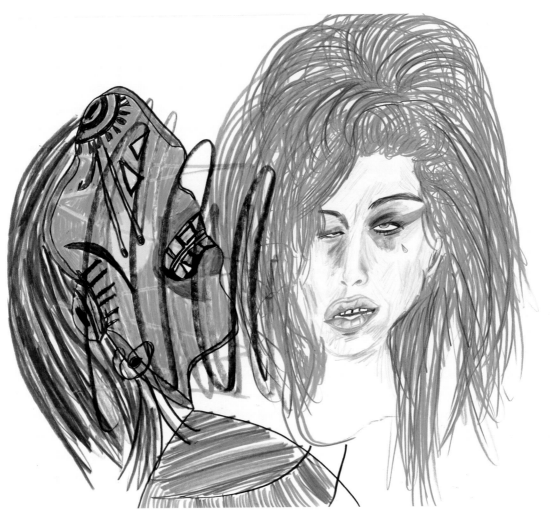

Untitled, 2012

Große wulstige oder sich blähende bunte Styropormassen, Alltagsobjekte (Reinigungs-geräte), kleinere Blecheimer und andere Behälter befinden sich untereinander, scheinen aneinanderzulehnen, Druck aufeinander auszuüben, einander zu stützen oder zu zer-malmen. Ihre Bedeutung und Wiedererkennbarkeit ist immer nur zu haben unter dem be-drohlichen Eindruck ihres potenziellen Gewichts oder ihrer Fragilität. Damit funktionie-ren sie als Allegorien von Bedeutung sehr viel realistischer als jede lineare Metapher für solche Aussagen, die auf heterogenem Material basieren. In einem komischen Sinne wird dieser vertikale Realismus des semantischen Geschehens auch in die Auseinander-setzung mit den an Picasso erinnernden Zeichnungen hineingetrieben. Die Verrutscht-heit des Gesichtes von Amy Winehouse und anderer Gesichter erscheint in diesem Zusammenhang auch auf interne Druckverhältnisse in der ebenfalls unter den Bedingun-gen von Schwerkraft sich konfigurierenden Architektur des Sängerinnenkopfes.

Zeichen miteinander so zu vermischen, dass sie sich aneinander reiben und den Ursprungskontext und den neuen Kontext als unversöhnte Teile der Welt hervortreten lassen, das können wir bei Rachel Harrison lernen, ist heutzutage nur noch relevant, wenn man die semiotische Differenz der Kontexte als physische Eigenschaften herausar-beitet: als Unterschiede in Dichte, Gewicht usw. Trotzdem muss erkennbar bleiben, dass sie nicht nur chemisch-physikalisch unterschieden sind, sondern semiotisch, se-mantisch, kulturell. Künstlerisch relevant ist es ja, gerade ein Verfahren zu finden, das intellektuell wahrgenommene Unterschiede sichtbar macht, etwa indem man einen sol-chen Unterschied und seine Klassifikation wörtlich nimmt: etwas ist „relevant", dann ist es „von Gewicht".

Nun braucht jede gute künstlerische Arbeit nicht nur ein Verfahren, sondern auch eine mit ausgestellte Reflexion über dieses Verfahren. Jene darf dieses nicht einfach de-mentieren oder ironisieren, sie muss vielmehr zur Diskussion einladen. Dafür muss sie

die eingesetzten Methoden ernst nehmen und validieren, aber zugleich mit Mitteln der Reflexion, des Humors und der allgemeinen Horizonterweiterung auf größere Zusammenhänge hin öffnen – sowohl auf solche, die mit der Tatsache zusammenhängen, dass es sich um künstlerische Arbeiten handelt, als auch auf diejenigen, die mit der referenzierten Welt und ihren Gesetzen und Geschehnissen jenseits der künstlerischen Darstellung zu tun haben. Insbesondere, wenn so viel erkennbare Welt jenseits der künstlerischen Produktion Eingang in das Werk findet wie bei Harrison.

Und hier kommt der Titel der Ausstellung, von der ich hier schreibe, im Wortsinn zum Tragen: *The Help*. Man könnte ja grundsätzlich sagen, dass die Skulptur an sich und insbesondere die Bezugnahme auf das Genre der Skulptur bei Rachel Harrison die kunsttheoretische Abstraktion eines Supports zurückweist, zumindest dann, wenn dieser Begriff auf eine generelle Austauschbarkeit dessen verweist, was je nötig ist, um eine bestimmte Menge von kulturellen Zeichen zu platzieren. Support wird oft in dem Sinne verwendet, dass zwar eine an der Dekonstruktion geschulte Aufmerksamkeit gegenüber dem jeweiligen Träger und dem jeweiligen Material eines künstlerischen Zeichenarrangements zu erbringen wäre. Dass aber zugleich eine Gemeinsamkeit zwischen all diesen möglichen Trägern besteht, die sie trotz der möglichen Entfaltung supplementären Eigensinns (wenn z. B. der Rahmen das Bild überwuchert) gemeinsam haben. Sie sind zwar nicht zu vernachlässigen, aber die pflichtgemäße Bezugnahme ist klar beschrieben und auch gewissermaßen beschränkt. Der Support spielt immer auf der gleichen ontologischen Ebene: materielle Träger, deren bloße physische in eine semantische Relevanz umschlagen könnte.

Der Inhalt von *The Help* hingegen ist die Konkretheit des Supports, wie sie die Skulptur mit ihren Kommentaren und Witzen zum Phänomen Gewicht besonders gut zu leisten bzw. darzustellen vermag. Hier wird konkret und materiell getragen, nicht nur hervorgebracht oder unterstützt. Neben der formalen Demonstration von Gewicht oder auch dem Weglassen von Gewicht (wenn etwas, das schwer aussieht, leicht zu sein scheint) geschieht dies aber vor allem in der Narration dieser Ausstellung. Und hier wechselt die Ontologie von physischer Kraft zu menschlicher, lebender Arbeitskraft. *The Help* handelt von Hilfskräften, insbesondere von den (meist weiblichen) Reinigungskräften, die nun nicht so sehr am skulpturalen Tragen und Stemmen arbeiten als an der Hervorbringung, dem Erscheinen-Lassen des Supports, indem sie die Räume weiß (oder eben sauber und indifferent) halten, vor deren Hintergrund die Zeichen erkennbar werden. Die quasi geheime, stets verschlossene Tür, die zu dem Raum führt, von dem aus Duchamps *Étant donnés* in Philadelphia sauber gehalten wird, erscheint hier wie die sprichwörtliche verbotene Information aus dem Märchen (und aus der Kafka-Welt). Es wird Zeit, dass wir sie öffnen.

Harrison führt aber beide Stütz- und Tragekonstruktionen eng: das Gewicht des kulturellen Zeichens in der Skulptur und die menschlichen Kosten des Supports in der Reinigung der White-Cube-Kunst. Sie platziert Staubsauger, Bodenroller und Putzeimer-Arrangements, so als würden sie tatsächlich großes Gewicht tragen, und sie widmet in dem ansonsten thematisch assoziationsreich mäandernden Bild-Collagen-Katalog konstant immer wieder Fotografien der Tätigkeit der Aufbauteams, der Packer und anderer Galeriebeschäftigter. Doch die Reinigungs- und Aufbaukräfte sind nicht einfach nur Platz-

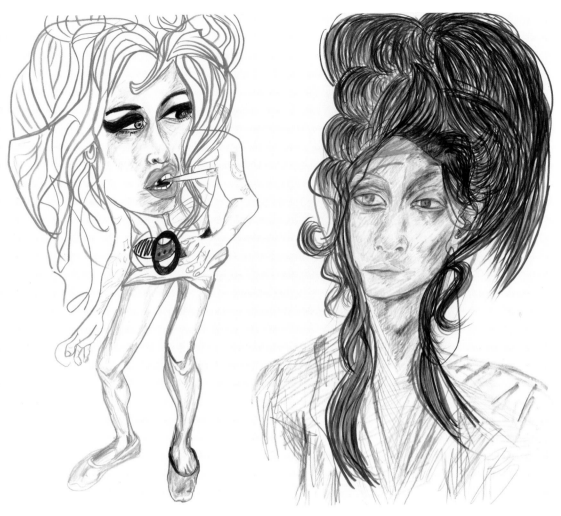

Untitled, 2011

halter der je verschwiegenen Seite von Kunstproduktion, sie sind auch nicht in erster Linie als konkrete Unterstützer zu sehen, die Harrison geholfen haben. Denn Harrison geht noch etwas weiter als das berühmte Bertolt-Brecht-Gedicht *Fragen eines lesenden Arbeiters*.

In diesem Gedicht durchsucht ein Arbeiter die Geschichtsbücher und stößt auf die verschwiegenen Massen, die die Geschichte gemacht haben und an die sich keiner erinnert, wenn die Namen der großen Männer fallen. Jörg Immendorff hat einmal einige Zeilen des Gedichts illustriert, etwa den Satz „Cäsar eroberte Gallien/Hatte er nicht wenigstens einen Koch dabei?", indem er zwischen lauter römischen Helmen eine Kochmütze hervorschauen ließ. Aber nicht allein diese Frage stellt oder beantwortet Harrison, sondern vielmehr die Frage nach der physischen und konkreten Arbeit, die es ermöglicht, dass Zeichen hervortreten – eine in Zeiten vermeintlich rein immaterieller und körperloser Kulturproduktion in Vergessenheit geratene Tatsache.

Doch jede Sichtbarkeit und Erkennbarkeit in der Öffentlichkeit kann nur erzielt werden, indem öffentliche Räume geschaffen, gesäubert, gestaltet, organisiert, in Vorder- und Hintergründe aufgeteilt und entsprechend definiert werden. Auch dort wo eine Putzkolonne nichts zu tun hat, auf der digitalen Seite, die mir mein Computer zeigt, bevor ich dort ein Zeichen setze, haben eine Fülle von Tätigkeiten stattgefunden, die den leeren Screen so wie jede andere Einschreibfläche erst gewährleisten konnten: vom Erzeugen und Bereitstellen von Elektrizität über günstige und fast steuerfreie Konditionen für elektronische Großunternehmen bis zu den Verfassern und Überprüfern von Codes und der Einrichtung einer symbolischen Ordnung, deren Charakteristikum es ist, dass wir mit anwesenden Zeichen über abwesende Dinge kommunizieren. Es ist der Vorzug der Skulptur (dieser Skulpturen), die materiellen Ordnungen hinter der Symbolproduktion in einer einleuchtenden Metapher vorzuführen: dem Bild des Gewichts.

Questions from an Abstraction Who Reads Diedrich Diederichsen

Amy Winehouse died a year before becoming one of the main figures in Rachel Harrison's exhibition *The Help*, taking her place alongside Martin Kippenberger and several classical heroes of modernism, like Gertrude Stein, Pablo Picasso, and the absent-present Marcel Duchamp, as part of the cast of the show, its dramatis personae. But as opposed to Harrison's earlier exhibitions, these individuals are portrayed not through sculptures that otherwise do not resemble the portrayed person; instead they appear as drawings along with attributes of their respective art or public presence as points of reference for Harrison's work. Although Winehouse and Kippenberger, both of whom died tragically early deaths, can be considered typical representatives of the dissipate artist, here they are not seen in this role. Nor are they part of the isolated and often grotesque scraps of everyday life and news items that have a fixed place in Rachel Harrison's sculptural syntax, representing typical reality (e.g., a video of a taxi conversation on the political situation) that could also have been represented otherwise (a cartoon from a newspaper). For these fragments can be recognized, not only because of their media support and their placement in the sculptural constellation, as not made, but found; they are also framed as the effect of external reality. Winehouse, in contrast, seems to have been an internal participant, and more a hero on her own account than a witness of an external reality. At best, it could be added that she might have played the role that she — at her disastrous appearance in Belgrade on June 18, 2011 — literally could no longer stand: she herself could have used "the Help."

The more plausible link between Harrison and Winehouse is in a certain way similar to that of Kippenberger to Picasso. What connects them is a detail of the corporeal armor. Kippenberger repeatedly portrayed himself modeled after a photograph of Picasso walking his dog in his underwear, painting himself in a similar pair of shorts and emphasizing his belly. Harrison contextualizes the Winehouse beehive hairdos in the companion guide to *The Help*, both with pictures of her studio assistant's hair and with a tableau of historical beehive hairdos from the early 1960s, photographs of girl groups like the Shangri-Las and the Supremes. Of course, the tower of the beehive hairdo is also a strong image of sculpture as an upright, standing construction. It is an artful, complex vertical construction, made of a material that of its own accord would rather lie flat and spread out horizontally and formlessly. The belly, in contrast, swollen and distended, expanding and sprawling, forms a material of a different kind in Harrison. It is created using Styrofoam as something like pure sculpturality, something that would sprawl uncontrollably if there were no syntax that subjected the nouns to the movement of verbs, by linking subjects and predicates.

Kippenberger did something that Harrison also did several years ago: assigning the names of prominent or historical figures to sculptures that bore no human resemblance. But in Harrison's work, this took place via a set of entirely different aesthetic procedures, a syntax of collage or assemblage, while in *Peter: Die russische Stellung* (*Peter: The Russian Position*), Kippenberger was more interested in the exclamation mark of the readymade and the *objet trouvé* or its dilettantish reconstruction. Nonetheless, by expressly and rather derisively thematizing 'standing' in contrast to hanging, he also was pursuing a parallel project: underscoring the upright, the reconstruction of an old link between standing and the sculptural portrait of an individual, and the expandability of

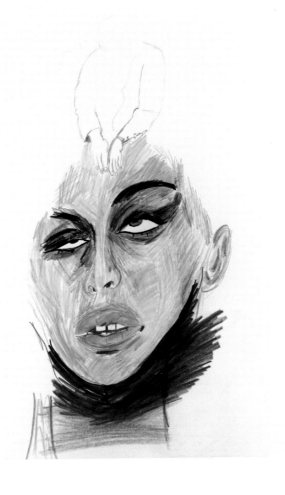

Untitled, 2011

similarity, where a proper name and a principle like verticality establish commonalities between a human being and an object. The extension of claims of similarities (that is, metaphor) is so important in Harrison's work because she quite intensely uses objects that serve as attributes of a (real or fictional) person (that is, as metonymies) but evokes them in a very different way. The particular amusement that consists in the truth effect, where an attribute seems to look like the person to whom it is attributed (a dog and its owner), ensues all on its own: it is somehow no longer clear whether this cleaning trolley is an attribute of the cleaners, whose underpaid activity is a requirement for the white in the white cube, or whether the shape of the long thin handle over the flat object equipped with rolls makes us sad, because a sad person looks just that way. A sad figure: what is that precisely?

But Harrison is more radical than (Winehouse and) Kippenberger in simultaneously making a claim and shaking off whatever happens to be claimed in a single gesture. The tower of the hairdo and the proper name, overcome in this exhibition and replaced by pure shape, stand in a larger context to a new formulation on the link between naturalness, natural language, and artistic formats. The standing, in that it consists of several parts, is not natural in Harrison, nor is it uncanny. The assembled and heterogeneous recalls parts of a sentence rather than the quasi-animistic animation of readymades (found cabinets) and their magic transformation to individuals (Kippenberger), or the metonymic animation of objects, transforming them into those related to them, as for example in the "Californian Portraits" (readymade sculpture) by Eleanor Antin.

Language as a *tertium comparationis* between language and non-language is a model that since (and in) classical Conceptual Art has failed and become outmoded; it nevertheless recurrently exudes an attraction. Linguistic and non-linguistic expressions have something in common on a deeper level, a non-media-based organization of content

almost free of format that can again be presented in a format or the medium of language, as if language were a layer of abstraction higher than the other languages, of which it is only one. Ever since the first collages — indeed if not since the multi-paneled altarpiece — visual art has worked with something that may not be described only as an image, but also as the syntactical linkage of images; toward this end, the terms and images for describing language with sequentially arranged elements of meaning are used.

The idea that images connect to images like parts of sentences corresponds to the notion that objects are linked on pictorial surfaces like grammatical sentences. The concept of the diagram conceives the drawing or painting of pictures as a writing out or through, a writing expanded on the surface and in imagined space. The concept of the proposition, so important for early Conceptual Art, represented content as transportable linkages that could be transferred to different codes. All these notions of linking heterogeneous elements to units share a thinking in linear, flat, sequential, and horizontal objects. Free association in psychoanalysis and surrealism and film montage are no exceptions to the rule. The chord in music is one of the few cultural models conceived as a tower — the bridge, the scale, and other architectural metaphors in music move in the same direction, but as a rule they serve to describe the link between things that are similar or fitting. Collage and montage remain caught in the conceptual cage of successiveness.

Why is this a problem? The metaphor of successiveness and the corresponding media condition suggests weightlessness, immateriality. The heterogeneity of signs and cultural objects can only be brought to bear when artistic accessibility is limited and weight and gravity are taken into account in order to erect a tower of heterogeneity. Only in the tower does the heterogeneous have a chance of developing beyond the convention that a collage mixes objects from various sources, because it threatens with its specific qualities to crush the other qualities or be crushed by them. That a statement comes about by using various sources entails on a material and semantic level that the relationship of the parts to one another is not neutral, that there is no ceasefire between them, that even if there is a moment of calm, it is at best a snapshot of what is actually a dynamic process.

Large, bulging, distended, colorful Styrofoam masses, everyday objects (devices for cleaning), small buckets and other containers are found assembled, seem to lean against one another, to exert pressure, to support or crush one another. Their meaning and easy recognition can be had only under the threatening impression of its potential weight or its fragility. Thus they serve as allegories of meaning that are much more realistic than any linear metaphor for statements based on heterogeneous material. In a comical sense, this vertical realism is driven into semantic events in engaging with the drawings that recall Picasso. In this context, the awry aspect of Amy Winehouse's face and the others seems due to internal relations of power in the architecture of the singer's head, which itself is also configured under the conditions of gravity.

We can learn from Rachel Harrison that mixing signs so that they rub against one another, allowing the original context and the new context to appear as unreconciled parts of the world, is relevant today only if the semiotic difference of the contexts is distilled in physical qualities: as differences in density, weight, and so on. All the same, it must

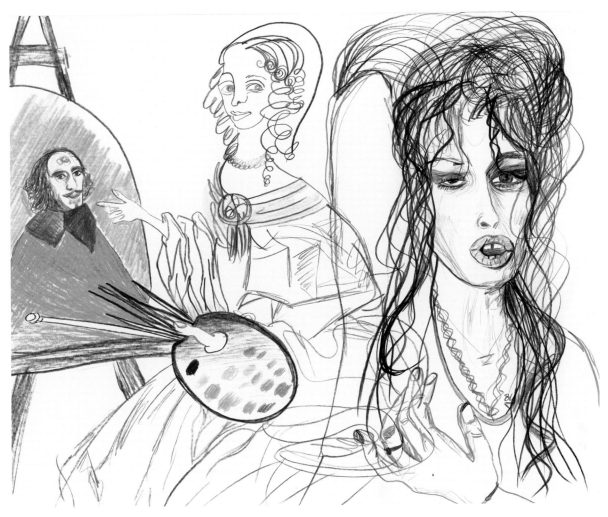

Untitled, 2011

remain clear that they are not only different chemically and physically, but also semiotically, semantically, and culturally. It is artistically relevant to find a technique that makes intellectually perceived differences visible, by, for example, taking such a difference and its classification literally: something is 'relevant', then it has a 'weight'.

Now every good artwork requires not just a technique, but a reflection on this technique that is presented along with the work. It cannot simply repudiate or ironize the technique, but it must invite discussion. For this, it needs to take its methods seriously and validate them, but also to have a means of reflection, humor, and a general expansion of horizons to larger contexts, both to contexts related to the fact that artistic works are at issue and to those that have to do with the world referred to and its laws and events beyond artistic depiction. Especially when so much of the recognizable world beyond artistic production finds its way into the work, as is true of Harrison.

And here, the title of the exhibition I am writing about literally comes to bear. It could be said that the sculpture itself and especially the reference to the genre of sculpture in Rachel Harrison's work refuses art theory's abstraction of a support, at least when this concept indicates a general exchangeability, that is, whatever is necessary to arrange a certain amount of cultural signs. The category of the support is often used to direct attention to the specificities and to the (physical) material of an artistic arrangement. At the same time this category assumes that there is an ontological level shared by all possible supports of artworks: they are material and physical components of the work that sometimes develop semantic qualities (i.e., when the frame takes over the picture).

The content of *The Help* by contrast is the concreteness of the support, which the sculpture, with its comments and jokes on the phenomenon of weight, is especially apt at providing or representing. Here there is something being borne in a concrete and material sense, not just engendered or supported. Alongside the formal demonstration

of weight or lack of weight (when something that looks heavy seems to be light), this happens above all in the narration of this exhibition. This leads to a different ontological plane of the category of support, from physical support to living labor: *The Help* deals with the staff, in particular the (usually female) cleaning staff that work not so much on sculptural bearing and lifting as on engendering, allowing the support to appear by keeping the spaces white (or clean and indifferent), against the background of which the signs become recognizable. The quasi-secret door, always closed, that leads to the antechamber from which Duchamp's *Étant donnés* in Philadelphia is kept clean, here appears like the proverbial forbidden information in the fairy tale (and the world of Kafka). It's time to open the door.

Harrison brings the constructions of support in both senses close together: the weight of the cultural sign in the sculpture and the human costs of support in cleaning white cube art. She arranges vacuum cleaners, cleaning trolleys, and constellations of cleaning buckets as if they actually supported significant weight, and in a collage of images in the companion guide, which meanders among thematically rich associations, she constantly features photographs of the installation team, the packers, and other gallery workers. And yet the cleaning and installation workers are not just placeholders for the silenced side of art production, they are not even primarily to be seen as the concrete supporters that helped Harrison. For Harrison goes somewhat beyond the famous Brecht poem *Questions from a Worker Who Reads*.

In this poem, a worker looks through history books and discovers the masses that are left out, those who made history and whom nobody remembers when the names of the great men are mentioned. Jörg Immendorff once illustrated several lines of the poem, for example, "Caesar conquered Gaul/Did he not have a cook with him?" by having a chef's hat appear among several Roman helmets. But Harrison does not pose or answer this question alone, but rather the question of the physical and concrete labor that makes it possible for signs to emerge, a fact that is often forgotten in times of supposedly immaterial and bodiless cultural production.

But every form of visibility and recognizability in public space can be achieved only in that public spaces are created, cleaned, designed, organized, divided into stage front and back, and defined accordingly. Even where a cleaning crew has nothing to do, on the digital page that my computer displays before I even set a sign, a plethora of activities have taken place to provide the empty screen, like any other surface of inscription. From the generation and provision of electricity to the favorable and almost tax-free conditions for major electronics companies, to the writers and testers of codes and the establishment of a symbolic order that is characterized by our using present signs to communicate about absent things. It is the advantage of sculpture (these sculptures) that it can present the material orders behind symbolic production in a convincing metaphor: the image of weight.

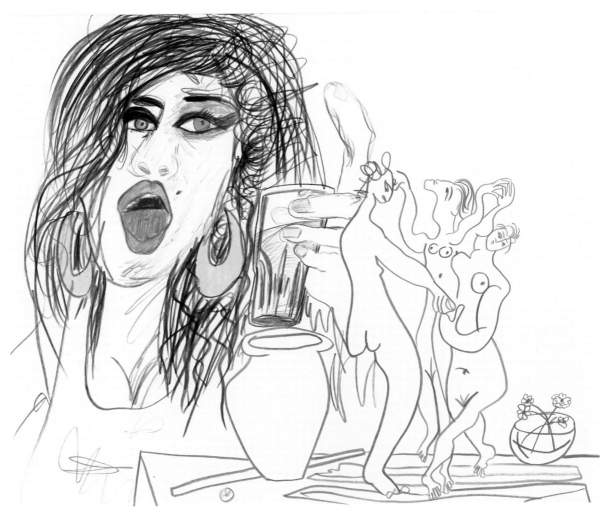

Untitled, 2012

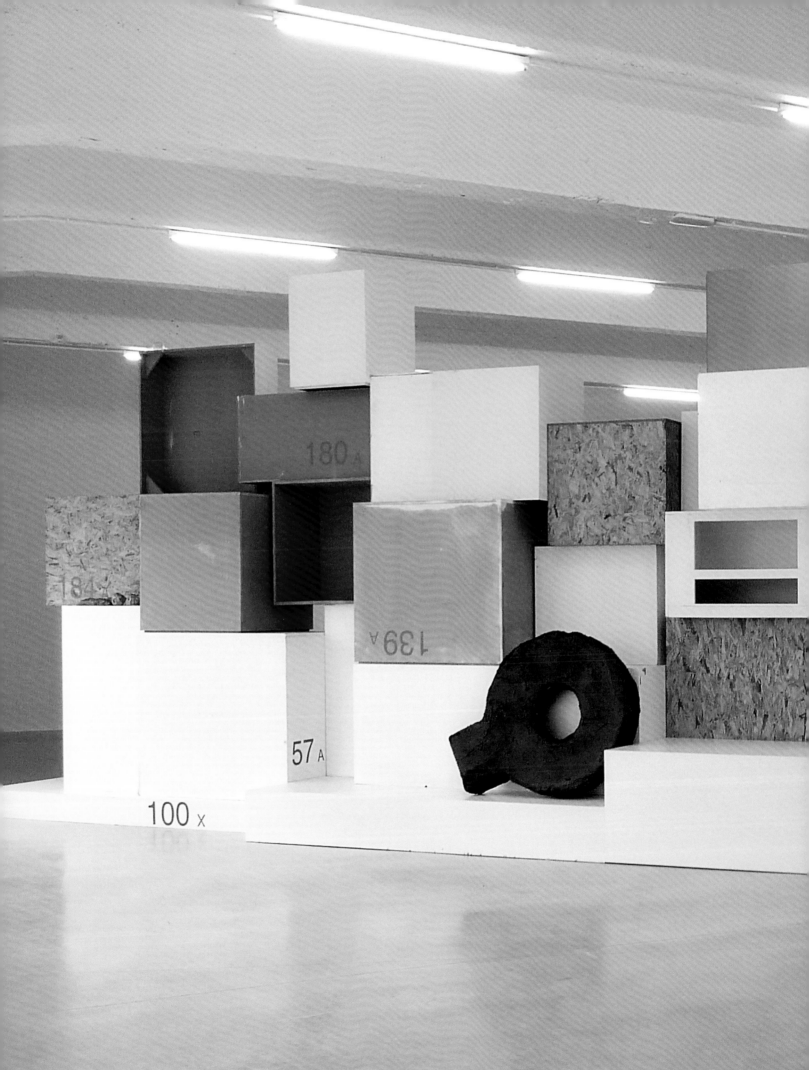

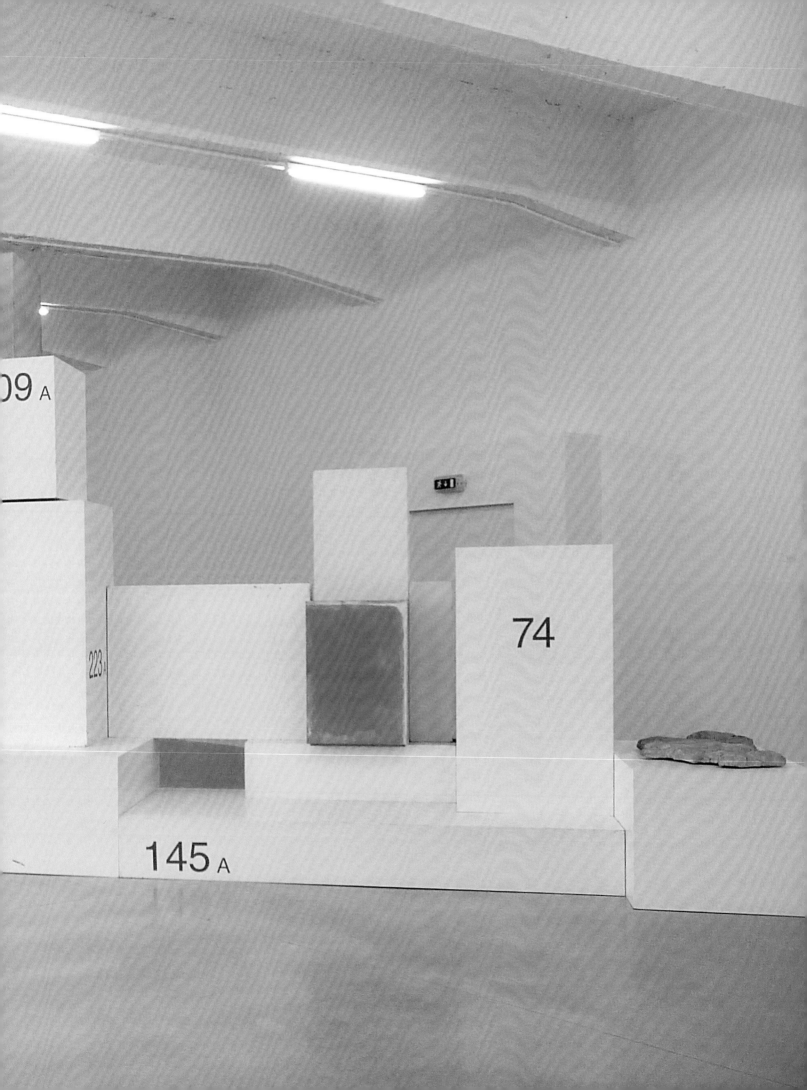

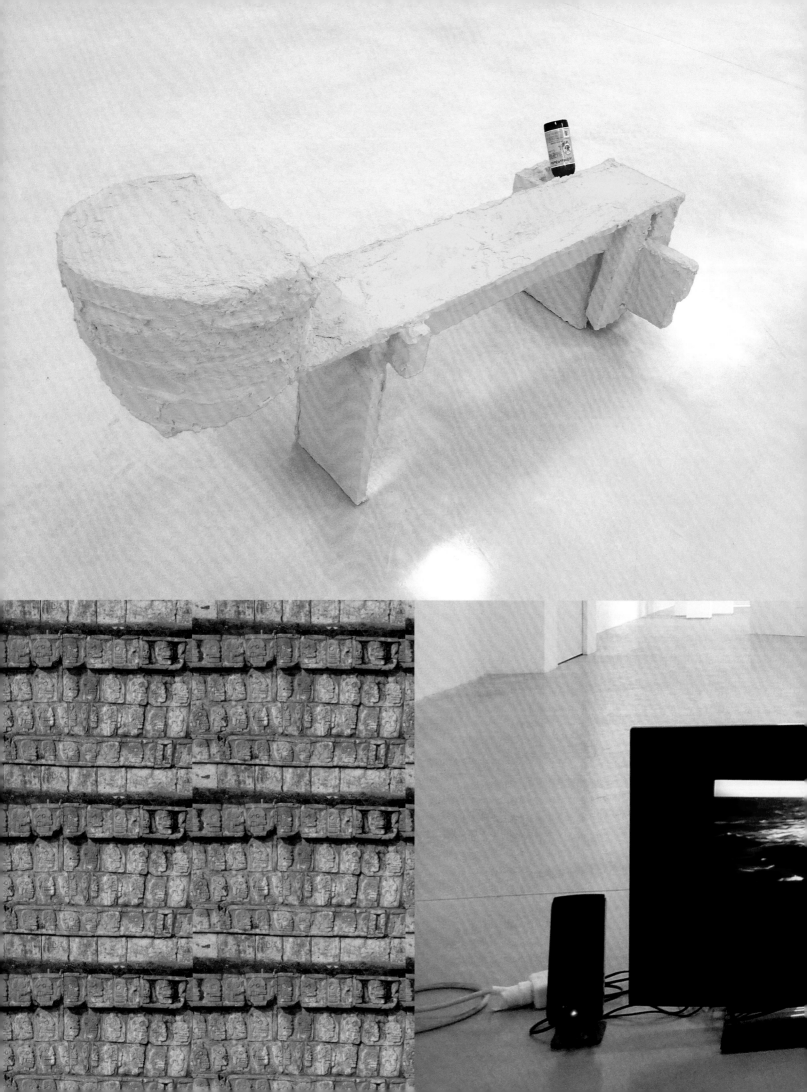

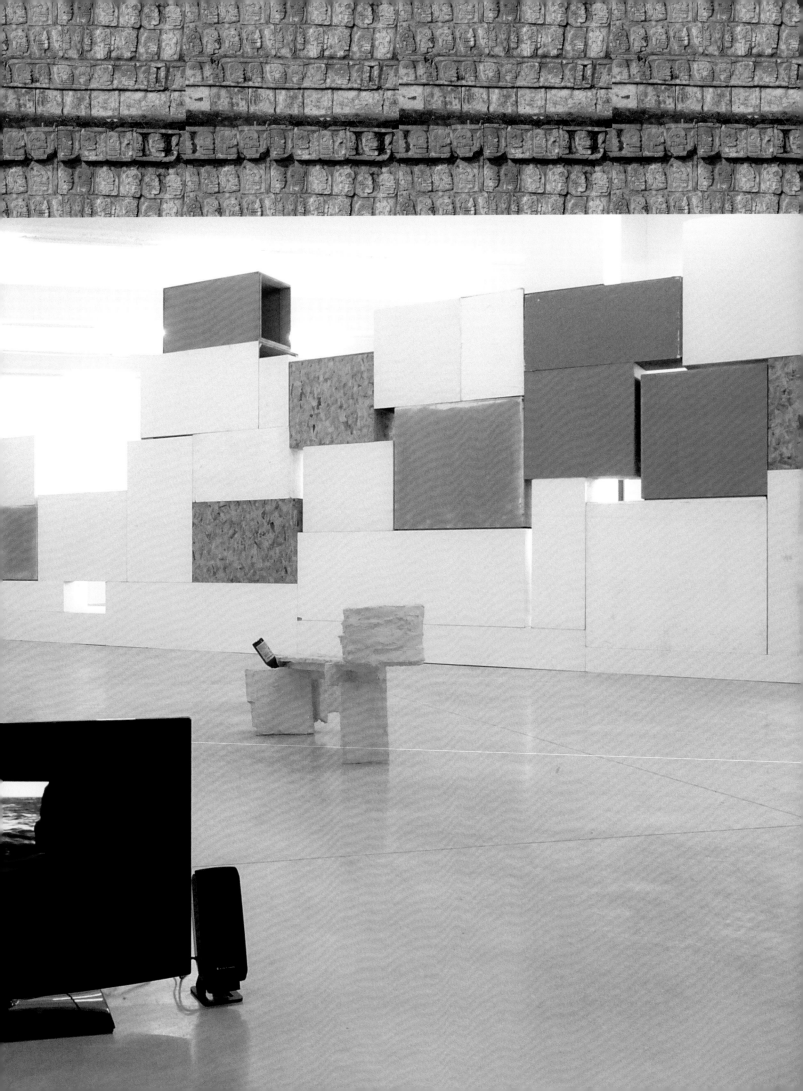

Geometry as origin

NAVAJO
ENGLISH

Produced in partnership with
THE FRENCH MINISTRY OF CULTURE AND COMMUNICATION,
DEPARTMENT OF ... RITAGE.

recognize real shit. Only one bitch put it down like this, se

184 A

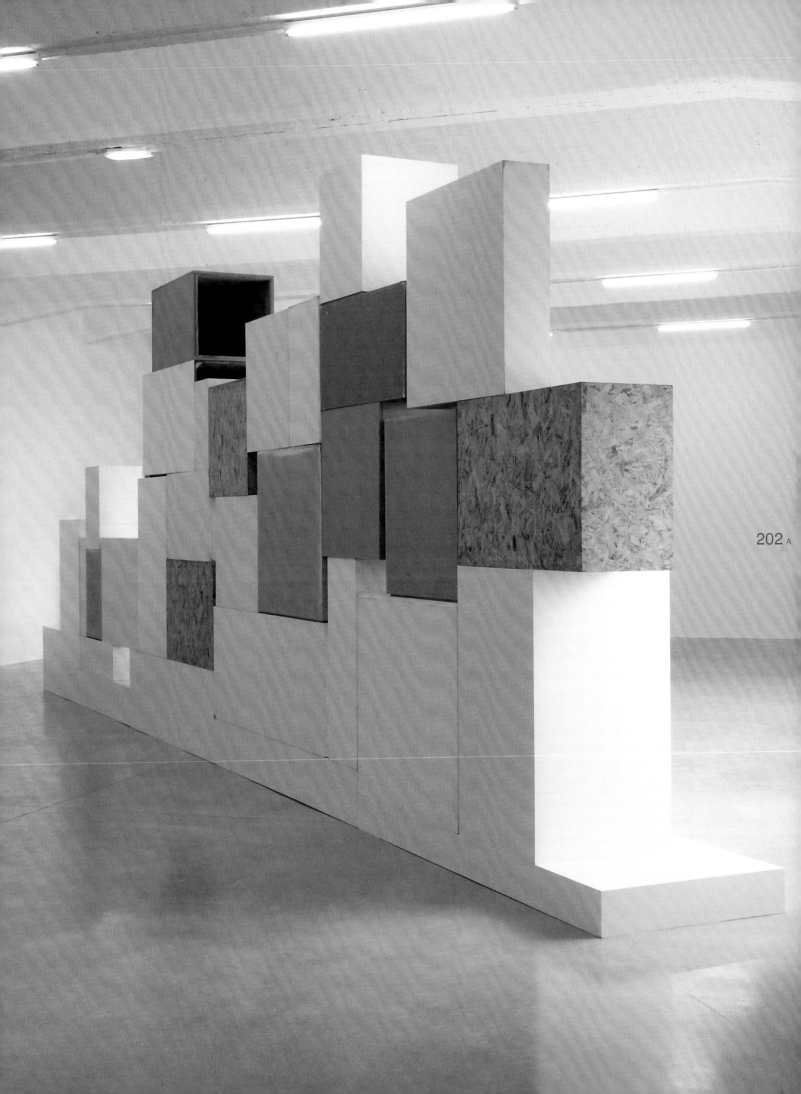

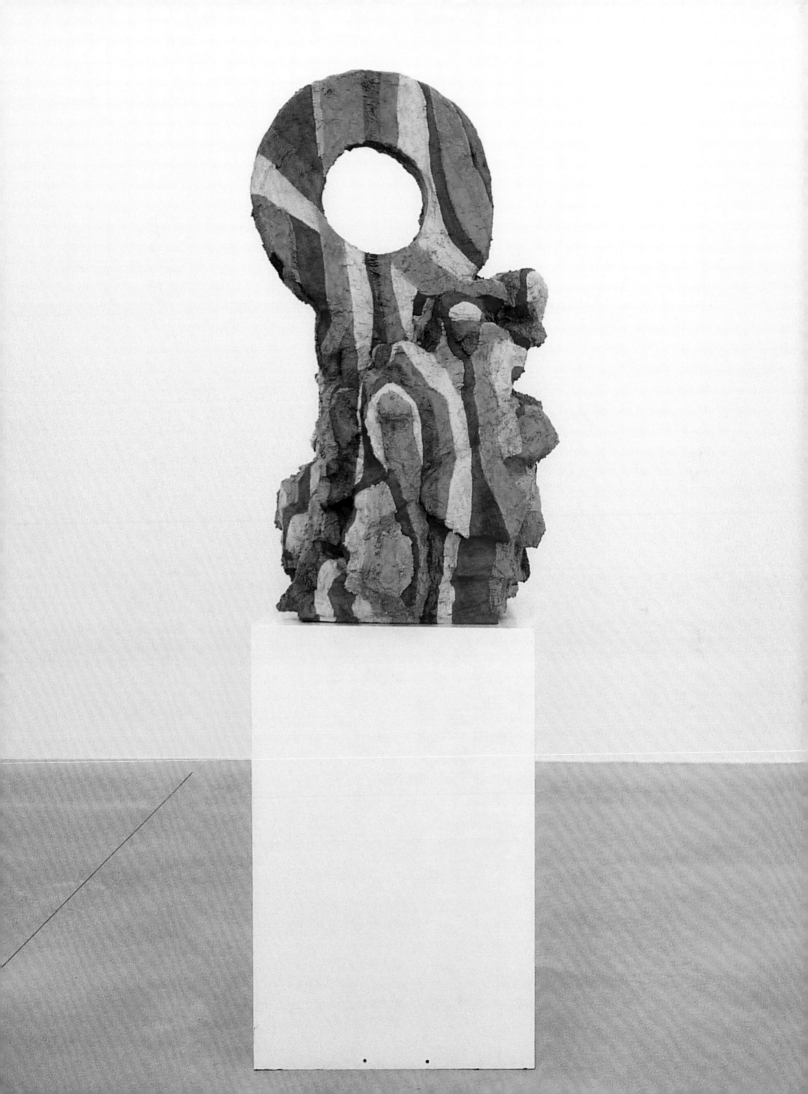

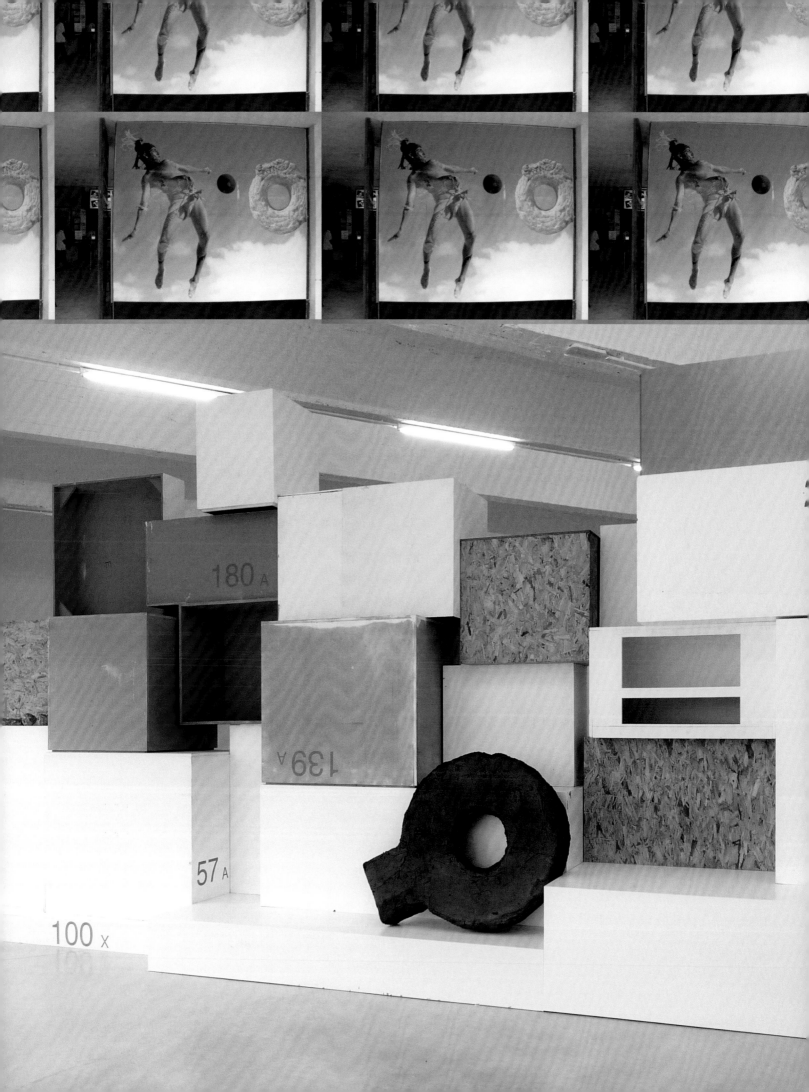

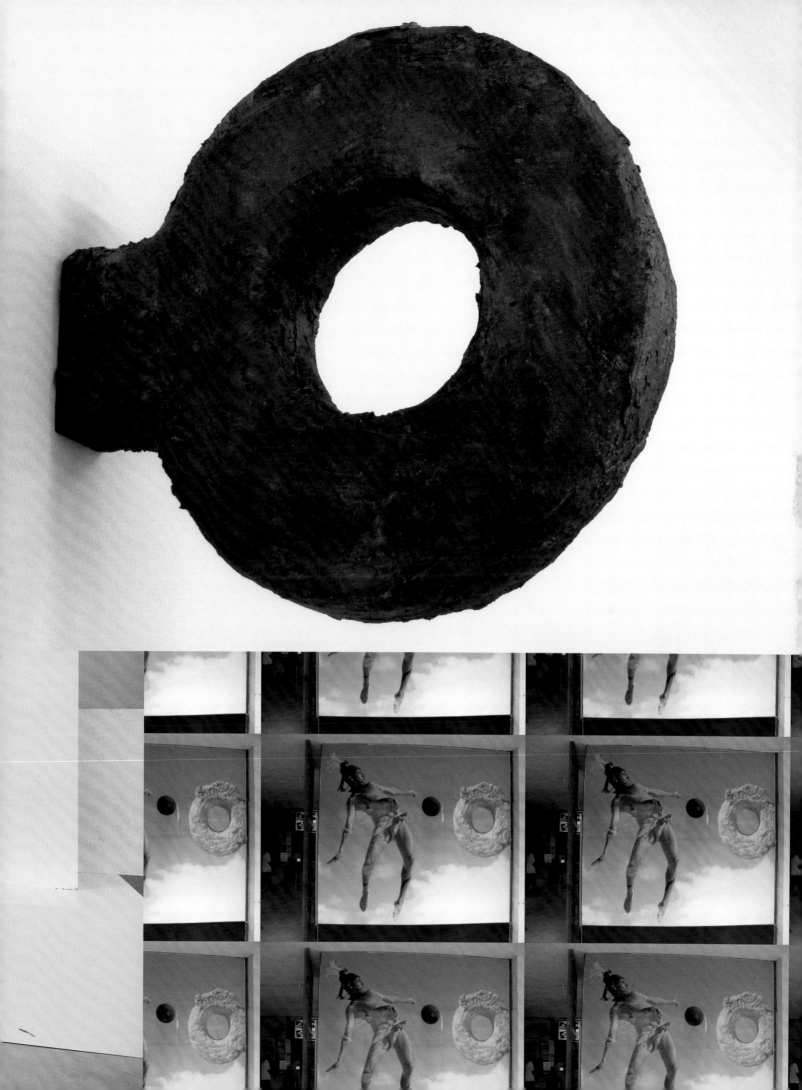

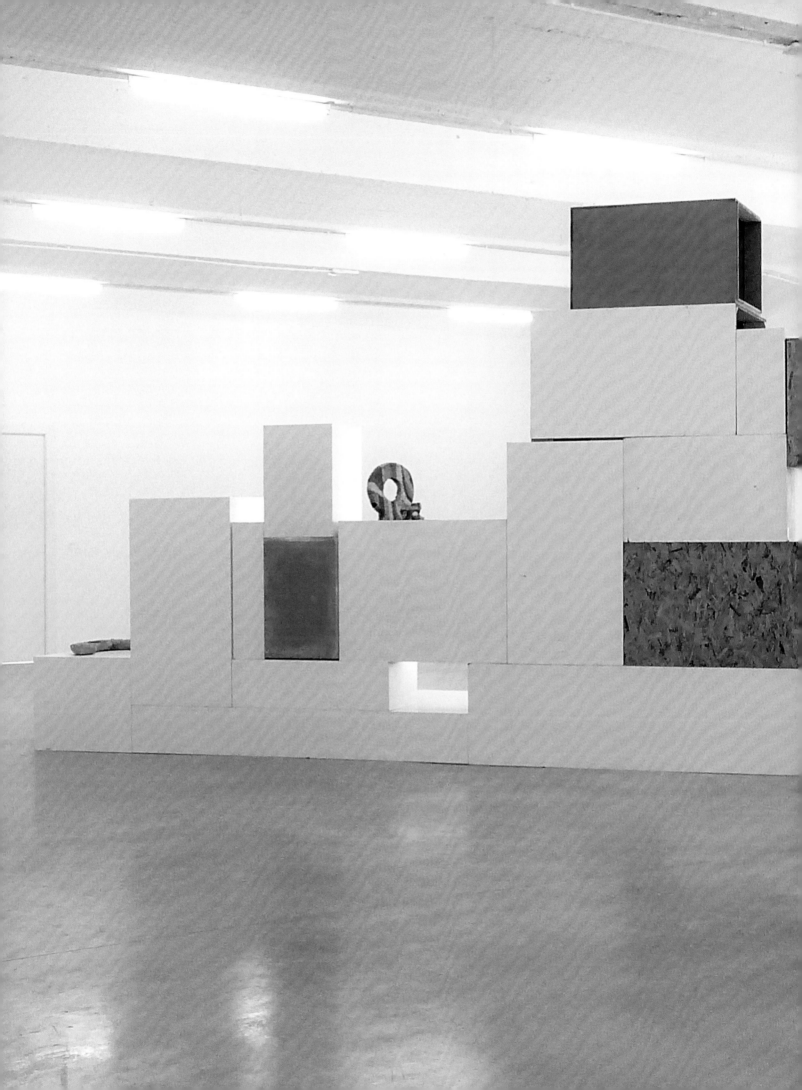

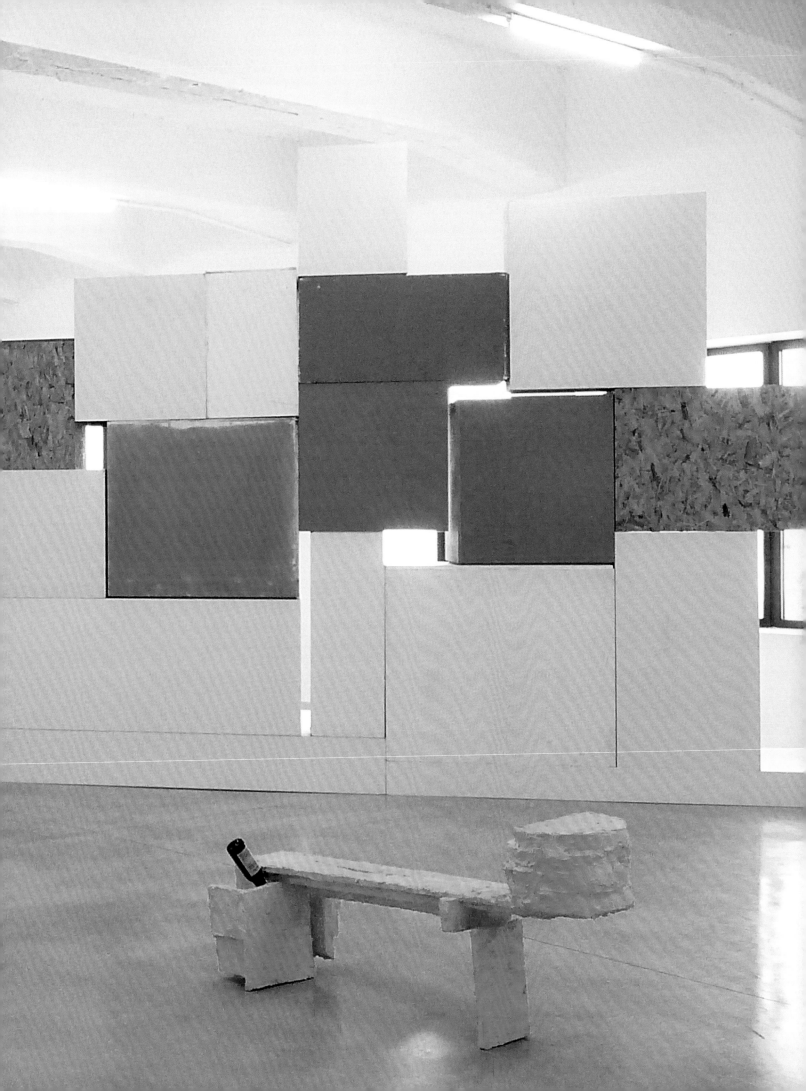

Von vorne, von hinten
Susanne Figner

Incidents of Travel in Yucatan (2011) ist nach Rachel Harrisons eigener Bezeichnung eine „Wand".[1] Der Begriff verweist auf eine simple Struktur mit potenten formalen und inhaltlichen Vernetzungen. Wände können als Schutz wie als Barriere eingesetzt werden, sie dienen als Behausung genauso wie als Trennwand. Sie werden geplant, gebaut und sie zerfallen, sie verfügen über zwei Seiten mit einer individuellen Struktur. Nicht zuletzt werden Wände aufgrund architektonischer, politischer, religiöser und sozialer Motivation erstellt und besitzen deshalb ein beträchtliches Machtpotenzial.

Zu Beginn unterliegen Wände einer Konstruktion, ein Begriff, den es lohnt genauer zu betrachten, da er Harrisons Arbeitsweise verdeutlicht. Konstruktion bezieht sich sowohl auf das industrielle Planen und Errichten von Gebäuden als auch auf eine semantische Montage, auf den Aufbau von Sätzen. Der englische Begriff „Construction", der umfassender als die deutsche Bezeichnung ist, beschreibt vier verschiedene Bedeutungen: 1) er wird synonym für die Bauindustrie verwendet, aber auch für Art und Prozess des Bauens; 2) er bezeichnet eine Skulptur, die sich aus Einzelteilen mit unterschiedlichen Materialien zusammensetzt; 3) im Kontext der Sprache beschreibt der Begriff ein Satzgefüge, bestehend aus Substantiven, Verben und Konjunktionen; 4) und letztlich involviert „Construction" auch den Akt oder das Ergebnis des Konstruierens, im Sinne einer Interpretation oder Erklärung.

Das Fragmentierte und der Prozess, die in diesem Begriff angelegt sind, werden bei Harrison mit dem Abenteuer der Entdeckungsreise verknüpft. Ihre Werke verschachteln die sprachliche mit der industriellen, der skulpturalen und der interpretativen Konstruktion und schicken den Betrachter auf Expeditionen, die politisch und amüsant zugleich sind. Redewendungen werden wörtlich verstanden und physisch konstruiert, und umgekehrt kann die Konstruktion auch beim Wort genommen werden. Verschiedene Ein- und Ausstiegsmöglichkeiten werden offeriert, genauso wie die Verknüpfungsvarianten zahlreich sind. Dies wird zusätzlich potenziert, indem die einzelnen Elemente nomadisch angelegt sind und in verschiedenen Werken in wechselnder Gestalt auftauchen. Es entsteht ein endloses Spiel der Destruktion und Konstruktion, das eine Ökonomie des Recycling verfolgt und die Fragmente und das interpretative Netzwerk in flux hält.

Lumpensammeln und Entdeckungsreise

WALL (1994) ist eine der ersten Wände in Harrisons Werk und wurde in einer Gruppenausstellung im Soho der 1990er Jahre gezeigt. Die Ausstellung fand in einem ehemaligen Ladenlokal statt, das für eine temporäre Zwischennutzung zur Verfügung stand.[2] Komplett leer geräumt fehlten die mobilen Zwischenwände, die bei Galerienausstellungen eingesetzt werden, um die Architektur zu unterteilen, und die Werke wurden in einem einzelnen, offenen Raum installiert. Harrison reflektierte diese Situation in einem Kunstwerk, das auf clevere Weise die existenzielle Abnormalität spiegelte: Sie stellte eine Flickenwand mitten in den Raum, die sie als „Room divider", als funktionale Trennwand bezeichnete.[3] Zusammengesetzt aus Trockenwänden, die sie in einem Abfallcontainer auf der Straße fand, verkörperte der reaktivierte Müll die Möglichkeiten eines Off-Space: Außerhalb des Marktes konnte und wollte man sich Einbauwände nicht leisten, es sei denn, sie kamen in Lumpenform.

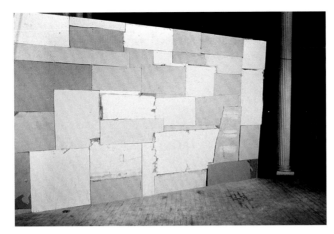

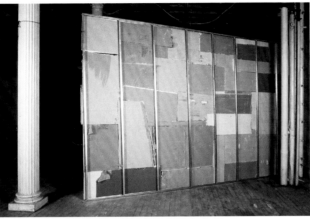

WALL, 1994
Aluminum studs, Sheetrock,
column, and string

Die Materialbeschaffung und die Herstellungsart transformierten diese „Support struc-
ture", wie im Englischen die Innenarchitektur von Museen auch genannt wird, von
einem ideologischen in ein subversives Element. In tagelanger Arbeit schnitt Harrison
die Einzelteile mit einem Rasiermesser aus und fügte sie zu einer neuen Supportstruk-
tur zusammen. Der aufwendige Arbeitsprozess trug nicht nur der Figur des Lumpen-
sammlers Rechnung, sondern auch der Tatsache, dass zum Errichten von Wänden und
politischem Widerstand Arbeiter benötigt werden. Schließlich stellte die Wand ihre
Konstruktion auf der zweiten Seite offen zur Schau und enthüllte damit den artifiziellen
Charakter des Kunstwerks mit einem Verfremdungseffekt, der Brechts theatralischen
Mitteln ähnlich ist. Die Wand war fragil, monumental und theatralisch zugleich, was nicht
zuletzt durch ihre Befestigungsart verstärkt wurde: Sie war mit einem Stück Schnur
an einer Säule fixiert, so dass ihre begrenzte Dauer offensichtlich war. Nach Ende der
Ausstellung wurde die Schnur von Harrison gekappt, die Wand kippte zu Boden, vor-
bei die Vorstellung. Und wie Kulissen, die von Bühnenbauern abgebaut, umgearbeitet
oder weggeworfen werden, wurde *WALL* im letzten Akt in den Abfallcontainer zurück-
gebracht.

Der Lumpensammler oder „Chiffonnier" ist eine Figur, die bei Charles Baudelaire,
Walter Benjamin, Theodor W. Adorno und Jacques Rancière genauso auftaucht wie bei
Diego Velázquez, Édouard Manet und Martin Kippenberger. Er verkörpert den Charme
eines Paris im 19. und 20. Jahrhundert, das unter den Umwälzungen Napoleons III. zu ver-
schwinden drohte. Als Trödler stand er am Rande der Gesellschaft, er war ein Kleinst-
unternehmer, welcher urbane Abfälle nach Wiederverwertbarem wie Schnipsel, Fetzen
und Schrott durchsuchte, die für die Herstellung von Karton und Glas verwendet wer-
den konnten. Nicht das komplette oder ganze Objekt interessierte den Lumpensammler,
sondern das Fragmentierte, das Zerschlissene und Unvollständige, das die Möglich-
keit bot, in etwas Neues transformiert zu werden. Der Arbeitsprozess war vergleichbar
mit demjenigen des Künstlers, der die Stadt auf der Suche nach konzeptuellem Material
durchstreifte und dessen prekären ökonomischen und sozialen Status er teilte.

Harrison überträgt die Lumpensuche auf den musealen Kontext und setzt die Ausstel-
lungsarchitektur als skulpturales Material nicht nur in der Arbeit *WALL* ein, sondern auch

Orlando Shuttle, 1995
Aluminum studs, Sheetrock,
and two framed chromogenic prints
96 × 48 × 48 inches
243.8 × 121.9 × 121.9 cm

in *Orlando Shuttle* (1995), *Indigenous Parts* (1995) und bei der großformatigen Installation *Incidents of Travel in Yucatan*. Letztere besteht aus Podesten, die einerseits aus einem vorherigen Werk stammen und andererseits vor Ort fabriziert werden.[4] Das Werk nimmt die Idee der Wand auf, die über zwei Seiten mit jeweils unterschiedlicher Struktur verfügt. Während die eine Seite eine glatte, bündige Oberfläche charakteristisch für eine Fassade zeigt, offenbart die andere Öffnungen, Nummerierungen und Objekte, so dass der Eindruck individueller Behausungen entsteht. Die zwei Seiten verkörpern ein Spiel mit Außen und Innen, Standardisierung und Ritual, Globalisierung und Lokalismus, Wettbewerb und Unterhaltung.

 Die Anhäufung von weggeworfenem Material stellt einen Querschnitt des urbanen Überflusses dar und ist gleichzeitig ein persönliches Tagebuch, das die Routen des Chiffonniers materiell vergegenwärtigt. Diese lokale Reise- und Sammeltätigkeit wird in Harrisons Arbeit mit der globalen Entdeckungsreise im kommerziellen und kulturellen Sinne geschichtet. *Incidents of Travel in Yucatan* verweist auf einen Travelogue von John Lloyd Stephens, der 1834 zum ersten Mal unter demselben Titel veröffentlicht wurde. Stephens gilt als Entdecker wichtiger Maya-Ruinen und reiste zweimal nach Yucatán, um diese als Erster systematisch zu dokumentieren. Die Exotik und Relevanz seiner Reisen zusammen mit einem Schreibstil, der Anekdoten und Abenteuer jeglicher Art mit derselben Nonchalance beschrieb, machten ihn zu einem der erfolgreichsten Berichterstatter ferner Länder und Sitten. Unter dem Titel „Incidents of …" erschien eine ganze Serie von Reisebüchern, die neben kulturellen Entdeckungen Heldentum, Exotik und Erotik vereinten und nicht umsonst von Schriftstellern wie Edgar Allan Poe und Herman Melville geschätzt wurden. Typisch für die westliche Kolonialpolitik eröffneten die Erzählungen einerseits Einblicke in fremde Kulturen und Länder, andererseits dienten sie auch der Verstärkung westlicher Werte und Normen. So wird wiederholt die Ineffizienz und Indifferenz der lokalen Bevölkerung mit dem Bild des disziplinierten und fortschrittlichen Amerikaners kontrastiert. Daraus folgt, dass nur der Yankee über die adäquaten Voraussetzungen verfügt, die für die Konservierung der Überreste einer Hochkultur nötig sind. Fortschritt ist dabei gleichbedeutend mit kapitalistischer Entwicklung, und Stephens geht so weit, die Ruinenstätte Copán für 50 Dollar zu kaufen, um sich seinen Traum ver-

wirklichen und die Artefakte in einem Museum im „kommerziellen Emporium" der USA aufstellen zu können.[5]

Kommerz und Wettbewerb

Während einer Mexiko-Reise besuchte Harrison die Ruinen von Yucatán, wobei sie sich speziell für die Architektur des mittelamerikanischen Ballspiels interessierte. Das Spiel, das auch als „Sport um Leben und Tod" bezeichnet wird, stellt eine Art prämodernen Fußball dar. Die exakten Regeln bleiben unklar, doch weiß man, dass es zwei Teams gab, die einen Kautschukball mithilfe von Knien, Hüften und dem Hintern bewegten. Der Wettkampf fand auf einem lang gezogenen Feld mit zwei Seitenwänden statt, auf denen ähnlich wie in einer Arena die Zuschauer saßen und dem Spiel von oben folgten. An beiden Seitenwänden war jeweils ein Steinring angebracht, den die Teams anspielen konnten. Treffer durch diese Ringe waren ein äußerst seltenes Ereignis und bedeuteten sprichwörtlich einen „sudden death". Nicht nur war das Spiel damit unmittelbar zu Ende, sondern es folgte ein ritueller Akt, in dem die Verlierer – oder alternativ die Sieger – auf einem Altar geopfert wurden, um den Göttern die Ehre zu erweisen.[6]

Indem Harrison den alles entscheidenden Ring an die Museumswand appliziert, überträgt sie das brutale Spiel in den institutionellen Kontext. Damit wird nicht nur der museale Wettbewerb kommentiert, sondern auch die Auswirkungen politischer und wirtschaftlicher Übermacht geprüft. Das Video *BP* (2011) und die Arbeit *Benched* (2011), die zu dieser Installation gehören, unterstützen diese Untersuchung. *BP* basiert auf *Film Socialisme* (2010) von Jean-Luc Godard. Der komplexe Film, der auf einem Kreuzfahrtschiff und an einer Tankstelle spielt, dreht sich um die Globalisierung und um die Bedeutung von Gütern wie Gold. Ein zentraler Dialog des Films debattiert den Stand der französischen Werte *Liberté, Egalité, Fraternité* in der heutigen Gesellschaft, während vor- und nachher monotone Szenen aneinandergereiht werden: Massen in der Kreuzfahrtdisco, im Pool, im Speisesaal – anonym und laut – mit dazwischengeschalteten Momenten, in denen Schauspieler Philosophen zitieren, politische Statements äußern („Wasser ist ein öffentliches Gut") und Alain Badiou seine Vorlesung über Edmund Husserl hält. „Der Sozialismus des Films" ist laut Godard „die Unterwanderung der Idee von Eigentum, angefangen mit Kunstwerken".[7]

Der Regisseur ist hier sowohl Autor als auch Sammler. Godard verwendet Segmente aus YouTube, Ausschnitte aus einem Film Noir und Amateuraufnahmen vom Mobiltelefon genauso, wie er für den Dreh ein professionelles Kamerateam einsetzt und auf dem Schiff die Schauspieler, unter anderem Patti Smith, anleitet. Die Aneinanderreihung von Fragmenten folgt einer Gleichheit der Einstellungen und Bilder, die jegliche Hierarchisierung vermeidet. Godard konstruiert keinen Film, sondern bietet eine Plattform für Debatten. Ähnlich wie David Lynch, der den Zuschauer auffordert, seine digitalen Filme neu und anders zu schneiden, funktioniert auch *Film Socialisme*.[8]

Harrison nimmt Godard beim Wort und gebraucht seinen Film als Rahmen, innerhalb dessen sie *BP* fertigt. Sie schneidet nicht einfach nur *Film Socialisme* um, sondern filmt ausgewählte Sequenzen ab, die sie als Projektionsfläche für ihre eigene politische Position und diejenige von Godard einsetzt. Der subjektive Standpunkt wird durch das bewusst

amateurhafte Abfilmen verdeutlicht: Einerseits nimmt Harrison versteckt im Kino auf, die Sicht auf die Leinwand ist durch die Silhouetten der Zuschauer in den Reihen vor ihr gestört. Andererseits filmt sie vom Computer ab, zeigt den Rand ihres Laptops und Reflexionen am Bildschirm. Dazwischen werden ihre eigenen Sequenzen geschnitten sowie Bilder und Texte über ihre und Godards Fragmente gelegt. Harrison fertigt ein Tagebuch ihrer Ausflüge durch New York und nach Mississippi und erweitert damit Godards Kreuzfahrt in die USA.[9]

Den Rahmen setzt die Politik des Wassers, das ein öffentliches Gut darstellt, wie die Anfangsszene in *Film Socialisme* deklariert. Als Harrisons Video entstand, war im Golf von Mexiko die größte Ölkatastrophe der Geschichte in Gang. Mehrere Millionen Tonnen Rohöl flossen über drei Monate ungehindert ins Meer, verursacht durch Sparmaßnahmen bei den Sicherheitsvorkehrungen, die eine Explosion auf der Ölplattform Deepwater Horizon zur Folge hatten. Harrisons *BP* zeigt weder die Plattform noch den Ölteppich oder die verzweifelten Versuche, die Strände und Naturschutzgebiete zu retten. Einzig der Titel der Arbeit gibt einen Hinweis auf die Katastrophe, indem er die geläufige Abkürzung für die verantwortliche Firma British Petroleum verwendet. Harrison schneidet vorgefundenes Material zwischen Godards Sequenzen, das von der Nahaufnahme eines Aquariums in einem Restaurant in Chinatown über das Putzpersonal in einem Kino bis hin zu einer Schulführung vor Gustave Courbets Bild *Ein Begräbnis in Ornans* (1849/50) und einem leer stehenden Laden in Mississippi reicht. Auch werden verschiedene Seiten aus Leni Riefenstahls Monografie mit Unterwasseraufnahmen vor den Bildschirm gehalten und durch ihre Reflexion in den Film integriert. Und schließlich werden die Titelseiten der Nuba-Bücher über eine Aufnahme des East River mit Touristenboot gelegt. Es entsteht ein Video, das über die toxische Mischung von Wasser, Politik und Wirtschaft reflektiert und zeitgenössische Lumpensammler innerhalb dieser Machtstrukturen dokumentiert.

Mit *Incidents of Travel in Yucatan* untersucht Harrison auch, wie und mit welchen Interessen Kunstgeschichte geschrieben wird und institutionelle Sammlungen entstehen. Die Podeste, die aus dem Museumsdepot zusammengetragen wurden, sind in einer Weise aufgetürmt, die Lücken und Durchblicke entstehen lassen, wie es einer Ruine eigen ist. Die Anhäufung halb fertiger und abgetakelter Sockel demonstriert Überfluss in zweifachem Sinne. Einerseits sind die Sockel in einer nutzlosen Überzahl vorhanden, seit die Konzeptkunst der 1970er Jahre die Entmaterialisierung der Kunst deklariert hat. Andererseits zeugen die Sockel von einer materiellen Fülle, sie stehen stellvertretend für die finanziellen Mittel einer Institution. Harrison setzt sie als Baumaterial ein, das die konzeptuelle Kritik weiterführt und gleichzeitig die exzessive Materialität der nachfolgenden Generation kritisch beleuchtet. *Incidents of Travel in Yucatan* verweist auf die Anfänge und den Ursprungsgedanken einer „expandierten" Materialität, die auf das recycelte Museumsinventar von Marcel Broodthaers zurückgeht.

Broodthaers gründete ein fiktives Museum in Brüssel, das *Musee d'Art Moderne, Département des Aigles* (1968), das an verschiedenen Orten in unterschiedlicher Form auftauchte und anstelle von Kunstwerken Transportkisten, Reproduktionen, Wandbeschriftungen und Filme zeigte. Damit einher ging eine kritische Reflexion gängiger Museumspraxis und die Auffassung, dass Kunst durch die institutionellen Strukturen deter-

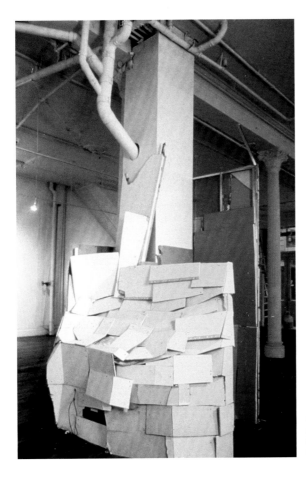

Indigenous Parts, 1995
Aluminum studs, wood,
Sheetrock, video, playing cards, and
framed chromogenic print

miniert ist, in denen sie gezeigt wird. Marcel Broodthaers argumentierte strikt gegen das Museum als Ort avantgardistischer Experimente. Seiner Meinung nach war die museale Institution voller ideologischer Verwirrungen, welche die Kunst in eine Art „olympische Spiele" transformierte.[10] Das Museum sollte sich darauf beschränken, ein Platz der Konservierung zu sein. Er beendet das kurze Statement mit dem Satz: „Long live the art fair, there at least things are clear and evident."[11]

Die hermetische Seite von *Incidents of Travel in Yucatan* exponiert den wettbewerbsorientierten, kommerziellen Kontext und veranschaulicht, wie eine lineare Geschichtsschreibung, ausgehend von Duchamps Readymade über minimalistische Kuben bis hin zur konzeptuellen Kunst und institutionellen Kritik, mit musealem Support geschrieben wurde. Die Ruine bildet den heroischen Abschluss dieser kompakten Konstruktion, und die Plattform, auf der sie steht, verdeutlicht, dass sie inzwischen selbst den Status einer klassischen Skulptur innehat.

Eccentric Flint

Ein Verbindungselement zwischen den beiden Seiten stellt die gelbgrüne Skulptur auf tiefem Sockel dar. Von Harrison als Karte oder auch als „Eccentric Flint" beschrieben, verknüpft sie den Kommerz mit dem Spiel, den Strand mit der Ruine, das TV mit der Archäologie.[12] Als Navigationshilfe für Reisen jeglicher Art kondensiert diese Flintkarte die politische, wirtschaftliche und kulturelle Geografie ganz im Sinne von Gilles Deleuzes Rhizom, das ebenfalls eine offene und verknüpfbare Form ähnlich einer Landkarte darstellt, die reversibel, abtrennbar und konstant modifizierbar ist. Vergleichbar mit den *1000 Plateaus*, bietet *Incidents of Travel in Yucatan* zahlreiche Ein- und Ausstiegsmöglichkeiten und kann gelesen werden, wie man ein Musikstück hört.

Spiel und Erotik

Im Gegensatz zu der hermetischen kompakten Fassade steht die zweite Seite, die verschiedene Podestgrößen, Öffnungen, Objekte und Nummerierungen offenbart. Die Sockel-

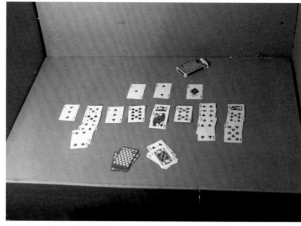

Container sind einem Interieur gleich gestapelt und können funktional zur Aufbewahrung von Bierflaschen oder auch rituell zur Darbringung von Gaben benutzt werden. Die Nummerierungen verweisen auf ein System der Klassifizierung, wie es bei archäologischen Ausgrabungen eingesetzt wird, und tatsächlich wurde auch die Ballspiel-Arena in Yucatán mit diesem System erfasst, wie die weißen Nummern auf einem persönlichen Foto von Harrison zeigen. Die Durchnummerierung der Steinwände verknüpft die Fragmente mit einem Platz in einem Archiv, der nicht nur eine wissenschaftliche Bearbeitung ermöglicht, sondern auch eine Duplikation/Rekonstruktion an anderer Stelle eröffnet. Damit greifen die Nummern eine Arbeit von Marcel Duchamp auf, der seine Ziegelwand in *Étant donnés* (1946–66) für eine exakte Rekonstruktion im Museum durchnummerierte und zusätzlich ein Handbuch mit Fotos und Notizen für den Wiederaufbau anfertigte.

Im Gegensatz zu Duchamps Readymade kommt *Étant donnés* weit weniger Aufmerksamkeit in der kunstwissenschaftlichen Debatte zu, was jedoch nicht bedeutet, dass die Arbeit weniger entscheidend für einen postmodernen Diskurs ist, wie Amelia Jones aufzeigt.[13] *Étant donnés* ist eine Installation, die posthum im Philadelphia Museum of Modern Art nach Duchamps Instruktionen eingerichtet wurde. Sie nimmt einen separaten Raum innerhalb des Museums ein und besteht im Wesentlichen aus einer Scheunentür und einer Installation dahinter. Die alte Holztür befindet sich im vorderen Drittel des Raumes und wurde über die gesamte Wandbreite errichtet. In der Mitte wurden zwei Gucklöcher angebracht, hinter denen sich dem Betrachter eine liegende Nackte offenbart: Kopf und Gesicht sind aus der Sicht verbannt, die Beine sind gespreizt. Die Geschlechtsöffnung liegt zentral und provokant im Fokus des Beobachters und schockiert den unvorbereiteten Besucher mit seiner penetranten Zurschaustellung. Die Arbeit thematisiert einerseits den dominanten männlichen Blick, stellt andererseits aber gerade diese Perspektive infrage. Die Stelle zwischen den Beinen verweigert jegliche anatomischen Referenzen, sie ist abstrakt, ein schwarzes Nichts. Dadurch geht der voyeuristische Blick ins Leere, wird auf den Betrachter zurückgeworfen, und eine alternative, kritische Position wird möglich.[14] Die Betonung körperlicher Aspekte, einer erotischen Sicht, einer maskulinen und femininen Position, bietet Alternativen, um Kunstgeschichte aus anderer Perspektive zu schreiben.

In diesem Zusammenhang wird auch ein zweiter Aspekt des oben geschilderten Ballspiels relevant. Die Tatsache, dass die Ballspieler beinahe nackt sind, Steine in Keilform als Schutz tragen sowie als hauptsächliches Spielmittel ihr Hinterteil gebrauchen, wird von Rosalind Krauss mit der Einführung eines dritten Geschlechts in Verbindung gebracht und als homoerotischer Unterton interpretiert.[15] Auch verfügen die Spieler über einen elaborierten Kopfschmuck und Dekorationen, die eine geschlechtsübergreifende Maskerade nahelegen. *Incidents of Travel in Yucatan* untersucht diese Zwischentöne mit den sogenannten „Trophies" (*Winner Takes All*, 2012), eine Bezeichnung, die auf Ehrung besonderer Verdienste verweist. Die Skulpturen verkörpern Porträts, die mithilfe von Readymades feminine, effeminierte und weibliche Eigenschaften in den Vordergrund stellen und die dominante männliche Perspektive spielerisch kontrastieren.

Mit dieser alternativen Seite wird nicht die Beschäftigung mit Lumpen als Geschäft thematisiert, sondern die Individualität und Freiheit, welche Baudelaire und Benjamin

dieser Außenseiterposition zusprachen. An der Peripherie ergibt sich eine Anti-Struktur mit Öffnungen und Lücken, die Möglichkeit, eine andere Kunst- oder Sammlungsgeschichte zu schreiben. An die Stelle der linearen Konstruktion tritt eine dadaistisch-surreale Form mit Ritual, Erotik, Maskerade und alternativer Geschlechtsidentität. Eine Identität, wie sie Duchamp mit seinem Alter Ego Rrose Sélavy auf den Punkt brachte: *Éros, c'est la vie.*

[1] Im Gespräch mit der Künstlerin, 8.1.2013.

[2] Ein damals nicht seltenes Phänomen, da die Galerienszene in den 1990er Jahren von Soho nach Chelsea emigrierte und anstelle dessen Modeketten und Restaurants einzogen.

[3] E-Mail-Korrespondenz mit der Künstlerin vom 4.4.2013.

[4] Die Installation wurde zum ersten Mal im Consortium in Dijon realisiert (*Exposition d'Ouverture*, 12.6.–10.12.2011) mit Sockeln, die Harrison im Depot fand. Zusätzliche Podeste kamen aus *Indigenous Parts V*, präsentiert in der Whitechapel Gallery, London (*Conquest of the Useless*, 30.4.–20.6.2010).

[5] Jennifer L. Roberts, *Mirror-Travels: Robert Smithson and History*, New Haven/London 2004, S. 87–98. Tatsächlich wurden einige Skulpturen nach New York transportiert, wo sie Robert Smithson als Kind in den 1940er Jahren im American Museum of Natural History gesehen hatte.

[6] Die Wissenschaft ist sich uneinig, ob die Verlierer oder die Sieger geopfert wurden, um den Göttern zu huldigen. Falls Letztere die Opfer waren, ergibt sich eine grundlegend andere Ausgangslage in der Motivation – Verlieren war möglicherweise attraktiver als Gewinnen.

[7] Daniel Morgan, *Late Godard and the Possibilities of Cinema*, Berkeley 2013, S. 263, zit. nach: Jean-Luc Godard, „Le droit d'auteur? Un auteur n'a que des devoirs", in: *Les Inrockuptibles,* Mai 2010.

[8] Ebenda.

[9] E-Mail-Korrespondenz mit der Künstlerin vom 30.4.2013.

[10] Benjamin Buchloh, „Contemplating Publicity: Marcel Broodthaers' Section Publicité", in: Maria Gilissen und Benjamin Buchloh (Hg.), *Marcel Broodthaers: Section Publicité*, New York 1995, S. 89.

[11] Ebenda, zit. nach: Irmeline Lebeer, „Musées personelles", in *Chroniques de l'art vivant*, Bd. 35, Paris 1973, S. 2r.

[12] E-Mail-Korrespondenz mit der Künstlerin vom 27.4.2013.

[13] Amelia Jones, *Postmodernism and the En-gendering of Marcel Duchamp*, Cambridge 1994, S. 195.

[14] Ebenda, S. 201–203.

[15] Rosalind Krauss, „No more play", in: *The Originality of the Avant-garde and Other Modernist Myths*, Cambridge 1986, S. 60.

From the Front, from the Rear
Susanne Figner

Rachel Harrison calls *Incidents of Travel in Yucatan* (2011) a "wall."[1] The term refers to a simple structure with potent formal and thematic interconnections. Walls can serve as protection or barriers; they are used to house and to separate. They are planned, built, and they disintegrate; they have two sides, each with an individual structure. Not least, walls are created with architectural, political, religious, or social motivations, and thus have considerable power.

Initially, walls are subject to construction, a term worth examining more closely, for it clarifies Harrison's working process. 'Construction' relates both to the industrial planning and erection of buildings and to semantic montage, the formation of sentences. Indeed, the term has four different meanings: first, it is synonymous with the construction industry and refers not only to the building site but also to the process or manner of constructing; second, it defines a sculpture made up of separate pieces of often disparate materials; third, in the context of language, the term describes a syntactical arrangement consisting of nouns, verbs, and conjunctions; and finally, it applies to the act or result of construing, of creating an interpretation or explanation.

The fragmented and the processual inherent in this concept are linked in Harrison's work with the adventure of a journey of discovery. Her pieces layer the linguistic with the industrial and the sculptural with interpretive construction, and send the beholder on expeditions that are simultaneously political and comical. Figures of speech are understood literally and as such transferred into physical constructions, and conversely the construction can also be taken literally. Various possibilities of entrance or exit into the works are offered, and there are manifold possibilities for connecting them. This aspect is multiplied further in that the individual elements are nomadic in nature, surfacing in various works in different forms. The result is an endless game of destruction and construction that pursues an economy of recycling and keeps the interpretive network in flux.

Rag-Picking and Journeys of Discovery

WALL (1994) is one of the first walls in Harrison's œuvre, and was shown in a group show in New York's SoHo during the 1990s. The exhibition took place in an empty storefront available for interim use.[2] Unlike that of a commercial gallery the space consisted of a single room with no room dividers at hand to break it up. Harrison reflected on the situation with an artwork that incorporates this existential abnormality in a clever way. She placed a wall made of scraps in the middle of the space, calling it a "room divider."[3] Assembled using dry wall from a dumpster on the street, the work underscored the possibilities of an off-space: beyond the market, room dividers are not desired — nor are they affordable, unless they come as scraps. The 'support structure', as the interior architecture in museums is called, was transformed from an ideological into a subversive element. In a process that took days of labor, Harrison cut out the individual parts with a razor and assembled them to form a new support structure. The elaborate work process not only evoked the figure of the rag-and-bone man, but also the fact that workers are necessary to erect walls and carry out political resistance. On its second side, meanwhile, the wall openly revealed its construction, the artificial character of the artwork, creating an alienating effect similar to Bertolt Brecht's theatrical devices. As such

Marcel Broodthaers, *Musée d'Art Moderne,
Département des Aigles, Section XIXème Siècle,*
Brussels, 1968–1969

it was fragile, monumental, and theatrical at the same time, qualities further illustrated by its installation: it was held up by a string attached to a column, highlighting its temporary nature. After the exhibition had closed Harrison cut the string, signifying that the wall's public performance was done. The wall fell to the ground and like a stage set being stored, reworked, or dumped by workers, it was returned to the dumpster in its final act.

The rag-picker or *chiffonier* is a prominent figure in the works of Charles Baudelaire, Walter Benjamin, Theodor Adorno, and Jacques Rancière, as in Diego Velázquez, Edouard Manet, and Martin Kippenberger. It embodies the charm of Paris in the nineteenth and twentieth centuries threatened with disappearance under the transformations taking place during the reign of Napoleon III. Situated on the margins of society, the rag-picker was a small businessman who looked through urban waste for reusable things such as snippets of paper, cloth, or scraps that could be used to create cardboard and glass. He was not interested in the complete or whole object, but in the fragmented, torn, and incomplete that could be transformed into something new. At the same time, his position and way of working was comparable to that of the artist who scours the city in search of conceptual material, whose precarious economic and social status he also shared.

Harrison transfers the search for scraps to the museum context, using the exhibition architecture as a sculptural material, not just in *WALL*, but also in *Orlando Shuttle* (1995), *Indigenous Parts* (1995), and the large-format installation *Incidents of Travel in Yucatan*. The latter consists of plinths that were partly taken from a prior work and previous shows, and partly assembled on site.[4] The work takes up the idea of the wall that has two sides each with a different structure. While one side has a flat, smooth surface characteristic of a façade, the other displays recesses, numbers, and objects, giving the impression of individual dwellings. The two sides reveal a play contrasting inside and outside, standardization and ritual, globalization and localism, competition and entertainment.

The collection of discarded material simultaneously represents a cross-section of urban excess and a personal diary recalling the routes of the rag-picker. *Incidents of Travel in Yucatan* layers this local activity of searching and collecting with global travel in the commercial and cultural sense. The title refers to a travelogue by John Lloyd Stephens

Wall Label, 2000
Wood, polystyrene, cardboard,
tape, and chromogenic print
33 × 33 × 33 inches
180.3 × 180.3 × 10.2 cm

published for the first time in 1834. Stephens is considered the discoverer of important Maya ruins, and made two excursions to Yucatán to document these systematically. The exoticism and relevance of his travels, together with a style of writing that described anecdotes and adventures of all kinds with the same nonchalance, made him one of the most successful writers of his day on distant lands and customs. With his *Incidents of* books, Stephens published an entire series of travelogues that not only included cultural discoveries, but combined heroism, exoticism, and eroticism, and were treasured by writers like Edgar Allan Poe and Herman Melville, not without reason. Furthermore, typical for Western colonial policy, the stories gave insight into foreign cultures and worlds while serving to strengthen Western values and norms. Repeatedly, the inefficiency and indifference of the local population is contrasted with the image of the disciplined and progressive American, resulting in the conclusion that only the Yankee has the qualities necessary to preserve the remains of a high culture. Progress here is equivalent to capitalist development, and Stephens went so far as to purchase Copán for $50, in order to realize his dream and exhibit the artifacts in a museum in the "commercial emporium" of the U.S.[5]

Commerce and Competition

During a trip to Mexico, Harrison visited the Yucatán ruins, with a particular interest in the architecture of the Meso-American ballcourt. The game, which is also called the 'sport of life and death', represented a pre-modern form of soccer. The precise rules remain unclear, though it is known that two teams moved a rubber ball across the playing field with the help of their knees, hips, and buttocks. The competition took place on a long field with two side walls, which, like an arena, seated spectators who followed the game from above. On both side walls of the ballcourt there was often a stone ring that the teams could try to reach with the ball. Getting the ball to pass through one of these rings was an extremely rare event, and literally meant sudden death. Not only was the game immediately over, but a ritual act followed in which the losers — or alternatively the winners — were beheaded on an altar to praise the gods.[6]

By applying the ring to the museum wall, Harrison transfers this brutal play to the institutional context. In so doing, she comments not only on museum competition, but also on the impacts of political and economic power. The video *BP* (2011) and the sculpture *Benched* (2011), which are also part of the installation, support this investigation. *BP* is based on *Film Socialisme* (2010) by Jean-Luc Godard. This complex film, which takes place on a cruise ship and at a gas station, deals with globalization and the meaning of commodities such as gold. Its middle section features a central dialog debating the relevance of the French core values of liberty, equality, and fraternity in today's society. Before and after that a series of sequences are shown: crowds in the cruise ship disco, in the pool, in the dining hall, anonymous and loud, with moments intercut between them in which actors quote philosophers, make political statements ("Water is a public good!"), and Alain Badiou gives a lecture on Edmund Husserl. "The socialism of the film," according to Godard, is "the undermining of the idea of property, beginning with that of artworks."[7]

The director acts both as *auteur* and as collector: he uses clips from YouTube, a scene from a *film noir*, and amateur mobile-phone films, while also shooting with a professional film camera and staging many scenes on the boat with hired actors, including Patti Smith. The series of fragments has no hierarchy: all shots and images are equivalent, and Godard does not so much construct a film as offer a platform for debate. *Film Socialisme* works in a similar fashion to David Lynch's project in which he encourages viewers to recut his digital films in new ways.[8]

Harrison takes Godard by his word, and uses his film as a framework to make *BP*. She not only re-edits *Film Socialisme*, but uses selected sequences as a projection surface to reflect on her own political position and that of Godard. The subjective standpoint is made clear by the consciously amateur quality of the filming. For one, Harrison shoots her film hiding in the cinema, and the view of the screen is disturbed by the silhouettes of the spectators in the rows in front of her. She also films from the computer, and the laptop's edges and reflections are visible on the screen. Her own sequences are intercut between these shots, and images and texts are placed over both her own and Godard's fragments. Harrison creates a diary of her excursions across New York and to Mississippi, and in so doing expands Godard's cruise to the U.S.[9]

The framework is set by the politics of water, which, as the opening scene in *Film Socialisme* declares, is a public good. When Harrison was working on *BP*, the worst oil catastrophe in history was unfolding. Over a three-month period, several million tons of raw oil flowed unhindered into the ocean due to a combination of factors that included a series of cost-cutting decisions, resulting in an explosion on the oil platform Deepwater Horizon. Harrison's *BP* shows neither the platform, the carpet of oil, nor the desperate attempts to save the beaches and nature reserves. The only indication of the catastrophe is the title of the work, which uses the common abbreviation for the company responsible, British Petroleum. Harrison intercuts found material between Godard's sequences that include a close-up shot of an aquarium in a Chinatown restaurant, the cleaning staff in a movie theater, a student tour in front of Gustav Courbet's painting *A Burial at Ornans* (1849–1850), and an empty local store in Mississippi. Leni Riefenstahl's monograph of underwater shots is held up before the screen and integrated by way of its reflection in the film. And finally, the title pages of Riefenstahl's Nuba books are placed over a shot of New York's East River with a tourist boat. The result is a video that reflects on the toxic mixture of water, politics, and economics, and documents contemporary rag-pickers within these power structures.

With *Incidents of Travel in Yucatan* Harrison also explores how and with what interests art history is written and institutional collections emerge. The plinths collected from the museum depot are towered in such a way that allows gaps and holes to emerge, as in a ruin. The assemblage of semi-finished and worn-down bases demonstrates excess in a dual sense. On the one hand, plinths are available in useless excess, since Conceptual Art declared the dematerialization of art in the 1970s. At the same time, they attest to the wealth of material that represents the financial means available to an institution. Harrison uses them as construction material, which continues a conceptual critique while at the same time critically spotlighting the excessive materiality of subsequent generations. *Incidents of Travel in Yucatan* refers back to the original notion of 'expanded' materiality that can be traced back to Marcel Broodthaers' recycled museum inventory.

Broodthaers founded a fictional museum in Brussels in 1968, *Musee d'Art Moderne, Départment des Aigles*, which surfaced in different guises and in various places. Instead

of showing artworks, this 'museum' presented transport boxes, reproductions, wall labels, and films. This was accompanied by a critical reflection on common museum practice and the view that art is determined by the institutional structures in which it is shown. Broodthaers argued strictly against the museum as a site of avant-garde experimentation. In his view, the museum institution was full of ideological confusions that transformed art into a kind of "Olympic Games."[10] The museum should limit itself to being a place of conservation. He ended his brief statement with the sentence, "Long live the art fair, there at least things are clear and evident."[11]

The hermetic side of *Incidents of Travel in Yucatan* exposes a competition-based, commercial context and presents a linear historiography that begins with Marcel Duchamp's readymades, moving through minimalist cubes, Conceptual Art and institutional critique with museum support. The ruin forms the heroic conclusion of this historical construction, and the platform on which it is placed makes it clear that the ruin itself has taken on the status of classical sculpture.

Eccentric Flint

An element linking the two sides is the yellow-green sculpture placed on a low plinth. This sculpture, which Harrison calls a map or "eccentric flint," links commerce with play, the beach with ruins, and TV with archaeology.[12] As a navigation device for journeys of all kinds, this flint map condenses the political, economic, and cultural geography very much in the sense of Gilles Deleuze's rhizome, which also represents an open and linkable form like a map, is reversible, removable, and constantly modifiable. Like Deleuze's *A Thousand Plateaus*, *Incidents of Travel in Yucatan* offers numerous possibilities of entry and exit and can be read like a record can be listened to.

Play and Eroticism

Contrary to the hermetic, compact façade, there is the second side that reveals various openings, objects, and numberings. The plinths are piled up in a way that displays their interiors, and they are used functionally — to store beer bottles, for example, to ritually present gifts. The numbers point to a system of classification like those used at archaeological excavations, and in fact the ballgame arena in Yucatán was catalogued using this system, as shown by the white numbers on one of Harrison's personal photographs taken in Yucatán. The numbering of the stone walls linked the fragments to a place in an archive that not only allows for scholarly treatment, but also enables duplication/reconstruction in another place. In so doing, the numbers point to a work by Duchamp, who numbered his brick wall in *Étant donnés* (1946–1966) for its exact reconstruction in the museum and completed a manual with photographs and notes for the same purpose.

In contrast to Duchamp's readymades, *Étant donnés* has received much less attention in art historical debate, but as Amelia Jones has shown, this does not mean the work is any less important for postmodern discourse.[13] *Étant donnés* is an installation erected posthumously in Philadelphia's Museum of Art according to Duchamp's instructions. It takes up a separate room all its own in the museum, and consists essentially of a barn door with an installation behind it. The old wooden door can be found in the front third of the room, at the center of a wall that stretches across the room's width. In the middle, there are two peepholes, through which the beholder can see a woman lying naked. Her head and face are invisible, her legs are spread. The central and provocative position of the genital opening at the focal point of the beholder shocks the unprepared visitor with its obtrusive display. The work explores the dominant male gaze while at the same time questioning this very perspective. The place between the woman's legs refuses all anatomic references, it is abstract, a black nothingness. Thus the voyeuristic gaze misses its target and is reflected back toward the beholder, and a critical, alternative position becomes possible.[14] The focus on bodily aspects, an erotic perspective, a masculine and a feminine position, offer alternatives for writing art history from a different point of view.

In this context, a second aspect of the ballgame described above becomes relevant. The ballplayers are almost naked, carry wedge-shaped stones for protection, and use primarily their buttocks to play the ball. This has been linked by Rosalind Krauss to the introduction of a third sex and interpreted as having a homoerotic undertone.[15] The players also wear elaborate head gear and decorations, suggesting a masquerade that

Marcel Duchamp, *Manual of Instructions for the assembly
of Étant donnés: 1° la chute d'eau, 2° le gaz d'éclairage*, 1966

transgresses gender. *Incidents of Travel in Yucatan* studies these nuances with Harrison's so-called "trophies" (*Winner Takes All*, 2011), a term that refers to honors for special achievements. The sculptures embody portraits that with the help of readymades foreground feminine, effeminate, and female qualities, and contrast the dominant, male perspective in a playful way.

The wall's second side explores less the use of scraps and rags as a business than the individuality and freedom that Baudelaire and Benjamin attribute to this outsider position. At the periphery there is an anti-structure with gaps and openings, the possibility of writing an alternative history of art or collecting. Linear construction is replaced by a Dadaist surreal form with ritual, eroticism, masquerade, and alternative gender identity. An identity summed up in Duchamp's alter ego Rrose Sélavy: *Éros, c'est la vie.*

1 Conversation with the artist, January 8, 2013.
2 In 1990s New York, interim space was a frequent phenomenon because small businesses and galleries moved out of SoHo (to Chelsea) and big businesses such as global fashion brands moved in.
3 Email correspondence with the artist, April 4, 2013.
4 The piece was previously shown at Le Consortium in Dijon (*Exposition d'Ouverture*, June 12–November 10, 2011), where it was made with plinths from the institution's storage. In addition some of the plinths came from *Indigenous Parts V* presented at the Whitechapel Gallery, London (*Conquest of the Useless*, April 30–June 20, 2010).
5 Jennifer L. Roberts, *Mirror-Travels: Robert Smithson and History*, Yale University Press, New Haven, 2004, pp. 87–98. In fact, several sculptures were moved to New York, where Robert Smithson saw them as a child during the 1940s at the American Museum of Natural History.
6 Mayan scholars are divided as to whether it was the losers or winners who were sacrificed in honor of the gods. If it was the latter the players might have had an entirely different set of motivations – losing may have been more attractive than winning.

7 Daniel Morgan, *Late Godard and the Possibilities of Cinema*, University of California Press, Berkeley, 2013, p. 263. Quoted in: Jean-Luc Godard, "Le droit d'auteur? Un auteur n'a que des devoirs," in: *Les Inrockuptibles*, May 2010.
8 Ibid.
9 Email correspondence with the artist, April 30, 2013.
10 Benjamin Buchloh, "Contemplating Publicity: Marcel Broodthaers' 'Section Publicité,'" in: Maria Gilissen and Benjamin Buchloh (eds.), *Marcel Broodthaers: Section Publicité*, New York, 1995, p. 89.
11 Ibid., quoted in Irmeline Lebeer, "Musées personelles," in: *Chroniques de l'art vivant 35*, 1973, p. 2.
12 Email correspondence with the artist, April 27, 2013.
13 Amelia Jones, *Postmodernism and the En-gendering of Marcel Duchamp*, Cambridge University Press, Cambridge, 1994, p. 195.
14 Ibid., pp. 201–203.
15 Rosalind Krauss, "No More Play," *The Originality of the Avant-garde and Other Modernist Myths*, MIT Press, Cambridge, 1986, p. 60.

Car Stereo Parkway, 2005 (detail)
5 sculptures, 18 air fresheners,
mylar flags, and KISS video projection,
color, silent, 35:49 min

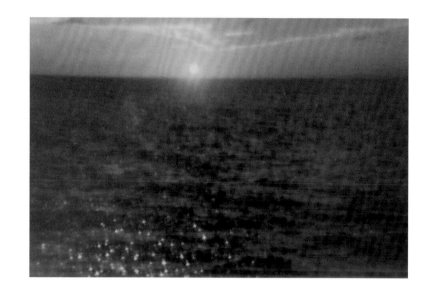

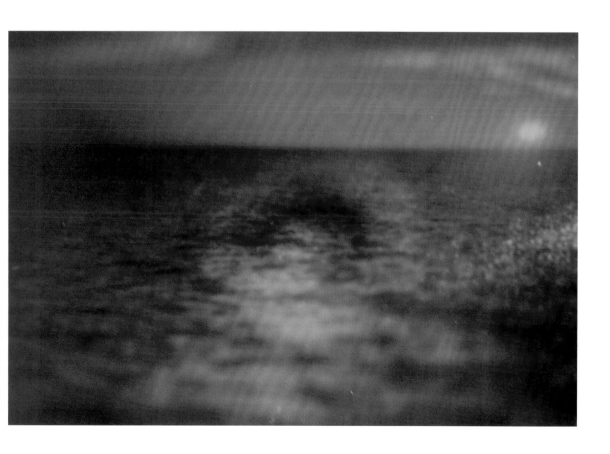

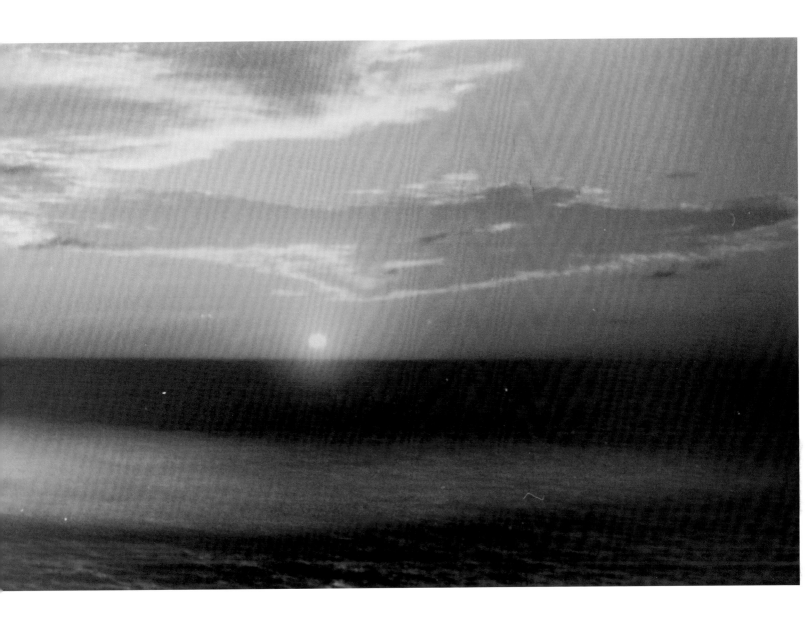

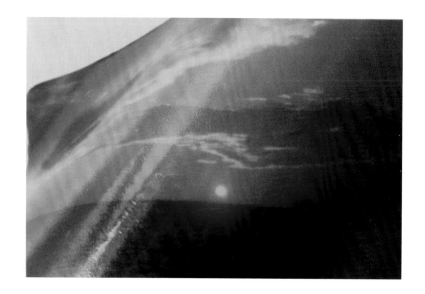

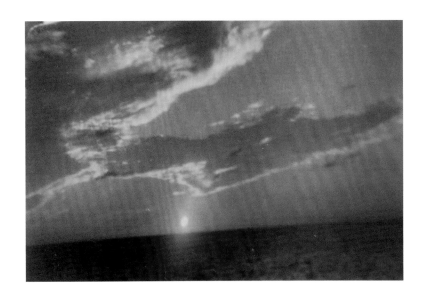

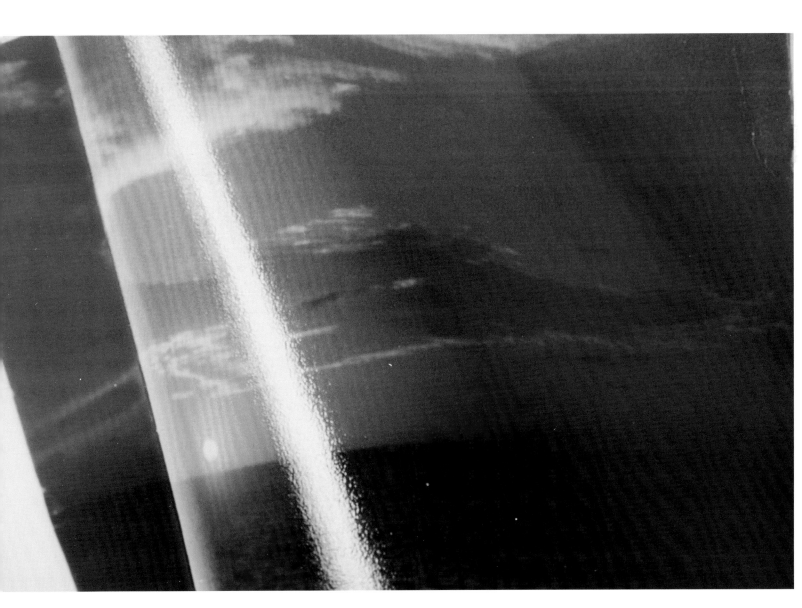

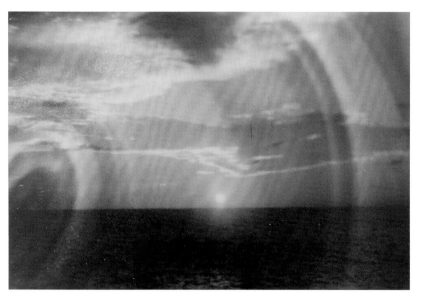

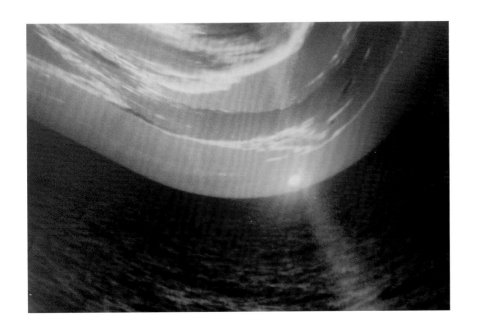

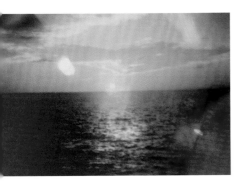

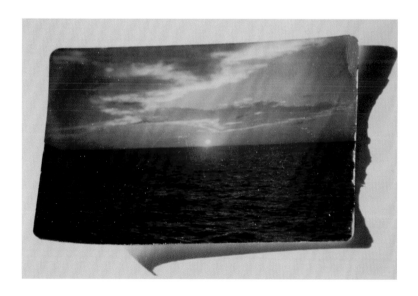

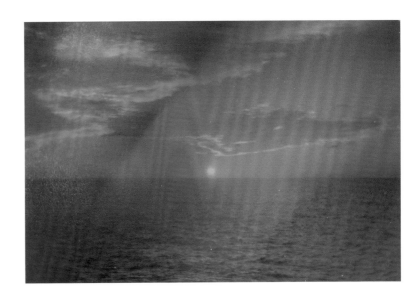

Weiterschießen
Alex Kitnick

„Ohne das obligatorische Bild eines Sonnenaufgangs oder -untergangs bleibt ein Reisealbum unvollständig!"
Viele Reisende scheinen nach diesem Motto zu leben – doch die meisten Fotos von Sonnenaufgängen und -untergängen, die ich sehe, sind ziemlich enttäuschend. Das muss nicht so sein – Sonnenaufgänge und -untergänge zu fotografieren, ist nicht so schwer!

Die Fotografie eines Sonnenuntergangs ist ein Klischee, doch ist auch diese Beobachtung ziemlich abgenutzt. Und dennoch ist die Beziehung der Fotografie zu Sonnenuntergängen und Klischees eine Diskussion wert. Das Wort Klischee oder Cliché stammt aus dem Französischen, aus dem Bereich des Schriftsetzens und Druckens. Eigentlich bezeichnet es eine Druckplatte mit Schrift oder Illustration. Statt die Buchstaben einzeln zusammenzufügen, gießen Schriftsetzer häufig verwendete Wörter in Klischees.[1] Im Laufe der Zeit wirkte sich der Druck, den diese mechanische Vorlage auf die Sprache ausübte – mit der Konnotation, dass Klischeewörter durch übermäßigen Gebrauch ihre Bedeutung verlieren –, auch auf die Fotografie aus. Ein *cliché*, so informiert uns das Französisch-Lexikon, ist auch ein fotografisches Negativ, was suggeriert, dass die Fotografie das Sehen irgendwie in Standardbilder verwandelt, so wie die Sprache idiomatische Klischees zu Standardformulierungen macht. Im Zuge der Banalisierung von Redewendungen wie *oublions le passé* (lass die Vergangenheit ruhen) und *tel père, tel fils* (wie der Vater, so der Sohn) erschienen in der Fotografie Bilder süßer Kinder und entzückender Kätzchen, deren Bestandteile alle so arrangiert waren, als ob sie schon im Kopf des Fotografen zusammen in eine Form gegossen worden wären. In diese Kategorie fällt auch das Foto eines Sonnenuntergangs, auf dem die Sonne im Meer versinkt und ihre Strahlen die Federwolken im Himmel darüber färben.

Doch hat die Fotografie eine besondere Affinität zu Sonnenuntergängen. Mit ihrer reinen Atmosphäre und frei von einem Thema führen Sonnenuntergänge die Fotografie auf ihre Grundprinzipien von Schwärze und Beleuchtung zurück. Auch haben Sonnenuntergänge eine materielle Ähnlichkeit mit der Fotografie; sie entwickeln sich durch die Mischung diverser chemischer Stoffe mit Licht. Es ist kein Geheimnis, dass es die dramatischsten Sonnenuntergänge im Los Angeles der 1980er Jahre gab, als die Smogkonzentration am höchsten war. Nun, da die Luft wieder sauberer ist, sind sie nur selten so rosa oder so blau. Heute muss man in der Regel reisen, um aufsehenerregende Sonnenuntergänge zu sehen, oder zumindest assoziiert man Sonnenuntergänge mit Ausflügen. Sie sind Teil des Pauschalangebots, zu dem auch leere Strände, billige Romantik, Touristenattraktionen und diverse andere Orte gehören, an denen man haltmacht, auf etwas zeigt und ein Foto schießt.

Im Jahr 2000 entdeckte Rachel Harrison in New York den Schnappschuss eines Sonnenuntergangs. Sie nahm ihn mit in ihr Atelier, um zu sehen, ob sie irgendetwas aus diesem trivialen Thema machen konnte, das zugleich ein kleines triviales Objekt war. Sie dachte in dieser Zeit viel über Fotografie nach. Sie klebte das Foto an die Wand und ließ

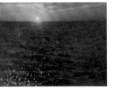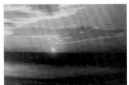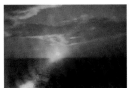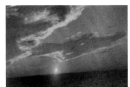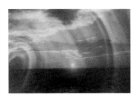

es dann auf den Boden fallen. Sie richtete eine Taschenlampe darauf, und all die Falten und Vertiefungen des Papiers traten so hervor, dass es aussah, als ob das Bild eine Haut hatte oder Haut war.[2] Dann stellte sie noch ein wenig mehr mit dem Foto an. Der Horizont schwankte und kippte, bog, wölbte und verzerrte sich. Sie begann nach neuen Farben zu suchen, die neue Erzählungen hervorbrachten und mit den gelben Wattewolken und den schreienden Orangetönen des ursprünglichen Abzugs wetteiferten. Ein grüner Strahl erschien; und damit Erinnerungen an Eric Rohmers *Le Rayon Vert* (1986) wie auch an einen Roman von Jules Verne. Später nahm die Fotografie ein Science-Fiction-artiges Glimmern an, ein Rot wie das des Mars. Weitere Sonnen tauchten auf. Ein Suchscheinwerfer forschte nach Zeichen von Leben.

Bald begann Harrison, die Fotografie zu fotografieren, sie hielt sie in der einen Hand und erhellte sie mit der Taschenlampe in der anderen. Mit dem Sucher einer 35-mm-Nikon-Spiegelreflexkamera konnte sie auf Details fokussieren (Kratzer auf dem Abzug, vieldeutige Texturen im Bild) und in der Fläche tiefe Stellen eruieren. Die Postkarte füllte den Bildausschnitt komplett aus. Sie zoomte heran und heraus. Sie veränderte die Blende und regulierte die Belichtungszeit. Sie schoss und schoss und schoss und schuf aus dieser einen Fotografie eine Fülle an Negativen.

Später, in der Dunkelkammer, machte Harrison Abzüge, ließ die Chemikalien sich auf unterschiedliche Weise auf dem Papier verteilen, kalibrierte die Farbe und fertigte schließlich 31 Abzüge im Format von 11 × 14 Zoll, größer als die ursprüngliche 4 × 6-Zoll-Fotografie. Die Zahl 31 hat einen guten Klang, sie entspricht einem Kalendermonat. Harrison zog einerseits eine klare Grenze (eine Zeitspanne), andererseits hatte sie sich instinktiv in ein Gebiet vertieft (ein Genre, eine Konvention), und gleichzeitig kam sie zu dieser Serie irgendwie durch die Mitte. Sie hat sich mitten in das Warenlager des kulturellen Gedächtnisses oder kultureller Klischees begeben. Sie buchte die Reise einer anderen Person. Sie leistete den Beitrag von jemand anderem, aber führte ihn falsch aus. Man sollte einzig und allein in die Erhabenheit des Himmels blicken, sie nicht in einem verkratzten Foto finden. Man sollte irgendwo hinreisen, um solche Dinge zu sehen, aber Harrison begab sich nicht einmal in ein Flugzeug.

Stativ – Wenn Sie mit längeren Verschlusszeiten und mit längeren Brennweiten fotografieren, ist ein Stativ oder etwas anderes unerlässlich, um sicherzustellen, dass sich Ihre Kamera nicht bewegt.

Rachel Harrison ist eine New Yorker Künstlerin, und schon vor ihr haben andere New Yorker Künstler – die man auch als Pictures Generation bezeichnet – Fotos von Fotos gemacht. Als er Anfang der 1980er Jahre in der Stockfoto-Abteilung von *Time-Life* arbeitete, fotografierte Richard Prince Ausschnitte von Anzeigen aus den Zeitschriften des Unternehmens ab. Er fand Muster für Frauenpaare und Serien von rauchenden Männern, die er dann erneut „aufnahm", um ihre Verhaltenscodes und Konventionen als Untersuchungsbeispiele anzubieten. Zwar präsentierte er seine Bildinhalte üblicherweise mit trockenem Humor („Es entsprach ‚fast' dem Bild, aus dem es entstand", hat er einmal gesagt), doch

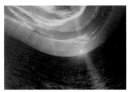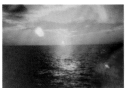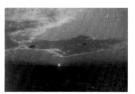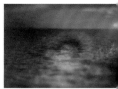

wenn er seine Linse auf etwas Gedrucktes richtete, trieb Prince die physischen Eigenschaften des Bildes mitunter ins Extrem, indem er den Ausschnitt vergrößerte, bis das Punktraster zum Vorschein kam. „Denken Sie an Prince' Bilder von Sonnenuntergängen, die er aus Urlaubsreklamen abfotografierte, an die vertrauten Bilder junger Liebespaare und süßer Kinder am Strand, im Angebot der vielen Konsumgüter auch Sonne und Meer", schrieb Hal Foster in *The Return of the Real*. „In einigen Bildern wirft ein Mann eine Frau aus dem Wasser, doch erscheint die Haut beider Personen verbrannt – wie in einer erotischen Leidenschaft, die zugleich eine tödliche Dosierung an schädlicher Strahlung ist."[3] Für Foster enthüllt Prince' Re-Fotografie die Realität von Tod und Begierde hinter der „Bild-Oberfläche" der Originalfotografie – sie bringt unterdrückte Gefühle hervor und entblößt deren negative Seite –, doch wird die Fotografie bis zuletzt als flaches, entkörperlichtes Bild begriffen, als Oberfläche.[4] Sie wird, anders ausgedrückt, als ein „Bild" präsentiert, das sich Douglas Crimp 1979 als etwas Schwebendes und Geisterhaftes vorstellte, das nicht an einen materiellen Träger gebunden ist.[5] Dies war die zu dieser Zeit übliche Denkweise. 1983 schrieb Vilém Flusser, dass der Wert von Fotografien „in der Information [liegt], die sie lose und reproduzierbar auf ihrer Oberfläche tragen", was bedeutet, dass die Information weggleiten und sich auch auf anderen Oberflächen ausbreiten konnte.[6] Das beste Beispiel für die Diskussion über Fluss und Erscheinungen, über Äußerlichkeit und Information, ist jedoch Jean Baudrillard: „Es gibt keine Transzendenz oder Tiefe mehr", schrieb er 1987 in *The Ecstasy of Communication*, „sondern nur die inhärente Oberfläche sich vollziehender Operationen, die glatte und funktionale Oberfläche der Kommunikation."[7]

Wenn Bilder glatte Oberflächen ohne Innenleben wären, wobei das eine das andere entstehen lässt und leicht auf das nächste übertragen werden kann, dann war es die Fotografie, welche diese verbindende Ebene ermöglichte. Die Fotografie brachte die Bilder in Bewegung, was wiederum so viel postmodernes Denken in Gang setzte, doch währenddessen wurde das Instrumentarium der Fotografie – ihre Filme und Abzüge und Linsen – irgendwie unwesentlich. Vielleicht war die Fotografie zu diesem Zeitpunkt noch zu allgegenwärtig, um in vollem Umfang wahrgenommen zu werden. Zwei Jahrzehnte später jedoch, als sie in eine Krise geriet und sich in andere Richtungen auszubreiten begann, fing das mit der Fotografie verbundene „Zeug" an, immer mehr in den Vordergrund zu drängen. „Wir könnten heute sagen, dass die außerordentliche Effloreszenz der fotografischen Theorie und Praxis zum Zeitpunkt des Beginns der Postmoderne so etwas wie der letzte schwere Atemzug des Mediums war, der Schein der Dämmerung vor dem Einbruch der Nacht", schrieb George Baker 2005. „Denn das fotografische Objekt, das damals Gegenstand der Theorie war, ist in den letzten zehn Jahren ganz und gar seiner digitalen Rekodierung erlegen, und die Welt der zeitgenössischen Kunst scheint, buchstäblich, zu einer Wendung vorgerückt zu sein, die wir nun eher als kinematisch denn als fotografisch bezeichnen sollten."[8] Allerdings können sich Dinge in mehr als eine Richtung entwickeln, und wenn die Fotografie in einigen Fällen ins Kinematische vorgeprescht sein mag, hat sie sich doch auch dem Skulpturalen zugewandt. Zu der Zeit, in der Harrison ihr Foto entdeckte, hatte sich die Kunst tatsächlich rasant vom Moment der fotografischen Dominanz in den 1980er Jahren entfernt. Vielleicht war Harrison aufgrund der darauf folgenden Geschwindigkeit der Entwicklung bildgebender

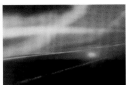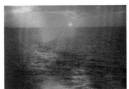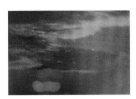

Technologien in der Lage, das negative Bild der Fotografie zu sehen, seine materiellen Realitäten; sie konnte der Fotografie als schäbigem Artefakt begegnen, sprich, anders als einem Archivbild oder als einem Motiv auf der Leinwand. Während die Pictures Generation sich die Fotografie als Fragment vorstellte, sah Harrison in ihr die Logik der Falte, was ihr ermöglichte, damit neue Dinge anzustellen – sie zu verformen und zu verbiegen, als ob es sich um das Material für eine Skulptur handelte. Vielleicht ist dieses Interesse für die Materialität der Grund dafür, dass sie, als sie 1996 eine *5 Guys Named Jean* betitelte Fotoassemblage schuf, Baudrillard ausließ. Bei der häuslich anmutenden Zusammenstellung von vorgefundenen Fotografien und Rahmen, die das Material und die emotionalen Qualitäten des fotografischen Dokuments in den Vordergrund stellt (die wir als ihren Gebrauchswert bezeichnen könnten), entschied sie sich stattdessen für Basquiat, Genet, Godard, Renoir und Sartre.

Schauen Sie sich um – Das Wunderbare an Sonnenuntergängen ist, dass sie nicht nur wunderbare Farben am Himmel vor Ihnen erzeugen, sondern die Umgebung in ein schönes goldenes Licht tauchen, das auch für andere Fotografien geeignet ist. Achten Sie im Verlauf des Sonnenuntergangs auf Motive um Sie herum (nicht nur vor Ihnen). Das goldene Licht hinter Ihnen könnte eine großartige Gelegenheit bieten, ein Porträt, eine Landschafts- oder eine Nahaufnahme usw. zu machen.

Wenn man die Fotografie als Kunst der Kopie ohne Original beschreibt, missachtet man die Bedeutung des ihr zugrunde liegenden Negativs. Das Negativ ist das Mittel zur Kopie, der Prototyp, der alle folgenden Stereotype möglich macht. Es ist die Macht des Negativs, die eine Unmenge an Kopien erlaubt, die ins Universum der technischen Bilder eingespeist werden, ins Mediengeflecht, in das die Fotografie eingebettet ist. Die Geschichte der mechanischen Reproduktion ist natürlich wahr – oder zumindest war sie es vor dem Aufkommen der Digitalität –, doch vielleicht ist diese Lesart in mancher Hinsicht *zu* mechanisch.[9] Sie verdeckt alternative Möglichkeiten, durch die sich Fotografien übermitteln und verbreiten können. Die Fotografie reproduziert sich auch durch das Leben, das sie als Druckerzeugnis in der Welt führt und das eine ganz eigene Aura hat. Fotografien erzeugen Begierde und Attraktion. Sie verleiten zu bedrohlichem oder konventionellem Verhalten.[10] Sie werden an Kühlschränke geheftet. Sich, so wie es Harrison in ihrer *Sunset Series* getan hat, auf einen Abzug zu konzentrieren bedeutet also nicht, aus diesem einen Fetisch zu machen oder die Vorstellung des „Originals" unterstützen zu wollen, sondern vielmehr, über andere Formen der Vervielfältigung und Übermittlung nachzudenken, über andere Arten, in denen sich Fotografien verbreiten und vervielfältigen. Indem sie einen Abzug wie ein Negativ verwendete, hat Harrison diesen in etwas verwandelt, mit dem sich mehr Abzüge machen lassen. Und indem sie dies tat, veranlasst sie uns zur Konzentration auf die materielle und affektive Wirkung der Fotografie – und

135

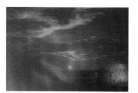

auch auf die affektive Wirkung des Materials – und darauf, wie wir diese Dinge wiederum zu unserem Vorteil nutzen könnten. Tatsächlich verschwinden im digitalen Zeitalter nicht nur die Negative, sondern auch die Abzüge. Heute verbleiben Bilder im Pixel-Stadium, in einem Zustand des Potenzials, und das für immer. Sie leben ihr Leben auf andere Art.

Fotografieren Sie mit unterschiedlichen Brennweiten – mit dem Weitwinkel können Sie dramatische Landschaftsaufnahmen schaffen, doch wenn Sie wollen, dass die Sonne selbst Teil der Aufnahme ist, wollen Sie die Möglichkeit haben, direkt heranzuzoomen.

Obwohl Harrison oft als Bildhauerin bezeichnet wird, ist die Fotografie seit Beginn ihrer Laufbahn zentral für ihre Arbeit. Auf frühe Skulpturen wie *Bobcat* (2002) und *Blazing Saddles* (2003) wurden Fotografien gestellt oder genagelt. Dies ist auch bei späteren Arbeiten wie *Stella 2* (2006) der Fall, die eine Fotografie der Boygroup Hanson in ihre Säule einbettet. Tatsächlich tritt die Fotografie häufig in Zusammenhang mit einer stabilen Ausstellungsarchitektur auf. In *Marilyn with Wall* (2004) hängt ein Foto von Marilyn Monroe, das in der Archivsammlung des Warhol Museum in Pittsburgh „beschlagnahmt" wurde, auf einer musealen Trockenbauplatte und erkundet die Beziehung zwischen der Fotografie und ihrer (physischen) Rahmenstruktur. Die Fotografie benötigt jedoch keine Wand, um zu hängen, sie kann in einer Zeitung zusammengefaltet oder in einer Zeitschrift eingerollt werden. „Fotos sind Blätter, die von Hand zu Hand gehen können", schreibt Flusser, „sie können in Schubladen abgelegt werden."[11] (Siehe Harrisons *Marlon and Indian*, 2002.) In seinem *Musée Imaginaire* spricht Malraux von der Bedeutung der Fotografie, die Skulptur neu zu formulieren, ihre Eigenschaften durch Schärfe und Beleuchtung hervorzuheben und so ein immaterielles Museum zu schaffen. Allerdings könnte man auch ein anderes Verfahren wählen und die Fotografie als Skulptur behandeln und sie einem entgegengesetzten, aber gleichartigen Test unterziehen. Genau dies tut Harrison.[12]

Es gibt Fotografien von Skulpturen, doch gibt es auch Fotografien, die in skulpturaler Form zu uns sprechen, die die Verbindung zwischen Sehen und Tasten betonen. Heute, im zweiten Jahrzehnt des 21. Jahrhunderts, berühren wir ständig Bilder, ändern die Größe von Partyfotos mit Zeigefinger und Daumen, doch wie wir gesehen haben, gibt es andere Arten, Bilder zu berühren. 2001 fotografierte Harrison Pilger, die ihre Hände auf ein Bild der Jungfrau Maria legten, das ihnen im Fenster eines Vorstadthauses in Perth Amboy, New Jersey, erschien. Sie wollten die Kraft des Bildes spüren. Wie die Motive aus *Perth Amboy* rufen Harrisons *Sunsets* ein ähnliches Bedürfnis hervor, etwas aus Bildern herauszuholen, doch vermitteln sie uns weder die Transzendenz der Jungfrau Maria noch die alltäglichen Freuden der heutigen Touchscreens. Sie markieren einen Platz zwischen beidem, der sich bereits weit entfernt anfühlt. Das fotografische Bild erscheint hier als etwas, das bezaubernd und widerspenstig zugleich ist.

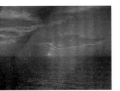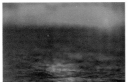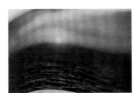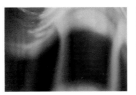

Es fällt auf, dass die Entstehungszeit von *Sunset Series* mit 2000 bis 2012 angegeben ist, obwohl Harrison diese Fotos im Jahr 2000 machte. Auch wenn sie eine Auswahl davon 2002 und erneut 2010 publizierte, war Harrison nicht der Ansicht, dass die Arbeiten ausgereift waren. So kehrte sie 2011 zu dieser Serie zurück, einem Zeitpunkt, in dem im Vergleich zur analog geprägten Entstehungszeit ein anderes Medium dominierte.[13] Erst jetzt fixierte sie die Bildabfolge, ordnete die Fotografien zu einer Serie.[14] Die Art, wie in der finalen, friesartigen Anordnung der Arbeiten ein Bild ins nächste übergeht, hat etwas Kinematisches, doch kann man sie auch als einen Katalog plastischer Möglichkeiten lesen. Unter ihrer Hand vereinigen sich die Skulptur und das Kino. Es war, als ob sich die wahre Bedeutung des Projektes im Jahr 2011 gerade erst gezeigt hätte, als Folge der letzten zehn Jahre, in denen sich unsere Beziehung zu Bildern stark veränderte.

Im letzten Bild der *Sunset Series* nimmt sich Harrison zurück und zeigt uns das Foto, das die Quelle für alle Permutationen war; mit seinen nach oben gebogenen Ecken liegt es auf einem einfachen weißen Grund, ein kleines handliches Objekt. Das aktuell so starke Bedürfnis, Bilder zu berühren, geht plötzlich einher mit der Tatsache, dass die in ihnen erhaltenen Erfahrungen weit weg sind. Auch der Schnappschuss mutet wie ein Artefakt an, stumm und aus dem Zusammenhang gerissen, ein kleines Indiz aus einer anderen Zeit. Die *Sunset Series* enthält ein Licht, das so indirekt ist, dass sich niemand je vorstellen könnte zu reisen – um diesen oder vielleicht *irgendeinen* Sonnenuntergang persönlich zu sehen. Er erscheint uns als eine Erinnerung, als eine Art von Souvenir. Und Souvenirs sind, wie Postkarten, die Sonnenuntergänge zieren, häufig Klischees. Wenn Sie etwas oft genug wiederholen, fängt es an, seine Bedeutung zu verlieren. Schließlich tun sich andere Ideen auf. Auch die Fotografie hat immer noch mehr zu sagen.

Weiterschießen – Ein Sonnenuntergang oder -aufgang verändert sich während seines Verlaufs ständig und kann, noch lange nachdem die Sonne unter- oder aufgegangen ist, großartige Farben erzeugen. Knipsen Sie deshalb mit verschiedenen Belichtungszeiten und Brennweiten weiter, wie ich es oben schon gesagt habe, bis Sie sicher sind, dass alles vorbei ist.

Zum Weiterlesen:
http://digital-photography-school.com/
how-to-photograph-sunrises-and-sunsets
#ixzz2IjEmQ4Zr

1 Das französische Wort *cliché* ist lautmalerisch – für die Franzosen klang der Begriff, wie wenn Metall auf Papier traf.
2 1991 heftete Harrison eine Auswahl von Polaroids auf ein Stück Bärenfell-Imitat.

3 Weiter schreibt Foster: „Hier schlägt das imaginäre Vergnügen des Urlaubs ins Gegenteil um, es wird obszön und durch eine *reale* Ekstase der Begierde verdrängt, die mit dem Tod durchmischt ist, eine *jouissance*, die hinter dem Lustprinzip des Werbebildes lauert und tatsächlich hinter der Wand des Bildes generell." Siehe Hal Foster, *The Return of the Real: The Avant-Garde at the End of the Century*, Cambridge (MA) 1996, S. 146. Die *Sunset*-Fotografien von Prince waren 1985 auch Teil der Ausstellung

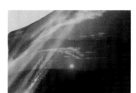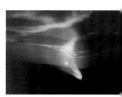

The Art of Memory, The Loss of History. Deren Kurator William Olander schrieb im Katalog: „Fasziniert vom Spektakel des ungezügelten Kapitalismus in Aktion, löst Prince das Bild los, um gegen den etablierten Code anzutreten. Das Ergebnis ist stets eine Frage: Welche Bedeutung hat beispielsweise die Natur, wenn sie als in den Medien aufgefundene Wiederholung wiedergegeben wird (Sonnenuntergänge)?" Siehe William Olander, „Fragments", in: *The Art of Memory, The Loss of History*, Ausst.-Kat. New Museum of Contemporary Art, New York 1985, S. 10.

4 Trotz dieser kritischen Rezeption hat Prince die Objekthaftigkeit seiner Fotografien betont: „Ich begann, über das Foto als Objekt nachzudenken und nicht als fotografisches Multiple", sagte er 2003. „Ich meine, für mich war der Rahmen um das Foto wichtig: Wie es präsentiert und an die Wand gehängt wurde. Wichtig war auch die Edition. Ich fing an, Editionen von zwei Arbeiten zu machen. Sie waren nicht wirklich einzigartig, aber doch fast." Siehe „In the Picture: Jeff Rian in conversation with Richard Prince", in: *Richard Prince*, London 2003, S. 10.

5 In Bezug auf ein Werk von Sherrie Levine in Form einer Diaprojektion schreibt Douglas Crimp: „Doch was war das Medium dieser Präsenz und folglich der Arbeit? Licht? Ein 35-mm-Dia? Ein aus einer Zeitschrift ausgeschnittenes Bild? Oder ist das Medium dieser Arbeit vielleicht seine Reproduktion in dieser Zeitschrift hier? Und wenn es unmöglich ist, das physische Medium der Arbeit aufzuspüren, können wir dann das originale Kunstwerk aufspüren?" Siehe Douglas Crimp, „Pictures", in: *October*, 8, Frühjahr 1979, S. 87.

6 Vilém Flusser, *Für eine Philosophie der Fotografie*, (1983), 11. Aufl. Berlin 2011, S. 51.

7 Jean Baudrillard, *The Ecstasy of Communication*, Semiotext(e), New York 1987, S. 12.

8 George Baker, „Photography's Expanded Field", in: *October*, 114, Herbst 2005, S. 122.

9 „Mit dem Wechsel von den analogen zu den digitalen Medien in den letzten Jahrzehnten", schreibt George Baker, „haben nur wenige den Umstand beklagt, dass dieser Wandel den Verlust des Negativs beinhaltete, was sicherlich für die meisten der aktuell vorherrschenden fotografischen Verfahren zutraf." Siehe George Baker, „The Black Mirror", in: *Paul Sietsema*, Ausst.-Kat. Wexner Center for the Arts, Columbus 2013, S. 4.

10 In seinem Roman *Weißes Rauschen* (engl. Originalausgabe: *White Noise*, 1985) erzählt Don DeLillo die Geschichte des meistfotografierten Schuppens in Amerika, eines Schuppens, den zu fotografieren jeder sich in die Schlange stellte, ein Schuppen, der fotografiert wurde, weil man ihn schon vorher fotografiert hatte. Im Laufe der Zeit schwoll die Zahl der Fotografien wie eine Lawine an, gewann an Schnelligkeit, brachte mehr und mehr Bilder hervor. Es waren keine Negative, die diese Bilder hervorbrachten; die Fotografien oder die um sie verbreiteten Gerüchte umhüllten den Schuppen mit einer Aura, die dann noch mehr Bilder erzeugte.

11 Flusser 2011 (wie Anm. 6), S. 45. Auch wenn er dies behauptet, leugnet Flusser die Wichtigkeit des Fotos: „Obwohl ihm letzte Reste der Dinglichkeit anhaften", schreibt er, „liegt sein Wert nicht im Ding, sondern in der Information auf seiner Oberfläche." (S. 47).

12 André Malraux, *Le Musée imaginaire*, in Bd. 1 von *La Psychologie de l'art*, Genf 1947 (engl.: *Museum without Walls*, New York 1967; dt.: *Das imaginäre Museum* (= *Psychologie der Kunst*, Bd. 1), Baden-Baden 1949. Beachten Sie, dass Harrison 2009 der Retrospektive ihrer Werke den Titel *Museum with Walls* gab.

13 Siehe Stefano Basilico, „Rachel Harrison: Trick and Treat", in: *Rachel Harrison*, Ausst.-Kat. Milwaukee Art Museum, Milwaukee 2002; David Joselit, „Touch to Begin", in: *Rachel Harrison: Museum With Walls*, Ausst.-Kat. Bard Center for Curatorial Studies, Annandale-on-Hudson 2010, S. 186–198.

14 In einem seiner frühesten und am wenigsten bekannten Werke, *Sunrise to Sunset* (1969), und einem weiteren möglicherweise verschollenen Werk schuf Dan Graham einen mächtigen, fast 25 Meter langen Fries aus Fotografien. Ohne den Standort seiner Kamera zu verändern, fotografierte Graham die Bewegung der Sonne innerhalb des gewählten Bildausschnitts. Die Fotografien bilden eine Zeitachse, die den bogenförmigen Verlauf der Sonne wiedergibt; in der Abbildung des Auf- und Untergehens enthalten sie einen Höhepunkt kultureller Konvention, woraufhin alles dunkel wird. In dem darauf folgenden Werk *Sunset to Sunrise* (1969) übertrug Graham diese Idee auf einen Film von vier Minuten, bei dem die Linse mal scharf und mal unscharf gestellt wurde.

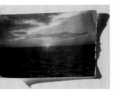

Sunset Series, 2000–2012
Set of 31 chromogenic prints

Keep Shooting
Alex Kitnick

'No good travel photo album is complete without the token sunrise or sunset picture!'
Many travelers seem to live by this mantra—however most sunset and sunrise photographs that I see are quite disappointing.
They need not be — sunsets and sunrises are not that difficult to photograph!

A photograph of a sunset is a cliché, but the observation is pretty well worn, too. Still, the relationship of photography to sunsets and clichés is worth discussing. The word *cliché* has its origins in France, in the world of typesetting and printing. It technically means a plate of type or a block of illustration. Instead of reassembling letters, type-setters cast frequently used words into *clichés*.[1] Over time the pressures that this mechanical matrix exerted on language — and the connotation that clichéd words lost their meaning in overuse — carried over to photography as well. A *cliché*, the French-English dictionary says, is also a photographic negative, which suggests that photography somehow turns vision into stock images, just as idiomatic clichés transform language into stock phrases. On the tail of expressions like *oublions le passé** and *tel père, tel fils,*** images of cute kids and adorable kittens subsequently appeared in the space of photography, with all their internal parts arranged as if already cast together in the photographer's head. A photograph of a sunset falls into this category as well, the sun dipping down into the ocean, lighting up the tufted clouds in the sky above.

Photography has a special affinity to sunsets, though. Pure of atmosphere and empty of subjects, sunsets return photography to its basic principles of darkness and illumination. Sunsets, too, have a material resemblance to photographs; they develop like photographs, various chemicals mixing with light. It's no secret that Los Angeles had its most dramatic sunsets in the 1980s when the city's smog levels were at their highest. Now that the air has been cleaned up they're rarely as pink and blue. Today one typically has to travel to see striking sunsets, or at least one associates sunsets with trips. Sunsets are included in package deals with empty beaches, cheap romance, tourist spots, and various other places where one stops, points, and shoots.

In 2000, though, Rachel Harrison found a snapshot of a sunset in New York. She took it back to her studio to see if there was anything she could do with this hackneyed subject, which is, at the same time, also a small hackneyed object. She was thinking a lot about photography at the time. She taped the photograph to the wall and then dropped it on the floor. She trained a flashlight on it and all the wrinkles and pits in the paper stood out so that it looked like the image had a skin, or was a skin.[2] Then she moved the photograph around a bit more. The horizon line bent, then wobbled, buckled, tilted, and warped. She started finding new colors — which created new narratives — that competed with the yellow cotton clouds and screaming acid oranges native to the original print itself. A green ray appeared; so did recollections of Eric Rohmer's *Le Rayon Vert* (1986), and through that a novel by Jules Verne. Later the photograph took on a bit of a sci-fi glow, a Martian red. Other suns appeared. A searchlight looked for signs of life.

Soon Harrison started to photograph this photograph, holding it in one hand while she shined the flashlight on it with the other. Looking through a Nikon 35mm single-lens reflex camera, she could focus in on details (scratches on the print, suggestive textures in the image) and pick out signs of depth from a flat field. She let the print fill the frame. She zoomed in and out. She adjusted the aperture and regulated the exposure. She shot and shot and shot, creating a cache of negatives from this one single photograph.

Later, in the darkroom, Harrison made prints, letting chemicals wash over paper in different ways, calibrating the color, and eventually making thirty-one 11 × 14 inch prints, which is bigger than the original 4 × 6 inch photograph. Thirty-one has a good ring to it, a calendar month. Harrison had demarcated something (a length of time), and burrowed into something (a genre, a convention), but at the same time, she'd come to this series somehow in the middle. She'd walked into a storehouse of cultural memory, or cultural cliché. She'd entered someone else's trip. She was doing someone else's bit, but she was doing it wrong. One is supposed to look into the sublimity of the sky alone, not find it in a scuffed photo. One is supposed to go somewhere to see such things, but Harrison never even got on a plane.

Tripod — If you're shooting at longer shutter speeds and with longer focal lengths then a tripod or some other way of ensuring your camera is completely still is essential.

Rachel Harrison is a New York artist, and other New York artists before her — what some called Pictures artists — took photographs of photographs too. While working in the stock photo department at Time-Life in the early 1980s Richard Prince rephotographed clippings of advertisements from the company's magazines. He found patterns of coupled women and series of smoking men and then 'took' them again so as to hold their codes and conventions up for analysis. Though he typically presented his subjects in deadpan fashion ("It was 'almost' the picture it came from," Prince has said), in training his lens on printed matter Prince occasionally pushed the physical properties of images to an extreme, bleeding them so that the dot matrix came through. "Consider the sunset images of Prince, which are rephotographs of vacation advertisements from magazines, familiar pictures of young lovers and cute kids on the beach, with the sun and sea offered as so many commodities," Hal Foster wrote in The Return of the Real. "In several images a man thrusts a woman out of the water, but the flesh of each appears burned — as if in an erotic passion that is also fatal irradiation."[3] For Foster Prince's rephotography exposes the reality of death and desire behind the "image-screen" of the original photograph — it brings submerged feelings to the surface and turns them sour — but the photograph is still imagined as a flat and disembodied image here, a surface to the end.[4] It is presented as a "picture," in other words, which Douglas Crimp imagined in 1979 as something floating and ghost-like, untied to any one material support.[5] This was a common line of thinking at the time. In 1983 Vilém Flusser wrote that the value of photographs "lies in the information that they carry loose and open for reproduction on their surface," which meant that the information was able to slip off and spill onto other

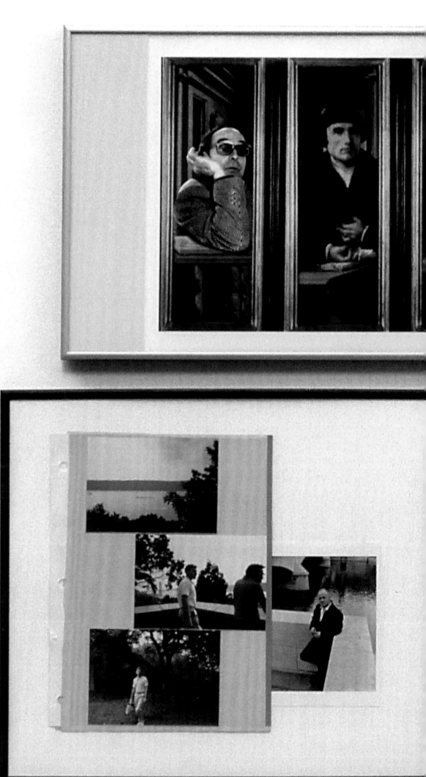

5 Guys Named Jean, 1996
Collaged found images
of Jean-Paul Sartre, Jean Genet,
Jean-Michel Basquiat,
Jean Renoir, Jean-Luc Godard
28 × 60 inches
71.1 × 152.4 cm

surfaces as well.[6] All this talk of flows and appearances, however, of exteriority and information, was best exemplified by Jean Baudrillard: "There is no longer any transcendence or depth," he wrote in *The Ecstasy of Communication* (1987), "but only the immanent surface of operations unfolding, the smooth and functional surface of communication."[7]

If images were smooth surfaces without insides, one giving rise to and easily grafted onto the next, it was photography that made this communicative plane possible. Photography let images move, which, in turn, put so much postmodern thinking into gear, but as it did so the apparatus of photography — its film and prints and lenses — was somehow rendered immaterial. Perhaps photography was still too omnipresent at this moment to be fully perceived. Two decades later, however, when it entered a moment of crisis and began expanding out in other directions, the stuff of photography began pushing ever more to the fore. "We might now say that the extraordinary efflorescence of both photographic theory and practice at the moment of the initiation of postmodernism was something like the last gasp of the medium, the crepuscular glow before nightfall," George Baker wrote in 2005. "For the photographic object theorized then has fully succumbed in the last ten years to its digital recoding, and the world of contemporary art seems to have moved on, quite literally, to a turn that we would now have to call cinematic rather than photographic."[8] Things turn in many directions, however, and if photography has in some cases sped forward to the cinematic, it has also turned around to the sculptural. Indeed, by the time Harrison found her photograph, things had changed rapidly from the moment of photography's dominance in the 1980s. Perhaps because of the subsequent acceleration in imaging technologies, she was able to see photography's negative image, its material realities; she was able to encounter photography as a grungy artifact in the world, in other words, rather than as a picture in an archive or an image on a screen. Where Pictures artists imagined the photograph as a fragment, Harrison saw in it the logic of the fold, and seeing it as such allowed her to do new things to it — to warp and bend it as if it were so much sculptural material. Perhaps it is due to this interest in materiality, in fact, that when, in 1996, Harrison made a photo-assemblage titled *5 Guys Named Jean* she left Baudrillard out. In this quasi-domestic smattering of found photographs and frames that foregrounds the material and sentimental qualities of the photographic document (what we might call its use value), she opted for Basquiat, Genet, Godard, Renoir, and Sartre instead.

Look around you — The wonderful thing about sunsets is that they not only create wonderful colors in the sky in front of you but they also can cast a beautiful golden light that is wonderful for other types of photography. As the sunset progresses keep an eye on other opportunities for shots around you (not just in front of you). You might find a great opportunity for a portrait, landscape shot, macro shot etc behind you in the golden light.

When people describe photography as an art of copies lacking an original, they neglect the power of the negative resting beneath it. The negative's the copying device, the prototype that makes all subsequent stereotypes possible. It's the power of negatives that allows the legion of copies to usher forth, which enters it into the universe of technical images, the whole nexus of media in which photography is immersed. This story of mechanical reproduction is true, of course, or, at least, it was true before the advent of the digital, but perhaps this reading is in some ways *too* mechanical.[9] It covers up the other ways in which photographs transmit and spread. Photography also reproduces through the life it lives in the world as printed matter, which has an aura all its own. Photographs create desire and attraction. They inspire intimidation and convention.[10] They get stuck to fridges. To focus on a print, then, as Harrison has done in her *Sunset Series*, is not to make a fetish of it, or shore up the notion of the 'original', but rather to think about other forms of reproduction and transmission, other ways in which photographs spread and reproduce. Using a print like a negative, Harrison has transformed it into something to make more prints with. And in doing this she makes us focus on photography's material and affective effects, and material's affective effects, and how we might take advantage of these things in turn. Indeed, just as negatives are disappearing in the digital age prints are as well. Today, images stay in pixel, in a state of potential, in perpetuity. They live their lives in other ways.

Shoot at a variety of focal lengths — wide angle can create sweeping landscape shots but if you want the sun itself to be a feature of the shot you'll want to be able to zoom right in.

Though Harrison has often been referred to as a sculptor, photography has been central to her work since the beginning of her career. Early sculptures like *Bobcat* (2002) and *Blazing Saddles* (2003) have photographs sitting on or nailed to them. So do later ones like *Stella 2* (2006), which incorporates a photograph of the boy band Hanson into its standing column. Indeed, photography often depends on such firm supports. In *Marilyn with Wall* (2004) a photograph of Marilyn Monroe appropriated from the archival collection at the Warhol Museum in Pittsburgh hangs on a cutout piece of gallery drywall, probing the relationship between photography and its (physical) structure. Photography does not need a wall to hang on, however; it can get folded over in a newspaper or rolled up in a magazine. "Photographs are loose leaves which can be passed from hand to hand," Flusser writes, "They can be put away in drawers."[11] (See Harrison's *Marlon and Indian*, 2002.) In *Museum Without Walls* André Malraux speaks of photography's power to rewrite sculpture, to accentuate its qualities through focus and lighting, and thus create an immaterial museum, but one might also carry out another operation and treat a photograph as sculpture and submit it to an equal and opposite test, which is what Harrison does.[12]

There are photographs of sculpture, then, but there are also photographs that speak to us sculpturally, that highlight the connection between vision and touch. Today, in the 2010s, we touch images all the time, rescaling party pictures between our pointer

Bobcat, 2002
Wood, polystyrene, cement,
acrylic, and chromogenic print
48 × 96 × 4 inches
121.9 × 243.8 × 10.2 cm

fingers and thumbs, but, as we have seen, there are other ways to touch images. In 2001, Harrison photographed pilgrims placing their hands on an image of the Virgin Mary that appeared in the window of a suburban house in Perth Amboy, New Jersey. They wanted to feel the picture's powers. Like the subjects in *Perth Amboy*, Harrison's *Sunsets* evoke a similar desire to get something out of images, but they deliver neither the transcendence of the Virgin Mary nor the routine pleasures offered by today's touchscreens. They mark a spot somewhere between the two, which already feels far away. The photographic image appears here as something both entrancing and obstinate at once.

One notices that the dates of the *Sunset Series* are given as 2000–2012 despite the fact that Harrison shot these photographs in 2000. Though a selection were published in 2002, and again in 2010, Harrison did not feel the work was settled and she returned to it in 2011, in a different media moment from the still mostly analogical time of its genesis.[13] It was then that she codified it, laid it out like a series.[14] There is something cinematic about the way one image gives way to the next in the work's final frieze-like form, but one also reads it as a catalogue of plastic possibilities. Sculpture and cinema come together in the palm of one's hand. It was as if the true import of the project had only just come to light in 2011. In ten years so much about our relation to images had changed.

In the last image in the *Sunset Series*, Harrison pulls back and shows us the source photo that generated all her permutations; it rests with curled corners on a simple white ground, a little handheld device. The desire to touch images that we feel so strongly today is suddenly matched by the fact that the experiences within them are impossibly far away. The snapshot, too, looks like an artifact, mute and out of context, a scrap of evidence from another time. The *Sunset Series* represents a light so mediated that no one could ever imagine making the trip to see this sunset — perhaps, *any* sunset — firsthand. Indeed, it appears to us as a memory, a kind of souvenir. And souvenirs, like postcards graced with sunsets, are often clichés. If you repeat things enough times though they start to lose their meaning. Eventually other ideas start to suggest themselves. The photograph, too, still has more to say.

Keep Shooting — A sunset or sunrise constantly changes over time and can produce great colors well after the sun goes down or appears so keep shooting at different exposures and focal lengths as I've mentioned above until you're sure it's all over.

Read more:
http://digital-photography-school.com/
how-to-photograph-sunrises-and-sunsets
#ixzz2IjEmQ4Zr

* Let bygones be bygones.
** Like father, like son.

1 *Cliché* is an onomatopoetic term — that's what it sounded like, in French, when metal type hit paper.

2 In 1991 Harrison taped an assortment of Polaroids onto a piece of a fake bearskin frock.

3 Foster continues: "Here the imaginary pleasure of the vacation scene goes bad, becomes obscene, displaced by a *real* ecstasy of desire shot through with death, a *jouissance* that lurks behind the pleasure principle of the ad image, indeed of the image screen in general." See Hal Foster, *The Return of the Real: The Avant-Garde at the End of the Century*, MIT Press, Cambridge/MA, 1996, p. 146. Prince's *Sunset* photographs also appeared in the 1985 exhibition *The Art of Memory, The Loss of History*. In the catalogue, curator William Olander wrote, "Fascinated by the spectacle of high capitalism in action [Prince] pries loose the image to play against the established code. The result is always a question: what is the significance of nature, for example, when it is rendered as a repetition located in the media (sunsets)?" See William Olander, "Fragments," in: *The Art of Memory, The Loss of History,* New Museum of Contemporary Art, New York, 1985, p. 10.

4 Despite this reception, Prince has stressed the object-like nature of his photographs: "I started to think about the photograph as an object and not a photographic multiple," he said in 2003. "I mean, for me the frame around the photograph was important: how it was presented and hung on the wall. The edition was important. I started making editions of two. Not quite unique but almost." See "In the Picture: Jeff Rian in conversation with Richard Prince," in: *Richard Prince*, Phaidon, London 2003, p. 10.

5 Writing about a slide projection work by Sherrie Levine, Douglas Crimp writes, "But what was the medium of that presence and thus of the work? Light? A 35-mm. slide? A cut-out picture from a magazine? Or is the medium of this work perhaps its reproduction here in this journal? And if it is impossible to locate the physical medium of the work, can we then locate the original artwork?" See Douglas Crimp, "Pictures," in: *October*, 8, Spring 1979, p. 87.

6 Vilém Flusser, *Towards a Philosophy of Photography* (1983), Reaktion Books, London, 2012, p. 56.

7 Jean Baudrillard, *The Ecstasy of Communication*, Semiotext(e), New York, 1987, p. 12.

8 George Baker, "Photography's Expanded Field," in: *October*, 114, Fall 2005, p. 122.

9 "With the shift from analogue to digital media in recent decades," George Baker has written, "few have mourned the fact that this transition has included the loss of the negative, surely from most of the dominant forms of current photographic processes." See George Baker, "The Black Mirror," in: *Paul Sietsema*, Wexner Center for the Arts, Columbus, 2013, p. 4.

10 In his 1985 novel *White Noise* Don Delillo tells the story about the most photographed barn in America, a barn that everyone lined up to shoot, a barn that was photographed because it had been photographed before. Over time the photographs of the barn snowballed, gathered steam, called forth more and more images. Negatives didn't create these images; the photographs, or the rumor around them, created an aura around the barn, which then created more images.

11 Flusser, op. cit., p. 49. Despite this claim, Flusser disavows its importance: "Even though the last vestiges of materiality are attached to photographs," he writes, "their value does not lie in the thing but in the information on their surface."

12 André Malraux, *Museum without Walls*, Doubleday, New York, 1967. Note that Harrison titled her 2009 retrospective *Museum with Walls*.

13 See Stefano Basilico, "Rachel Harrison: Trick and Treat," in: *Rachel Harrison*, exhib. cat., Milwaukee Art Museum, Milwaukee, 2002, and David Joselit, "Touch to Begin," in: *Rachel Harrison: Museum With Walls*, exhib. cat., Bard Center for Curatorial Studies, Annandale-on-Hudson, 2010, pp. 186–198.

14 In one of his earliest, and least known works, *Sunrise to Sunset*, 1969, and one, in fact, that may be lost, Dan Graham created a massive 80-foot frieze of photographs. Leaving his camera stationary, Graham shot the movement of the sun in relation to its frame. The photographs form a timeline delineating the sun's arc; picturing a rise and fall, they contain a climax of cultural convention and then everything goes dark. In a subsequent work, *Sunset to Sunrise* (1969), Graham transferred this idea to a four-minute film, now spiraling the lens in and out of focus.

Marlon and Indian, 2002
Wood, polystyrene, cement,
acrylic, plastic Indian figurine,
and Marlon Brando photograph
45 × 49 × 31 inches
114.3 × 124.5 × 78.7 cm

Interview mit einer Künstlerin
Martin Germann und Rachel Harrison

Martin Germann: Indem er Rosalind Krauss' Begriff des „erweiterten Feldes" paraphrasierte, hat der Autor John Kelsey dein Schaffen einmal im „verlassenen Feld" verortet. Was befindet sich aber jenseits dessen – womöglich das „dissoziative Feld"?

Rachel Harrison: Wir können uns alle in einem guten Buch oder Film verlieren. Doch jemand mit einer dissoziativen Störung entflieht der Wirklichkeit auf unbewusste und ungesunde Weise. Die Symptome solcher Persönlichkeitsstörungen – sie reichen von Amnesie bis zu multiplen Identitäten – entwickeln sich meist als Reaktion auf Traumata, um belastende Erinnerungen möglichst in Schach zu halten.[1]

MG: Findet sich viel davon in deinen Arbeiten wieder?

RH: Der Begriff des Identitätsdiebstahls ist in einem globalen Kontext nicht ohne Weiteres zu fassen, lässt sich aber durch eine einfache mathematische Formel ausdrücken: Identitätsbesitz + Identitätsverlangen + Aneignung von Identitäten + Missbrauch von Identitäten + Wiederherstellung von Identitäten = Identitätsdiebstahl. Diese Gleichung können wir auch als einen sozialen Kreislauf betrachten, der – so scheint es – als Reaktion auf den Identitätskult im Allgemeinen und seine Umstände entstanden ist.[2]

MG: Angesichts der Tatsache, dass die Skulpturen von Styropor und anderen Materialien zusammengehalten werden, dass alles aneinandergefügt ist – könnte man nicht sagen, dass sie dennoch ein „Ganzes" bilden?

RH: Der Himmel ist kein Disneyland; er befindet sich mitten unter euch, denn der Ort, wo ihr seid, wird zur Wohnung Gottes und zur Wohnung eurer Eltern.[3]

MG: Ließe sich vereinfacht behaupten, dass das Trägermaterial stellvertretend für die Kultur als Gesamtes steht und die damit verbundenen Objekte für die unaufhörlich darin durchlaufenen Schleifen und Wiederholungen?

RH: Wer ein Haus bauen will, beginnt mit dem Dachdecken.[4]

MG: Es geht dir nicht darum, Konsumgüter und Konsumobjekte in etwas anderes zu verwandeln, wie du ja mehrfach gesagt hast. Können diese aber in erster Linie sich selbst repräsentieren und zugleich auch Kunst sein?

RH: Meister Proper putzt so sauber, dass man sich drin spiegeln kann.[5]

MG: Gilt dies ebenso in Bezug auf deine Fotoserie Sunsets?

RH: Sunsets. Also nein. Bei der Eröffnung vor einigen Jahren war das einmal ein guter Ort für Fischgerichte und ein schönes Glas Wein oder einen Drink. Heute ist man eher irritiert. Eine Bar? Oder doch ein schickes Restaurant? Was soll es sein? Meiner Meinung nach täte Sunsets am besten daran, sich auf das Minimum zu beschränken: ein einfaches Lokal mit Gerichten von der Bar und Getränke-Specials. Sie sollten die Happy-Hour-Kundschaft binden, die Leute mit Fußball-Events locken und mit guter Laune. Das ist der richtige Weg. Warum sich besser geben, als man ist?[6]

MG: Hat die Tendenz, deinen Arbeiten durch den Titel eine persönliche Note zu

geben, in den letzten Jahren etwas nach-
gelassen?

RH: Well we can't take it this week. And
her friends don't want another speech.
Hoping for a better day to hear what she's
got to say. All about that. Personality crisis
you got it while it was hot. But now frustra-
tion and heartache is what you got.[7]

MG: Liegt es daran, dass dein Œuvre
bereits überbevölkert ist?

RH: Zu den häufigen Protestschreien vieler
Linken gehört auch jener, dass die Welt
überbevölkert sei. Der jüngste hysterische
Ausbruch in dieser Sache kam von Sir
David Attenborough, seit Kurzem auch
Schirmherr des „Optimum Population
Trust". Der 86-jährige Attenborough, der
Naturwissenschaften studiert hat und
früher in leitender Position bei der BBC tätig
war, geriert sich als Hohepriester unter
den liberalen Erdanbetern. Attenborough,
vor allem bekannt für seine *Life*-Doku-
mentarfilme, erklärte: „Wir sind eine Plage
auf der Erde, was sich in gut 50 Jahren
rächen wird. Dies betrifft nicht nur den Klima-
wandel, sondern ist auch eine Frage des
schieren Platzes, der notwendigen Anbau-
flächen für diese enormen Menschen-
massen. Entweder wir begrenzen das Be-
völkerungswachstum oder die Natur wird
es an unserer Stelle tun". Nichts könnte
weiter von der Wahrheit entfernt sein. Im
Hinblick auf „schieren Platz" und „An-
bauflächen" haben wir doch gerade erst
an dem genippt, was die Erde zu bieten
hat. Wenn man bedenkt, dass es etwas mehr
als sieben Milliarden Menschen weltweit
gibt, würde die gesamte Bevölkerung un-
seres Planeten mühelos in den Bundes-
staat Texas passen, der nicht einmal 0,14%
der Landoberfläche der Erde ausmacht.[8]

MG: Hast du Helden?

RH: I, I wish you could swim. Like the
dolphins. Like dolphins can swim.[9]

MG: Ist dir jemals in den Sinn gekommen,
dass die Flachheit einer zunehmend durch
den Monitor erfahrenen Welt eine große
Resonanz im physischen Raum findet?

RH: Apple ist bestrebt, durch seine inno-
vative Hardware, Software sowie Internet-
angebote die beste Benutzererfahrung
für Studenten und Pädagogen, kreative
Profis und Konsumenten rund um den
Globus zu bieten. Apple freut sich auf Ihre
Meinung zu den Produkten.[10]

MG: Lässt sich die vermeintliche Beliebig-
keit in Zusammenhang mit dem Internet
bringen, das einen gleichwertigen Zugang
zu allem Wissen bietet?

*Sculpture
with Raincoat*, 2012
Wood, polystyrene,
cement, acrylic, hanger,
The Economist,
and Gherardini rain coat
68 × 27 × 20 1/2 inches
172.7 × 68.6 × 52.1 cm

153

RH: Der strikte Schutz der Redefreiheit würde kaum für jemanden gelten, der im Theater fälschlicherweise Feuer schreit und eine Panik auslöst ... Die Frage ist in jedem Fall, ob die Worte und die Umstände, unter denen sie geäußert werden, von ihrer Natur her eine klar und unmittelbare Gefahr bedeuten, ob sie erhebliche Übel mit sich bringen, die der Kongress abzuwenden berechtigt ist. Es ist eine Frage der Dringlichkeit und des Ausmaßes.[11]

MG: Gesetzt den Fall, du würdest gefragt, ob deine Arbeit ein Spiegelbild der kulturellen Verhältnisse sei, hättest du dem beispielsweise 2002 mit derselben Vehemenz zugestimmt wie jetzt im Jahr 2013?

RH: Ein Stamm pflanzenfressender Vormenschen streift auf der Suche nach Nahrung durch die afrikanische Wüstenlandschaft. Ein Leopard tötet ein Mitglied der Gruppe, und von einem anderen Stamm Affenmenschen wird sie von ihrer Wasserstelle vertrieben. Die Unterlegenen verbringen die Nacht in den nackten Felswänden eines kleinen Kraters und finden beim Aufwachen einen schwarzen Monolithen vor, der vor ihnen erschienen ist. Schreiend und springend nähern sie sich vorsichtig und berühren ihn. Kurz darauf entdeckt einer der Affenmenschen den Gebrauch von Knochen als Werkzeug und Waffe, und so beginnt die Gruppe, Tiere zu erlegen. Dank ihrer neuen Fähigkeiten und ihres wachsenden Selbstbewusstseins kann sie den Anführer des anderen Stammes töten und die Herrschaft über die Wasserstelle zurückgewinnen. Triumphierend schleudert der Stammesführer seine Waffe in die Luft, während ein Match Cut zur nächsten Szene überleitet.[12] [13]

MG: Fasst du gern Styropor an?

RH: Oft reicht es doch, mit jemandem zusammen zu sein. Ich brauche denjenigen aber nicht zu berühren, nicht einmal mit ihm zu sprechen. Ein Gefühl entspinnt sich zwischen beiden. Man ist nicht allein.[14]

MG: Magst du Shoppen mehr als Picasso?

RH: Exakt oder als Könige. Schließen schließen und öffnen so wie Königinnen. Schließen schließen und Schließen und so schließen Schließen und Schließen und so und so Schließen und so schließen Schließen und so schließen Schließen und Schließen und so. Und so schließen Schließen und so und also. Und also und so und so und also. Exakte Ähnlichkeit zu exakter Ähnlichkeit die exakte Ähnlichkeit so exakt wie Ähnlichkeit, exakt so ähnlich, exakt ähnlich, exakt in der Ähnlichkeit eine exakte Ähnlichkeit, exakt und Ähnlichkeit. Denn dies ist so. Weil. Überhaupt wiederhole jetzt aktiv, überhaupt wiederhole jetzt aktiv, überhaupt wiederhole jetzt aktiv. Handhabe und höre, überhaupt wiederhole jetzt aktiv. Ich richte Richter.[15]

MG: Machst du das, was Marcel Broodthaers heute tun würde?

RH: Wuff.

MG: Er spielte mit Klassifizierungssystemen und natürlich mit der Rolle des Künstlers. Seine Ausgangsmaterialien waren – wie bei dir auch – Dinge und Bilder des Alltags, in seinem Sinne allerdings auf sehr belgische Weise, wir finden da zum Beispiel Eier oder Muscheln.

RH: Miau.[16]

MG: Bist Du eine manische Sammlerin?

RH: Wuff.

MG: Geht es letzten Endes wirklich um gutes Aussehen?

RH: Miau.

MG: Bist du Feministin?

RH: Wuff.

MG: Lässt du dich gern zitieren?

RH: Nur wenn die Zitate von anderen stammen.

1 <http://www.MayoClinic.com> [15.5.2013].
2 Megan McNally, *Identity Theft in Today's World*, Santa Barbara CA 2011.
3 Reverend Sun Myung Moon, *Word and Deed*, 30. Januar 1977.
4 Entweder Franz West oder ein altes chinesisches Sprichwort.
5 Werbeslogan für Meister Proper.
6 Beitrag auf der Bewertungsplattform Yelp zum Restaurant Sunsets, 302 S Concourse Avenue, Neptune, NJ.
7 New York Dolls, David Johansen/Johnny Thunders, *Personality Crisis*.
8 Trevor Thomas, *The Myth of Overpopulation*, http://www.americanthinker.com/2013/02/the_myth_of_overpopulation (mit einer Meinung, die von der Verfasserin der Antwort nicht geteilt wird).
9 David Bowie, *Heroes*, 1977.
10 Website von Apple.
11 Oliver Wendell Holmes Jr., *Schenck vs. Vereinigte Staaten*, 249 U.S. 47, 52 (3. März 1919).
12 Giulio Angioni, *Fare, dire, sentire: l'identico e il diverso nelle culture* (2011), S. 37, und „Un film del cuore", in: *Il dito alzato* (2012), S. 121–136.
13 Kommentatoren des Films vermuten generell einen Zeitsprung von Jahrmillionen, nicht Jahrtausenden. Vgl. Patrick Webster, *Love and Death in Kubrick*, McFarland, 2010, 0786459166, 9780786459162, S. 47, und Thomas Allen Nelson, *Kubrick. Inside a Film Artist's Maze*, Indiana University Press, 2000, S. 107, ISBN 978-0-253-21390-7. Der Roman gibt für den Monolithen auf dem Mond ein Alter von drei Millionen Jahren an (Kapitel 11, „Anomalie"), während der Filmdialog und eine frühe Drehbuchfassung von vier Millionen Jahren sprechen.
14 Marliyn Monroe, aus einer Internetquelle mit Zitaten zweifelhafter Provenienz zum Thema Berührung.
15 Gertrude Stein, *If I told Him: A completed Portrait of Picasso*. Vanity Fair 21, no. 8, September 1923.
16 Marcel Broodthaers, *Interview mit einer Katze*, aufgezeichnet im Musée d'Art Moderne, Département des Aigles, Düsseldorf, 1970.

Interview with an Artist
Martin Germann and Rachel Harrison

Martin Germann: By paraphrasing Rosalind Krauss' term "expanded field," John Kelsey once situated your work in the "abandoned field." What, though, is behind that — might it be the "dissociative field"?

Rachel Harrison: We all get lost in a good book or movie. But someone with dissociative disorder escapes reality in ways that are involuntary and unhealthy. The symptoms of dissociative disorders — ranging from amnesia to alternate identities — usually develop as a reaction to trauma and help keep difficult memories at bay.[1]

MG: Dissociating in terms of owning identities that are completely disconnected with each other, split and apart. Are your works sometimes like that?

RH: The concept of identity theft is not easily defined in a global context, but it can be expressed in simple mathematical terms: Owning Identities + Needing Identities + Acquiring Identities + Misusing Identities + Recovering Identities = Identity Theft. This equation can be viewed as a social cycle, which seems to have developed in response to the realities of identity worship in general.[2]

MG: But because the sculptures are often connected through polystyrene and other materials tie everything together — they are nevertheless something 'unified'?

RH: Heaven is not any kind of Disneyland; heaven is in the midst of you because the place where you are becomes God's dwelling place and the dwelling place of your parents.[3]

MG: Can we simplify things radically and state that the support material stands for culture at large, and the objects stand for the endless loops and repetitions in it?

RH: To build a house you start with a roof.[4]

MG: You don't want to transform consumer goods and objects into something else, as you said a couple of times. But can they represent themselves at the same time as being art?

RH: Mr. Clean gets rid of dirt and grime and grease in just a minute, Mr. Clean will clean your whole house and everything that's in it.[5]

MG: Is this also true if we speak about the sunsets in your photography series?

RH: Sunsets. Ugh. This was a great place for some seafood and a nice glass of wine or a drink several years ago when they opened. Now, it's confusing. Bar? Fine dining? Which is it? Personally, I think Sunsets would do best to just be a basic place: raw bar, bar food and drink specials. Stick to the happy hour crowd. Get in people for football and fun times. Lose the pretense and you will be on the right track.[6]

MG: Has the tendency to give your works a personal note through the titles decreased a bit over the last few years?

RH: Well we can't take it this week. And her friends don't want another speech. Hoping for a better day to hear what she's got to say. All about that. Personality crisis you got it while it was hot. But now frustration and heartache is what you got.[7]

MG: Is it because your œuvre is already overpopulated?

RH: One of the frequent cries of many on the left is that the world is overpopulated. The latest hysterical outburst on this matter came from Sir David Attenborough, a recent patron of "The Optimum Population Trust." The 86-year-old Attenborough, who has a degree in natural sciences and is a former senior manager of the BBC, is a high priest among earth-worshiping liberals. Attenborough, famous mostly for his *Life* documentaries, declared, "We are a plague on the Earth. It's coming home to roost over the next 50 years or so. It's not just climate change; it's sheer space, places to grow food for this enormous horde. Either we limit our population growth or the natural world will do it for us[.]" Nothing could be farther from the truth. When it comes to "sheer space" and "places to grow food," we have barely touched what the earth has available. Given that the earth contains just north of 7 billion people, the entire population of the planet could easily fit into the state of Texas, which contains less than 0.14% of the earth's land area.[8]

MG: Do you have heroes?

RH: I, I wish you could swim. Like the dolphins. Like dolphins can swim.[9]

MG: Have you ever thought about the idea that a screen's flatness has a strong feedback in physical space?

RH: Apple strives to bring the best personal computing experience to students, educators, creative professionals and consumers around the world through its innovative hardware, software and Internet offerings. Apple welcomes your feedback on its products.[10]

MG: Is the outwardly random appearance of your work related to the internet, which seems to make access to all knowledge equivalent?

RH: The most stringent protection of free speech would not protect a man falsely shouting fire in a theatre and causing a panic ... The question in every case is whether the words used are used in such circumstances and are of such a nature as to create a clear and present danger that they will bring about the substantive evils that Congress has a right to prevent. It is a question of proximity and degree.[11]

MG: If you were asked to agree with the idea that your work mirrors cultural conditions in, let's say, 2002, would you say 'yes' with the same volume of voice now, in 2013?

RH: A tribe of herbivorous early hominids is foraging for food in the African desert. A leopard kills one member, and another tribe of man-apes drives them from their

water hole. Defeated, they sleep overnight in a small exposed rock crater, and awake to find a black monolith has appeared in front of them. They approach it shrieking and jumping, and eventually touch it cautiously. Soon after, one of the man-apes realizes how to use a bone as both a tool and a weapon, which they start using to kill prey for their food. Growing increasingly capable and assertive, they reclaim control of the water hole from the other tribe by killing its leader. Triumphant, the tribe's leader throws his weapon-tool into the air as the scene shifts via match cut.[12] [13]

MG: Do you enjoy touching styrofoam?

RH: It's often just enough to be with someone. I don't need to touch them. Not even talk. A feeling passes between you both. You're not alone.[14]

MG: Do you like shopping more than Picasso?

RH: Exactly or as kings. Shutters shut and open so do queens. Shutters shut and shutters and so shutters shut and shutters and so and so shutters and so shutters shut and so shutters shut and shutters and so. And so shutters shut and so and also. And also and so and so and also. Exact resemblance to exact resemblance the exact resemblance as exact as a resemblance, exactly as resembling, exactly resembling, exactly in resemblance exactly a resemblance, exactly and resemblance. For this is so. Because. Now actively repeat at all, now actively repeat at all, now actively repeat at all. Have hold and hear, actively repeat at all. I judge judge.[15]

MG: Are you doing what Marcel Broodthaers would have done today?

RH: Woof.

MG: He played with classification systems, and, of course, the role of the artist. His source material was, like yours, the fabric of the everyday, in his sense very Belgian, for example eggs or mussels.

RH: Miaouw.[16]

MG: Are you a maniac collector?

RH: Woof.

MG: Is it, in the end, really about a good look?

RH: Meow.

MG: Are you a feminist?

RH: Woof.

MG: Do you like to be quoted?

RH: Only when the quotes come from other people.

1 MayoClinic.com.
2 Megan McNally, *Identity Theft in Today's World*,
 Praeger, 2011.
3 Reverend Sun Myung Moon, *Word and Deed*,
 January 30, 1977.
4 Either Franz West or an ancient Chinese saying.
5 Mr. Clean commercial jingle lyrics.
6 Yelp review for Sunsets, 302 S Concourse Avenue,
 Neptune, NJ.
7 New York Dolls, David Johansen/Johnny Thunders,
 Personality Crisis.
8 Trevor Thomas, *The Myth of Overpopulation*,
 http://www.americanthinker.com/2013/02/
 the_myth_of_overpopulation (and a view the author
 of this answer does not share).
9 David Bowie, *Heroes*, 1977.
10 Apple website.
11 Oliver Wendell Holmes Jr., *Schenck v. United States*,
 249 U.S. 47, 52 (3 March 1919).
12 Giulio Angioni, *Fare, dire, sentire: l'identico e il
 diverso nelle culture* (2011), p. 37 and *Un film del
 cuore, in Il dito alzato* (2012), pp. 121-136.
13 Commentators on the film generally assume
 this is a gap of millions, not thousands, of years.
 See Patrick Webster, *Love and Death in Kubrick*,
 McFarland, 2010, 0786459166, 9780786459162,
 p. 47, and Thomas Allen Nelson, *Kubrick, Inside
 a Film Artist's Maze*, Indiana University Press,
 2000, p. 107. ISBN 978-0-253-21390-7. The novel
 gives the age of the monolith on the Moon as
 three million years (Chapter 11, Anomaly) while the
 film dialog and an early draft of the screenplay
 gives it as four million.
14 Marliyn Monroe, from an internet site of quotes
 about touch that are not properly attributed.
15 Gertrude Stein, *If I told Him: A completed Portrait
 of Picasso*. September 1923. Vanity Fair 21, no. 8.
16 Marcel Broodthaers, *Interview with a Cat*, recorded
 at the Musée d'Art Moderne, Département des
 Aigles, Dusseldorf, 1970.

in Strauss's *Die Frau ohne*
Photo: Louis Melançon

Geleitwort der Direktoren
Veit Görner und Philippe Van Cauteren

Gleiches stößt einander angeblich ab, wie wir nicht nur von Sprichwörtern, sondern auch vom Magnetismus kennen. Rachel Harrison scheint sich das künstlerische Spiel mit dieser Regel zur Aufgabe gemacht zu haben: Wir kennen die amorphen Oberflächen von Yves Kleins Schwämmen. Wir kennen die krustendicken Ölbilder von Eugen Leroy, und selbstverständlich kennen wir die berühmtesten Readymades der Kunstgeschichte. Spannend wird es, wenn Künstlerinnen und Künstler über das Verhältnis solcher, scheinbar größter Gegensätzlichkeit nachdenken. Rachel Harrison stellt sich dieser Herausforderung: Sie untersucht die Vermählbarkeit von skulpturaler Form und ihrer Oberfläche, von maximaler Expressivität mit der Dinglichkeit der Readymades, des von Künstlerhand unberührten vorhandenen Objektes. Diese intellektuelle Strategie erlaubt es ihr, enorme Sinnesfreuden in der Betrachtung ihrer Skulpturen hervorzurufen, auf oder an die sie stets Objekte appliziert: bei *All in the family*, 2012, einen Staubsauger in Anspielung auf Jeff Koons' Werke mit Hoover-Staubsaugern – der sich bei dieser Werkserie wiederum die Leuchtstoffröhren der Lichtarbeiten von Dan Flavin einverleibt, also die minimalistische Skulptur mit dem Readymade-Gedanken liiert. Bei *Log*, 2012, begegnen wir einem portionierten Holzstamm, dessen fast symmetrische Seitentriebe so geschnitten sind, dass sie wie ein männliches Geschlechtsteil aussehen – oder aber wie ein weiblicher Torso, der auch keineswegs zufällig an Brâncuşis *Torse de jeune homme* erinnert.

Auf diese Weise widmet sich Rachel Harrison nicht nur dem bildhauerischen Wechselspiel von Farbe und Oberfläche, sondern auch dem Verhältnis von Fotografie und Objekt und weiteren Aufgaben im Rahmen einer Idee von Skulptur, die sich längst vom Monument, vom sprichwörtlichen Sockel der Anbetung, entfernt hat, und in die konsumintensiven Material- und Bilderschlachten unserer Alltagskultur hineinreicht. So hat Harrison ein vielschichtiges und radikales Werk geschaffen, das sich stets auch als veränderbare, dem jeweiligen Kontext angepasste Rauminstallation zeigt.

Im Sinne eines bildhauerischen Kosmos finden sich gerade vor dem Hintergrund der Ausstellungs- und Sammlungsgeschichte des S.M.A.K. viele künstlerische Paten wie etwa Paul Thek, Jason Rhoades oder Cady Noland, aber auch Franz West, um nur einige zu nennen. Doch lässt sich Harrisons Werk eben keinesfalls nur als kunstimmanente Fortschreibung bestehender Genregeschichte betrachten. Vielmehr liest sich Ihr Œuvre auch als seit den 1990er Jahren konsequent durchexerzierte Präambel auf unsere Jetztzeit, eine Gegenwart, in der Maus und Computerscreen wesentliche Orientierungshilfen im Leben darstellen: Geschichte und Entfernung erscheinen auf dem Bildschirm flach und gleichwertig, die gefühlte Räumlichkeit und Körperlichkeit schwindet zugunsten eines gigantischen Plateaus aus allzeit verfügbarem und gefühlt chaotisch übereinandergeschichtetem Material. Gegenwärtige Künstlerinnen und Künstler arbeiten innerhalb eines solchen neuen räumlichen Gefüges eher als Übersetzer zwischen Offline und Online als mit Hammer, Meißel und Pinsel. Und unsere zuweilen bereits als „postdigital" bezeichnete Epoche hat längst eine eigene junge Künstlergeneration hervorgebracht, für die Rachel Harrison als installativ arbeitende Content-Managerin eines der relevantesten Vorbilder überhaupt darstellt. Diesen Zirkelschluss in eine Gegenwart aus lauter Übersetzungen und entsprechenden Fehlleistungen findet sich in zutreffender Weise auf dem Cover dieses Kataloges. Denn auch darum geht es in Harrisons Werk ganz sicher:

Verbindungen herzustellen, kulturelle Transfers und deren Scheitern zu zeigen, zwischen scheinbar willkürlich kombinierten Materialien und Bildern, häufig über die Hervorrufung des aufgeschobenen Witzes, eine Technik, die sie in geradezu meisterhafter Manier beherrscht. In diesem Sinne ist sie zu Recht eine der interessantesten Bildhauerinnen unserer Zeit, der wir dankbar sind, ihre Werke in einer umfassenden Einzelausstellung in Deutschland und erstmals in einer belgischen Institution zeigen zu können.

Den Autoren Diedrich Diederichsen, Susanne Figner, Martin Germann und Alex Kitnick danken wir sehr herzlich für ihre gelungenen Katalogbeiträge, die unter verschiedensten Aspekten das Werk von Rachel Harrison beleuchten und einordnen. Nicht zuletzt danken wir Susanne Figner, die die Ausstellung ebenso mit Bravour kuratiert hat, wie sie den Ausstellungskatalog betreut hat, sowie Martin Germann, der das Projekt auf die örtlichen Gegebenheiten in Gent hin angepasst hat.

Veit Görner, kestnergesellschaft Philippe Van Cauteren, S.M.A.K.

Dank

Zuerst möchten wir Rachel Harrison sehr herzlich für die Zusammenarbeit danken, ohne deren Engagement, Humor und Professionalität dieses Projekt nicht möglich gewesen wäre.

Ebenso herzlich möchten wir uns bei der Galerie Greene Naftali bedanken, insbesondere bei Carol Greene, Alexandra Tuttle, Martha Fleming-Ives und Linda Yun, ohne deren großzügige Unterstützung die Ausstellungen und der begleitende Katalog heute nicht hier wären. Zu danken haben wir den Leihgebern, dem Guggenheim Museum, New York, dem Museum of Contemporary Art, MCA Chicago, sowie allen privaten Leihgebern.

Danken möchte die kestnergesellschaft auch sehr herzlich der Niedersächsischen Sparkassenstiftung, der Sparkasse, dem Förderkreis der kestnergesellschaft und unserem jungen Förderkreis, kunstkomm für die großzügige finanzielle Unterstützung.

Directors' Note
Veit Görner and Philippe Van Cauteren

Opposites attract: we know that not only from the popular saying, but also from the law of magnetism. Rachel Harrison seems to have focused her artistic play on this rule. We know the amorphous surfaces of Yves Klein's sponges. We know the crusty oil paintings of Eugene Leroy, and of course we are familiar with the famous readymades of art history. It is exciting when artists think about relationships between things that seem to be so opposite. Rachel Harrison takes on this challenge: she explores the possible combinations of sculptural form and a surface's maximal expressivity with the thingness of the readymade, the object untouched by the artist. This intellectual strategy makes it possible to evoke enormous sensual pleasure in considering her sculptures, to which she applies objects of various kinds. In *All in the Family* (2012), a vacuum cleaner alludes to Jeff Koons' works using Hoover vacuum cleaners, a series which incorporates the fluorescent light tubes of Dan Flavin's light works, linking minimalist sculpture with the idea of the readymade. In *Log* (2012), we encounter a natural log with almost symmetrical side branches cut to look like male genitalia, or like a female torso recalling Constantin Brâncuşi's *Torse de jeune homme*, no means by accident. In this way, Harrison not only tackles the sculptural interplay of color and surface, but also the relationship between photograph and object and other tasks generated by notions of a sculpture that has long since departed from the monument, dismounted from the proverbial pedestal of worship, and entered the consumerist material and pictorial battles of everyday culture. Harrison has thus created a multilayered, radical œuvre that always emerges as spatial installations that can be altered to fit the context in question.

In the sense of the sculptural cosmos, many inspirations could be mentioned, particularly against the backdrop of the exhibition and collection history of S.M.A.K: Paul Thek, Jason Rhoades, Cady Noland, but also Franz West, to name a few. And yet Harrison's work should by no means only be seen as an art-immanent continuation of extant genre history. It should be read as a preamble of the present that has been worked on consistently since the 1990s, a present in which the mouse and computer screen represent key points of orientation. History and distance appear on the screen as flat and of equal importance; felt spatiality and physicality disappear in favor of a gigantic plateau with materials that are constantly accessible and seem chaotically piled up on top of one another. Contemporary artists work within this spatial arrangement as translators between the offline and online, rather than working with the hammer, chisel, or brush. And our current age, already labeled 'post-digital', has long since brought about a generation of its own young artists, and Rachel Harrison, as an installation maker and manager of content, is one of that generation's most relevant models. The short circuit in a present of countless translations and resulting blunders can be found fittingly depicted on the cover of this catalogue. For this is also what Harrison's work is about: creating links and showing cultural transfers and their failures between apparently arbitrarily combined materials and images, often by evoking a delayed joke, a technique she has mastered. In this sense, she is rightly considered one of the most interesting sculptors of our time, and we are very grateful to be able to present her work in a comprehensive exhibition in Germany and in her first solo show at a Belgian institution.

Our thanks go to Diedrich Diederichsen, Susanne Figner, Martin Germann, and Alex Kitnick for their catalogue contributions, which examine Rachel Harrison's work from

various angles. We are also grateful to Susanne Figner for curating the exhibition with the same bravura with which she managed the exhibition catalogue, and to Martin Germann, who adapted the project to the local situation in Ghent.

Veit Görner, kestnergesellschaft Philippe Van Cauteren, S.M.A.K.

Acknowledgements

First of all, our heartfelt thanks go to Rachel Harrison for her collaboration: without her commitment, humor, and professionalism, this project would not have been possible.

We would also like to thank very much Greene Naftali, New York, especially Carol Greene, Alexandra Tuttle, Martha Fleming-Ives, and Linda Yun, whose support was essential in putting together the exhibitions and accompanying catalogue. Our warm thanks go to the lenders as well: New York's Guggenheim Museum, the Museum of Contemporary Art in Chicago, and all private lenders.

Kestnergesellschaft would also like to offer special thanks to Niedersächsische Sparkassenstiftung, Sparkasse, Förderkreis der kestnergesellschaft, and kunstkomm, our young supporters association, for their generous financial support.

Index

The Help, 2012

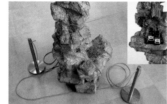

Lazy Hardware, 2012

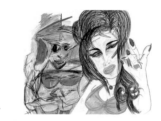

Untitled, 2012

Untitled, 2012

Wandering Jew, 2012

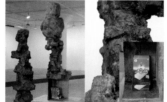

Mastro Lindo, 2012

Untitled, 2012

The Death of Ironing, 2012

Valid Like Salad, 2012

Untitled, 2011

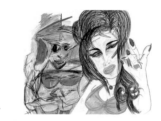

Untitled, 2011

Hoarders, 2012

Untitled, 2012

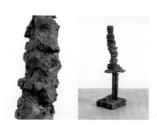

Log, 2012

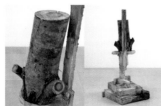

The Line of Beauty, 2012

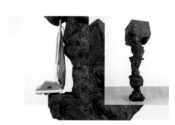

All in the Family, 2012

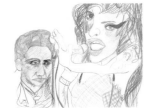
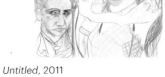

Untitled, 2011

Newt, 2012

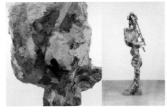

HOJOTOHO, 2012

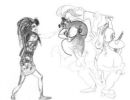

Untitled, 2012

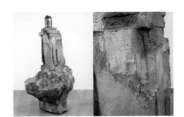

Syntha-6, 2012

Untitled, 2012

Untitled, 2012

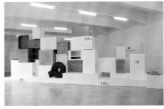

Incidents of Travel in Yucatan, 2011

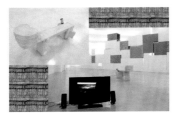

Benched, 2011

BP Video stills, 2011

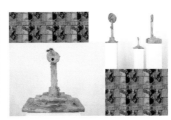

Winner Takes All, 2011

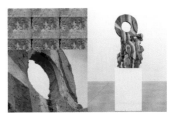

Ah Pitzlaw, 2011

Hoop, 2011

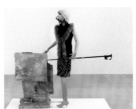

The Duck Hunter, 2012

Werkliste / List of Works

Werke in der Ausstellung / Exhibition Checklist

The Help, 2012
Archival pigment print
22 3/4 × 17 3/4 × 1 1/2 inches
57.8 × 45.1 × 3.8 cm
Edition of 6, + 3 APs
Courtesy of the artist and
Greene Naftali, New York

Wandering Jew, 2012
Wood, acrylic, plaster bust,
ceramic peppers, chair, carpet, and
plastic crates with studio materials
70 × 60 × 22 inches
177.8 × 152.4 × 55.9 cm
Defares Collection

Mastro Lindo, 2012
Wood, polystyrene, cement, acrylic,
and Mr. Clean Magic Erasers
97 × 29 × 43 inches
246.4 × 73.7 × 109.2 cm
Collection Museum of Contem-
porary Art Chicago, Gift of Mary
and Earle Ludgin by exchange

Valid Like Salad, 2012
Wood, polystyrene, cement, acrylic,
framed digital print, and dog collar
82 × 46 × 48 inches
208.3 × 116.8 × 121.9 cm
Courtesy of the artist and
Greene Naftali, New York

Hoarders, 2012
Wood, polystyrene, chicken wire,
cement, cardboard, acrylic,
metal pail, flat screen monitor,
wireless headphones, video, color,
sound, 10:39 min, and purple
runway carpet
Overall dimensions variable
(sculptural component)
61 × 47 × 45 inches
154.9 × 119.4 × 114.3 cm
Private Collection, New York

Log, 2012
Wood, cement, acrylic, and log
44 × 18 × 17 inches
111.8 × 45.7 × 43.2 cm
Private Collection, New York

The Line of Beauty, 2012
Wood, polystyrene, cement,
and acrylic
57 × 18 × 15 inches
144.8 × 45.7 × 38.1 cm
Collection Alexandre and
Lori Chemla

All in the Family, 2012
Wood, polystyrene, cement,
chicken wire, acrylic, and Hoover
vacuum cleaner
93 × 34 × 34 inches
236.2 × 86.4 × 86.4 cm
Solomon R. Guggenheim
Museum, New York
Purchased with funds contributed
by the International Directors
Council, 2012
2012.126

Syntha-6, 2012
Wood, polystyrene, chicken wire,
cement, acrylic, and Syntha-6
74 × 42 × 40 inches
188 × 106.7 × 101.6 cm
Courtesy of the artist and Greene
Naftali, New York

Untitled, 2012
Colored pencil on paper
22 3/8 × 27 7/8 × 1 1/2 inches
56.8 × 70.8 × 3.8 cm
Courtesy of the artist and
Galerie Meyer Kainer, Vienna

Untitled, 2012
Colored pencil on paper
22 3/8 × 27 7/8 × 1 1/2 inches
56.8 × 70.8 × 3.8 cm
Courtesy of the artist and Greene
Naftali, New York

Untitled, 2011
Colored pencil on paper
22 3/8 × 27 7/8 × 1 1/2 inches
56.8 × 70.8 × 3.8 cm
Courtesy of the artist and
Regen Projects, Los Angeles

Untitled, 2011
Colored pencil on paper
22 3/8 × 27 7/8 × 1 1/2 inches
56.8 × 70.8 × 3.8 cm
Courtesy of the artist

Untitled, 2011
Colored pencil on paper
22 3/8 × 27 7/8 × 1 1/2 inches
56.8 × 70.8 × 3.8 cm
Courtesy of the artist

Untitled, 2012
Colored pencil on paper
22 3/8 × 27 7/8 × 1 1/2 inches
56.8 × 70.8 × 3.8 cm
Courtesy of the artist

Incidents of Travel in Yucatan, 2011
Mixed media including pedestals,
sculptures, Pacifico six-pack,
vinyl wall text, and *BP* video, color,
sound, 30:01 min (2011)
(wall dimensions)
137 × 402 3/4 × 59 7/8 inches
348 × 1023 × 152 cm
Courtesy of the artist and Greene
Naftali, New York

Benched, 2011
Wood, polystyrene, cement,
acrylic, and beer bottle
26 × 55 1/4 × 19 3/4 inches
66 × 140 × 50 cm
Courtesy of the artist and Greene
Naftali, New York

BP, 2011
Video, color, sound
30:01 min
Courtesy of the artist and Greene
Naftali, New York

Winner Takes All, 2011
Wood, polystyrene, cement,
acrylic, meat tenderizer, kitchen
timer, and fake eyelashes
Overall dimensions variable
Courtesy of the artist and
Greene Naftali, New York

Ah Pitzlaw, 2011
Wood, polystyrene, cement,
and acrylic
85 × 33 × 36 inches
216 × 84 × 91 cm
Courtesy of the artist and
Greene Naftali, New York

Hoop, 2011
Wood, polystyrene, cement,
and acrylic
24 × 4 3/4 × 27 1/8 inches
61 × 12 × 69 cm
Courtesy of the artist and
Greene Naftali, New York

Sunset Series, 2000–2012
Set of 31 c-prints
(overall dimensions framed)
14 3/8 × 600 × 1 inches
36.5 × 1524 × 2.5 cm
Edition of 3, + 2 APs
Courtesy of the artist; Greene
Naftali, New York; Galerie Meyer
Kainer, Vienna; and Regen
Projects, Los Angeles

The Duck Hunter, 2012
Wood, polystyrene, cement,
acrylic, mannequin, Dick Cheney
mask, fabric, feather boa,
sunglasses, glasses, and ski pole
69 5/8 × 75 × 33 inches
176.8 × 190.5 × 83.8 cm
Courtesy of the artist and
Greene Naftali, New York

Zusätzliche Abbildungen / Additional Works

Lazy Hardware, 2012
Wood, polystyrene, cement,
acrylic, metal stanchions, cord,
and glass bottles
97 × 54 × 43 inches
246.4 × 137.2 × 109.2 cm

Untitled, 2012
Colored pencil on paper
22 3/8 × 27 7/8 × 1 1/2 inches
56.8 × 70.8 × 3.8 cm

Untitled, 2012
Colored pencil on paper
22 3/8 × 27 7/8 × 1 1/2 inches
56.8 × 70.8 × 3.8 cm

Untitled, 2012
Colored pencil on paper
22 3/8 × 27 7/8 × 1 1/2 inches
56.8 × 70.8 × 3.8 cm

The Death of Ironing, 2012
Polystyrene, cement, acrylic,
carpet sweeper, and purple
runway carpet
Overall dimensions variable
(sculptural component)
55 × 47 × 32 inches
139.7 × 119.4 × 81.3 cm

Untitled, 2011
Colored pencil on paper
22 3/8 × 27 7/8 × 1 1/2 inches
56.8 × 70.8 × 3.8 cm

Untitled, 2011
Colored pencil on paper
22 3/8 × 27 7/8 × 1 1/2 inches
56.8 × 70.8 × 3.8 cm

Untitled, 2012
Colored pencil on paper
22 3/8 × 27 7/8 × 1 1/2 inches
56.8 × 70.8 × 3.8 cm

Untitled, 2011
Colored pencil on paper
22 3/8 × 27 7/8 × 1 1/2 inches
56.8 × 70.8 × 3.8 cm

Newt, 2012
Wood, polystyrene, cement, acrylic,
Theo Klein Cleaning Trolley, and
construction helmet
57 × 32 × 24 inches
144.8 × 81.3 × 61 cm

HOJOTOHO, 2012
Wood, polystyrene, cement, acrylic,
and auger
95 × 23 × 25 inches
241.3 × 58.4 × 63.5 cm

Untitled, 2012
Colored pencil on paper
22 3/8 × 27 7/8 × 1 1/2 inches
56.8 × 70.8 × 3.8 cm

Untitled, 2012
Colored pencil on paper
22 3/8 × 27 7/8 × 1 1/2 inches
56.8 × 70.8 × 3.8 cm

Untitled, 2012
Colored pencil on paper
22 3/8 × 27 7/8 × 1 1/2 inches
56.8 × 70.8 × 3.8 cm

Marcel Duchamp,
*Manual of Instructions for
the assembly of Étant donnés:
1° la chute d'eau, 2° le gaz
d'éclairage*, 1966
Black vinyl binder with gelatin
silver photographs, drawings, and
manuscript notes on paper and
on photogaphs in graphite, colored
inks, and paint in clear vinyl sheet
protectors
11 5/8 × 9 13/16 × 1 3/4 inches
29.5 × 25 × 4.5 cm
Philadelphia Museum of Art: Gift
of the Cassandra Foundation, 1969

Biografie / Biography

Geboren / Born 1966 in New York
Lebt und arbeitet / Lives and works
in Brooklyn, New York

Einzelausstellungen / Solo Exhibitions

2013 *Fake Titel*, curated by Susanne Figner,
kestnergesellschaft, Hannover; traveled to
S.M.A.K., Gent, curated by Martin
Germann (catalogue)
Villeperdue, Galerie Meyer Kainer, Vienna

2012 *The Help*, Greene Naftali Gallery, New York

2010 *Asdfjkl;*, Regen Projects, Los Angeles
Conquest of the Useless, curated by Iwona
Blazwick, Whitechapel Gallery, London
(catalogue)

2009 *HAYCATION*, curated by Daniel Birnbaum and
Melanie Ohnemus, Portikus, Frankfurt am Main
(catalogue)
Consider the Lobster, curated by Tom Eccles,
Center for Curatorial Studies, Hessel Museum,
Bard College, Annandale-on-Hudson,
New York (catalogue)

2008 *Sunny Side Up*, Galerie Meyer Kainer, Vienna
Lay of the Land, curated by Franck Gautherot,
Le Consortium, Dijon

2007 *Voyage of the Beagle*, curated by Heike Munder,
Migros Museum für Gegenwartskunst, Zurich;
traveled to Kunsthalle Nürnberg, Nuremburg,
curated by Ellen Seifermann (catalogue)
If I Did It, Greene Naftali Gallery, New York

2006 *sometimes it snows in april* (presentation
with Michael Krebber), The McAllister Institute,
New York
*Checking the Tires, Not To Mention the Marble
Nude*, Galerie Christian Nagel, Cologne
When Hangover Becomes Form, in collaboration
with Scott Lyall, The Contemporary Art Gallery,
Vancouver; traveled to LACE, Los Angeles

2005 *Car Stereo Parkway*, Transmission Gallery, Glasgow

2004 *New Work*, curated by Jill Dawsey, San Francisco
Museum of Modern Art, San Francisco
Latka/Latkas, Greene Naftali Gallery, New York

Posh Floored as Ali G Tackles Becks, curated by
Jenny Lomax, Camden Arts Centre, London;
traveled to Arndt & Partner, Berlin (catalogue)

2003 *Westward Ho*, curated by Bjarne Melgaard,
Bergen Kunsthall, Gallery No. 5, Bergen

2002 *Currents 30: Rachel Harrison*, curated
by Stefano Basilico, Milwaukee Art Museum,
Milwaukee, Wisconsin (catalogue)
Brides and Bases, curated by Ben Portis,
Oakville Galleries, Toronto (catalogue)
Seven Sculptures, Arndt & Partner, Berlin

2001 *Perth Amboy*, Greene Naftali Gallery, New York

1999 *Patent Pending: Beveled Rasp Sac*, Greene Naf-
tali Gallery, New York

1997 *The Look of Dress-Separates*, Greene Naftali
Gallery, New York

1996 *Should home windows or shutters be required
to withstand a direct hit from an eight-foot-long
two-by-four shot from a cannon at 34 miles
an hour, without creating a hole big enough to
let through a three-inch sphere?*,
Arena Gallery, Brooklyn

Ausgewählte Gruppenausstellungen / Selected Group Exhibitions

2014 *Post-Picasso: Contemporary Artists'
Responses to His Life and Art*, curated by
Michael FitzGerald, Museu Picasso,
Barcelona (catalogue)

2013 *Collagierte Skulpturen*, curated by Zdenek Felix,
KAI 10, Dusseldorf (catalogue)
Nasher Xchange, Dallas City Hall Plaza,
Nasher Sculpture Center, Dallas,
Texas (catalogue)
Once again the world is flat, curated by
Haim Steinbach, Center for Curatorial Studies,
Hessel Museum, Bard College,
Annandale-on-Hudson, New York
Film as Sculpture, curated by Elena Filipovic,
WIELS Contemporary Art Centre, Brussels
*NYC 1993: Experimental Jet Set, Trash
and No Star*, curated by Massimiliano Gioni
and Gary Carrion-Murayari, New Museum,
New York (catalogue)

2012 *Once Removed: Sculpture's Changing Frame of Reference*, Yale University Art Gallery, New Haven, Connecticut
Blues for Smoke, curated by Bennett Simpson, The Museum of Contemporary Art, Los Angeles; traveled to Whitney Museum of American Art, New York; Wexner Center for the Arts, Columbus, Ohio (catalogue)
Migros meets Museion. 20th Century Remix, curated by Letizia Ragaglia in collaboration with Heike Munder and Judith Welter, Museion, Bolzano
To Be With Art Is All We Ask, Astrup Fearnley Museum, Oslo
Imagination Adrift, Palais de Tokyo, Paris
Beyond Imagination, curated by Martijn van Nieuwenhuyzen and Kathrin Jentjens, Stedelijk Museum, Amsterdam
Decade: Contemporary Collecting, 2002–2012, Albright-Knox Art Gallery, Buffalo, New York (catalogue)
ZOO, curated by Marie Fraser & François LeTourneux, Musée d'art contemporain de Montréal, Montreal (catalogue)
The Institute of Contemporary Art Collection Show, The Institute of Contemporary Art/Boston
Utopia/Dystopia: Constructed with Photography, curated by Yasufumi Nakamori, Museum of Fine Arts, Houston, Texas (catalogue)

2011 *Universes in Universe*, Astrup Fearnley Museum Collection at the São Paulo Biennial Pavilion, São Paulo
Exposition d'Ouverture, Le Consortium, Dijon
Absentee Landlord, curated by John Waters, Walker Art Center, Minneapolis, Minnesota
Schnitte im Raum, Skulpturale Collagen, curated by Fritz Emslander and Markus Heinzelmann, Museum Morsbroich, Leverkusen (catalogue)
So machen wir es / That's the way we do it, curated by Yilmaz Dziewior, Kunsthaus Bregenz, Bregenz (catalogue)
Rachel Harrison/Scott Lyall: Double Yolk, Galerie Christian Nagel, Antwerp
Human Nature: Contemporary Art from the Collection, Los Angeles County Museum of Art, Los Angeles
Notations/Everyday Disturbances, Philadelphia Museum of Art, Philadelphia
The Spectacular of Vernacular, curated by Darsie Alexander, Walker Art Center, Minneapolis, Minnesota; traveled to Contemporary Arts Museum Houston, Texas; Montclair Art Museum, Montclair, New Jersey; Ackland Art Museum, Chapel Hill, North Carolina (catalogue)
Modern British Sculpture, curated by Penelope Curtis and Keith Wilson, Royal Academy of Arts, London (catalogue)

2010 *Ordinary Madness*, curated by Dan Byers, Carnegie Museum of Art, Pittsburgh, Pennsylvania (catalogue)
Fotoskulptur: die Fotografie der Skulptur 1839 bis heute / The Original Copy: Photography of Sculpture, 1839 to Today, curated by Roxana Marcoci, Museum of Modern Art, New York; traveled to Kunsthaus Zürich, Zurich
Pictures by Women: A History of Modern Photography, curated by Roxana Marcoci, Museum of Modern Art, New York (catalogue)
Haunted: Contemporary Photography/Video/Performance, curated by Jennifer Blessing, Solomon R. Guggenheim Museum, New York; traveled to Guggenheim Museum Bilbao (catalogue)
Abstract Resistance, curated by Yasmil Raymond, Walker Art Center, Minneapolis, Minnesota (catalogue)

2009 *A Few Frames: Photography and the Contact Sheet*, curated by Elisabeth Sussman and Tina Kukielski, Whitney Museum of American Art, New York
For the blind man in the dark room looking for the black cat that isn't there, curated by Anthony Huberman, Contemporary Art Museum, St. Louis; traveled to Institute of Contemporary Arts, London; Museum of Contemporary Art Detroit, Michigan; de Appel Arts Centre, Amsterdam; Culturgest, Lisbon (catalogue)
Collecting History: Highlighting Recent Acquisitions, curated by Ann Goldstein and Bennett Simpson, The Museum of Contemporary Art, Los Angeles
Making Worlds, 53rd Venice Biennale, curated by Daniel Birnbaum, Italian Pavilion, Venice (catalogue)
Practice, Practice, Practice, curated by Michael Smith and Jay Sanders, Lora Reynolds Gallery, Austin, Texas
phot(o)bjects, curated by Bob Nickas, Presentation House Gallery, Vancouver
N'importe quoi, curated by Vincent Pécoil and Olivier Vadrot, Musée d'art contemporain de Lyon, Lyon

Altermodern, Tate Triennial, curated by
Nicolas Bourriaud, Tate Britain,
London (catalogue)

2008 *Front Room: Dieter Roth and Rachel Harrison*,
curated by Darsie Alexander, Baltimore Museum
of Art, Baltimore, Maryland (catalogue)
The Alliance, curated by Seung-duk Kim and
Franck Gautherot, doART, Beijing; traveled to
doART, Seoul (catalogue)
Plug In #38, curated by Lily van der Stokker,
Van Abbemuseum, Eindhoven
Whitney Biennial, curated by Henriette Huldisch
and Shamim M. Momin, Whitney Museum of
American Art, New York (catalogue)

2007 *Paul Thek. Werkschau im Kontext zeitgenössi-
scher Kunst / Paul Thek in the Context of
Today's Contemporary Art*, curated by Roland
Groenenboom and Gregor Jansen, Zentrum
für Kunst und Medientechnologie, Karlsruhe;
traveled to Sammlung Falckenberg, Hamburg
(catalogue)
*Perspectives 159: Superconscious,
Automatisms Now*, curated by Paola Morsiani,
Contemporary Arts Museum Houston, Texas
Unmonumental: The Object in the 21st Century,
curated by Richard Flood, Laura Hoptman
and Massimiliano Gioni, New Museum,
New York (catalogue)
The Hamsterwheel, curated by Franz West
Studio, Arsenale di Venezia, Venice; traveled
to Festival de Printemps de Septembre,
Toulouse; Centre d'Art Santa Mònica, Barcelona;
Malmö Konsthall, Malmö
*Hidden in Plain Sight: Contemporary
Photographs from the Collection*,
The Metropolitan Museum of Art, New York

2006 *The Uncertainty of Objects and Ideas:
Recent Sculpture*, curated by Anne Ellegood,
Hirshhorn Museum and Sculpture Garden,
Washington, DC (catalogue)
Shiny, curated by Helen Molesworth,
Wexner Center for the Arts,
Columbus, Ohio
Of Mice and Men, The 4th Berlin Biennale,
curated by Maurizio Cattelan,
Massimiliano Gioni and Ali Subotnick,
Kunst-Werke Institute for Contemporary Art,
Berlin (catalogue)
Dark, curated by Jan Grosfeld and Rein Wolfs,
Museum Boijmans Van Beuningen,
Rotterdam (catalogue)

2005 *When Humor Becomes Painful*, curated
by Heike Munder and Felicity Lunn,
Migros Museum für Gegenwartskunst,
Zurich (catalogue)
fünfmalskulptur, curated by Carina Plath,
Westfälischer Kunstverein, Münster

2004 *54th Carnegie International*, curated by Laura
Hoptman, Carnegie Museum of Art, Pittsburgh,
Pennsylvania (catalogue)
Home, curated by Patterson Beckwith, American
Fine Arts, Co., New York
*Speaking with Hands: Photographs from The
Buhl Collection*, curated by Jennifer Blessing,
Solomon R. Guggenheim Museum, New York
(catalogue)
Open House: Working in Brooklyn, curated
by Charlotta Kotik and Tumelo Mosaka, Brooklyn
Museum of Art, Brooklyn (catalogue)
*Reordering Reality: Collecting Contemporary
Art*, curated by Annegreth T. Nill, Columbus
Museum of Art, Columbus, Ohio
*Building the Collection: New and Future
Acquisitions*, Art Gallery of Ontario, Toronto

2003 *The Inconsiderable Things*, Brighton Photo
Biennial, curated by Jeremy Millar,
University of Brighton
The Structure of Survival, curated by Carlos
Basualdo, Arsenale di Venezia, *Dreams and
Conflicts: The Dictatorship of the Viewer*,
50th Venice Biennale, Venice (catalogue)

2002 *Stories*, curated by Stephanie Rosenthal,
Haus der Kunst, Munich (catalogue)
Building Structures, curated by Klaus
Biesenbach, MoMA PS1 Contemporary Art
Center, Long Island City, New York
Whitney Biennial, curated by Lawrence Rinder,
Whitney Museum of American Art,
New York (catalogue)

2000 *Walker Evans & Company*, curated by Peter
Galassi, Museum of Modern Art, New York;
traveled to J. Paul Getty Museum, Los Angeles
(catalogue)
Greater New York: New Art in New York Now,
curated by Klaus Biesenbach, Carolyn Christov-
Bakargiev and Alanna Heiss, MoMA PS1
Contemporary Art Center, Long Island City,
New York (catalogue)
Photography about Photography, curated by
Liz Deschenes, Andrew Kreps Gallery,
New York

Photasm: Sculptors Using Photography,
curated by Peter Dudek, Arts Atrium Gallery,
Union College, Schenectady, New York;
traveled to Hunter College/Times
Square Gallery, New York (catalogue)

1999 *DOPE. An XXX-Mas Show*, American Fine
Arts, Co., New York
Still Life, curated by Helen Molesworth,
State University of New York College at Old
Westbury, Old Westbury, New York
New York Neither/Nor, curated by Bill Arning,
Grand Arts, Kansas City, Missouri

1998 *New Photography 14*, curated by Darsie
Alexander, Museum of Modern Art,
New York
Science, Feature Inc., New York
Lo-Fi Baroque, curated by Michael Sarff
and Carol Stakenas, Thread Waxing Space,
New York (catalogue)

1997 *TXInstallations/Projects*, MoMA PS1
Contemporary Art Center, Long Island City,
New York
Current Undercurrent: Working in Brooklyn,
curated by Charlotta Kotik, Brooklyn Museum
of Art, Brooklyn

1996 *Facing The Millennium: The Song Remains
The Same*, curated by Kenny Schachter,
Arlington Museum of Art
DISSOCIATIONISM, Four Walls, Brooklyn
Shit, Baron Boisante Gallery, New York
Space, Mind, Place, curated by John Connelly
and Michelle Reyes, Andrea Rosen Gallery,
New York
Rachel Harrison and Michael Lazarus, Feature
Inc., New York

1995 *Oy!*, curated by Kenny Schachter, 121 Greene
Street, New York
Looky Loo, curated by Kenny Schachter,
SculptureCenter, Long Island City, New York

1994 *Tight*, curated by Keith Wilson and
Richard Woods, Tannery Arts, 57 Bermondsey
Street, London
I Could Do That, curated by Kenny Schachter,
109 Spring Street, New York

1993 *TRESSPASS: Beyond Borders*, curated
by Donald O. Odita, The Right Bank, 409 Kent
Avenue, Brooklyn

*1920: The Subtlety of Subversion, The
Continuity of Intervention*, Exit Art, New York
Simply Made in America, curated by Barry
Rosenberg, Aldrich Museum of Contemporary
Art, Ridgefield, Connecticut; traveled to
Contemporary Arts Center, Cincinnati, Ohio;
Butler Institute of American Art, Youngstown,
Ohio; Palm Beach Community College of Art,
Palm Beach, Florida; Delaware Art Museum,
Wilmington, Delaware (catalogue)

1992 *7 Rooms, 7 Shows, Binging*, curated by
Kenny Schachter, MoMA PS1 Contemporary
Art Center, Long Island City, New York

1991 *Unlearning*, curated by Kenny Schachter, 142
Greene Street, New York
*The Neurotic Art Show, group show comprising
the first fifty-five callers to a designated phone
number*, Four Walls Gallery, Brooklyn

Impressum / Colophon

kestnergesellschaft
Goseriede 11
30159 Hannover
Deutschland / Germany
Fon +49 (0) 511 70120 0
Fax +49 (0) 511 70120 20
kestner@kestnergesellschaft.de
www.kestnergesellschaft.de

Vorstand / Members of the Board
Uwe H. Reuter
(1. Vorsitzender | Chairman)
Herbert K. Haas
(2. Vorsitzender | Vice Chairman)
Dr. Michael Kunst
(Schatzmeister | Treasurer)
Dr. Thomas Noth
(Schriftführer | Secretary)
Herbert Flecken
Eckhard Forst
Dr. Peter Thormann
Dr. Sandra Lüth
Inga Samii
Dr. Immanuel Hermreck
Thomas Düffert

Kuratorium / Advisory Board
Herbert K. Haas
(Vorsitzender | Chairman)
Dr. Carl Haenlein
(Ehrenmitglied | Honorary Member)
Dr. Stella A. Ahlers
R. Claus Bingemer
Dr. Volker Böttcher
Dr. Max-Georg Büchner
Norbert H. Essing
Dipl.-Ing. Michael G. Feist
Dr. Friedhelm Haak
Sepp D. Heckmann
Dr. Immanuel Hermreck
Albrecht Hertz-Eichenrode
Michael Hocks
Hermann Kasten
Walter Kleine
Hans Künzle
Klaus Laminet
Sylvia von Metzler
Volker Müller
Günter Papenburg
Prof. Dr. Hannes Rehm
Andreas Schober
Jörg Schubert
Elke Strathmann
Dr. Bernd Thiemann

Dr. Peter Thormann
Stephan Weil
Wilhelm Zeller

Direktor / Director
Dr. Veit Görner

Ausstellung / Exhibition
Rachel Harrison »Fake Titel«

Geschäftsführerin /
Managing Director
Mairi Kroll

Kurator/Innen / Curators
Heinrich Dietz, Susanne Figner,
Antonia Lotz

Presse- und Öffentlichkeitsarbeit /
Public Relations
Konstantin Wenzel

Marketing
Hendrik Bartels

Rechnungswesen /
Accounting Department
Florian Hanebutt, Hartmut Jahnel,
Dr. Brigitte Kirch, Petra Lücke,
Uwe Meyer

Ausstellungstechnik,
Betriebstechnik / Installation,
Technical Resources
Jörg-Maria Brügger, Rainer Walter

Mitgliederverwaltung /
Member Administration
Sabine Sauermilch

Administration Förderkreise /
Administration Patrons' Circles
Sinje Schwammbach

Unterstützung Förderkreise /
Support Patrons' Circles
Maria-Isabel Rössel

Empfang / Front Desk
Germaine Mogg, Angela Pohl

Recherche Editionen
und Geschichte / Research
Editions and History
Dorothee Schniewind

kestnerlabor Praktikanten / Interns
Paul Joshua Adlung
Cay Cordes
Sarah Langhorst
Lisa-Marie Meyer
Julia Schäfer
Henning Schlüter

Firmenmitglieder /
Company Members
Ahlers AG
Architekten BKSP
Bahlsen GmbH & Co. KG
Bantleon AG
Bertelsmann SE & Co. KG aA
R. Claus Bingemer
Continental AG
Deloitte
Deutsche Messe AG
ars mundi Edition Max Büchner
Norbert Essing Kommunikation
GmbH
HANNOVER Finanz GmbH
Hannover Rückversicherung AG
Institut der Norddeutschen
Wirtschaft e.V.
Investa Projektentwicklungs- und
Verwaltungsgesellschaft mbH
Bankhaus Metzler seel. Sohn und Co.
Nationale Suisse
KIND
NORD/LB
Sal. Oppenheim jr. & Cie. AG & Co.
KGaA
GP Günter Papenburg AG
Sparkasse Hannover
Stadtwerke Hannover AG
Mediengruppe Madsack
VGH Versicherungen
VHV Gruppe
Gerhard D. Wempe KG
Witte Projektmanagement GmbH

Partner / Partners
Aserto
Blumen am Aegi
BREE in der Galerie Luise
Finanz Informatik
klartxt
Neuwaerts
Sektkellerei Duprès-Kollmeyer

Das Land Niedersachsen fördert
die kestnergesellschaft / The
kestnergesellschaft is supported by
the Federal State of Lower Saxony

 Niedersächsisches Ministerium
für Wissenschaft und Kultur

Die Ausstellung wird gefördert von
der Stiftung Niedersachsen sowie
unterstützt vom Förderkreis der
kestnergesellschaft.

 Niedersächsische
Sparkassenstiftung

 Sparkasse
Hannover
 kunstkomm

 kestner
gesellschaft
 förderkreis
kestnergesellschaft

Kulturpartner

 NDRkultur

S.M.A.K.
Citadelpark
9000 Ghent
Belgium
Fon +32 (0) 922 117 03
Fax +32 (0) 922 171 09
www.smak.be

 S.M.A.K.

Strukturelle Partner /
Structural partners:

 STAD GENT

Firmen / Companies:

 Levis
let's colour
 DJN

Medienpartner / Media partners:

 Klara
CO
BRA.be

Knack

www.kunsthart.org

Künstlerischer Direktor /
Artistic Director
Philippe Van Cauteren

Geschäftsführer /
Managing Director
Philippe Vandenweghe

Staff
Katrien Blanchaert, Rom Bohez,
Aziz Boukhzar, Dominique Cahay,
Alexandr Caradjov, Thomas Caron,
Suzy Castermans, Virginie
De Clercq, Tashina De Ketele,
Natan De Rijcke, Filip De Poortere,
Tineke De Rijck, Catherine De Smet,
Eva De Winter, Lotte De Voeght,
Marleen Deceukelier, Michel
Delabarre, Veronique Despodt,
Anna Drijbooms, Eric Elet, Annie
Expeels, Martin Germann, Leen
Goossens, Rebecca Heremans,
Björn Heyzak, Ann Hoste, Carine
Hoste, Claudia Kramer, Carine
Lafaut, Christine Maes, Sabine
Mistiaen, Brice Muylle, Eva
Monsaert, Christoph Neerman, Dirk
Pauwels, Iris Paschalidis, Mike
Rasschaert, Lien Roelandt, Doris
Rogiers, Catherine Ruyffelaere,
Schelfthout David, Aïcha Snoussi,
Gilbert Thiery, Lander Thys,
Marie-Louise Van Baveghem,
Véronique Van Bever, Filip Van De
Velde, Odelinde Van Thieghem,
Christa Van Den Berghe, Ronny
Vande Gehuchte, Liesje
Vandenbroeck, Annemie Vander
Borght, Werner Vander Schueren,
Tony Vandevyvere, Evy Vanparys,
Eline Verbauwhede, Marieke
Verboven, Elsie Vercaigne, Thibaut
Verhoeven, Maud Verlynde,
Bea Verougstraete, Els Wuyts

v.m.h.k.
Carla De Boeck, Griet Van de Velde

Diese Publikation erscheint anlässlich der Ausstellung / This catalogue is published on the occasion of the exhibition

Rachel Harrison
Fake Titel

kestnergesellschaft, Hannover
7. Juni 2013 – 4. August 2013
June 7, 2013 – August 4, 2013

S.M.A.K. Museum of Contemporary Art, Gent
7. September 2013 – 5. Januar 2014
September 7, 2013 – January 5, 2014

Herausgeber / Editors
Susanne Figner, Martin Germann

Redaktion / Editing
Susanne Figner

Autoren / Authors
Diederich Diederichsen, Susanne Figner, Martin Germann, Veit Görner, Alex Kitnick, Philippe Van Cauteren

Übersetzung Deutsch-Englisch /
Translation German-English
Brian Currid

Übersetzungen Englisch-Deutsch /
Translations English-German
Uta Hasenkamp
Ursula Fethke

Lektorat Deutsch /
Copyediting German
Joachim Geil
Hella Neukötter

Lektorat Englisch /
Copyediting English
Jenifer Evans

Redaktion / Editing
Greene Naftali, New York
Martha Fleming-Ives,
Alexandra Tuttle, Linda Yun

Gestaltung / Design
Surface Gesellschaft für Gestaltung, Frankfurt am Main
Markus Weisbeck, Pascal Kress, Maximiliane Schling

Herstellung / Production
DZA Druckerei zu Altenburg GmbH

Die Hilfe / The Help
Eric Banks

Erschienen im / Published by
Verlag der Buchhandlung Walther König, Köln
Ehrenstr. 4
50672 Köln
Fon +49 (0) 221 205 96 53
Fax +49 (0) 221 205 96 60
verlag@buchhandlung-walther-koenig.de

Bibliografische Information der Deutschen Nationalbibliothek
Die Deutsche Nationalbibliothek verzeichnet diese Publikation in der Deutschen Nationalbibliografie; detaillierte bibliografische Daten sind über http://dnb.d-nb.de abrufbar. / Bibliographic information published by the Deutsche Nationalbibliothek
The Deutsche Nationalbibliothek lists this publication in the Deutsche Nationalbibliografie; detailed bibliographic data are available on the Internet at http://dnb.d-nb.de.

Printed in Germany

Vertrieb / Distribution:

Schweiz / Switzerland
AVA Verlagsauslieferungen AG
Centralweg 16
CH-8910 Affoltern a.A.
Fon +41 (44) 762 42 60
Fax +41 (44) 762 42 10
verlagsservice@ava.ch

Großbritannien & Irland / UK & Eire
Cornerhouse Publications
70 Oxford Street
GB-Manchester M1 5NH
Fon +44 (0) 161 200 15 03
Fax +44 (0) 161 200 15 04
publications@cornerhouse.org

Außerhalb Europas / Outside Europe
D.A.P. / Distributed Art Publishers, Inc.
155 6th Avenue, 2nd Floor USA-
New York, NY 10013
Fon +1 (0) 212 627 1999
Fax +1 (0) 212 627 9484
eleshowitz@dapinc.com

The Help, A Companion Guide
ebook available on iTunes

ISBN 978-3-86335-378-0

Abbildungsnachweis /
Photo Credits
John Berens: 4–65
Bernd Borchardt: 150–151
Alan Dimmeck: 117
André Morin: 80–83, 86–92, 94–101
Rachel Harrison: 3, 84–85,
103–108, 118–131
Martha Fleming-Ives: 66–67
Martha Fleming-Ives
and Rachel Harrison: 160–161
Jason Mandella: 69, 71, 73, 75, 77,
79, 146–147, 153, 157, 178–183
John Richey: 93
Oren Slor: 112, 142–143

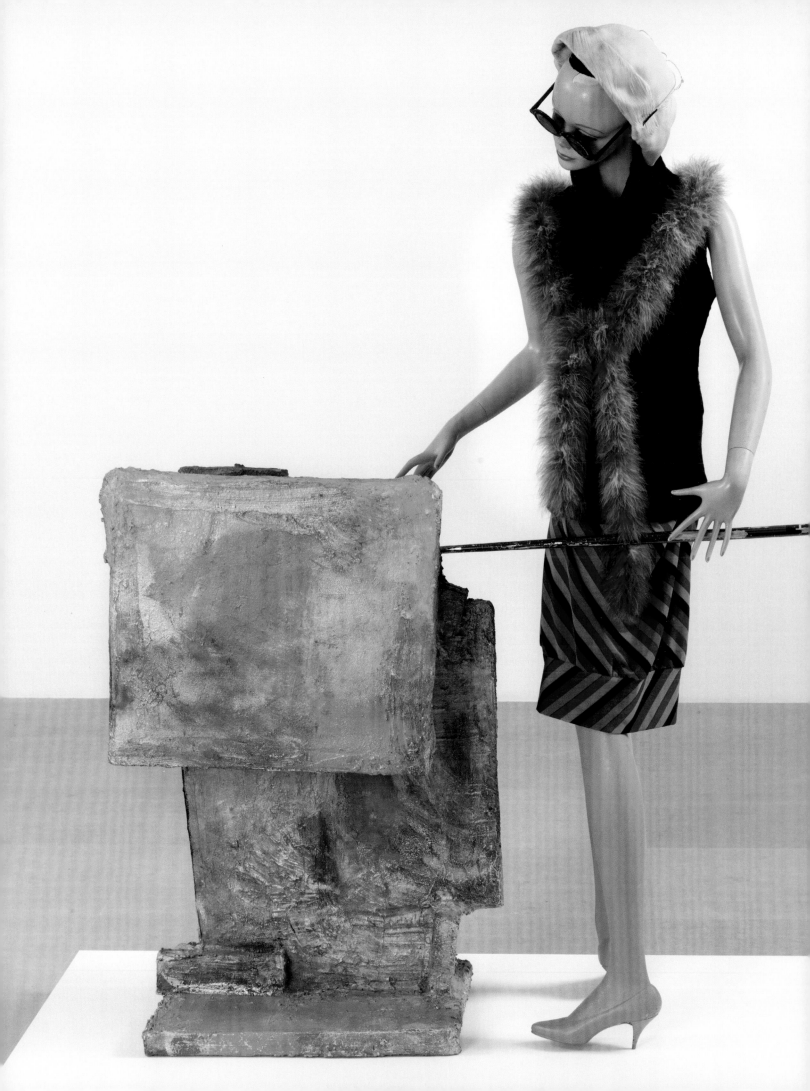

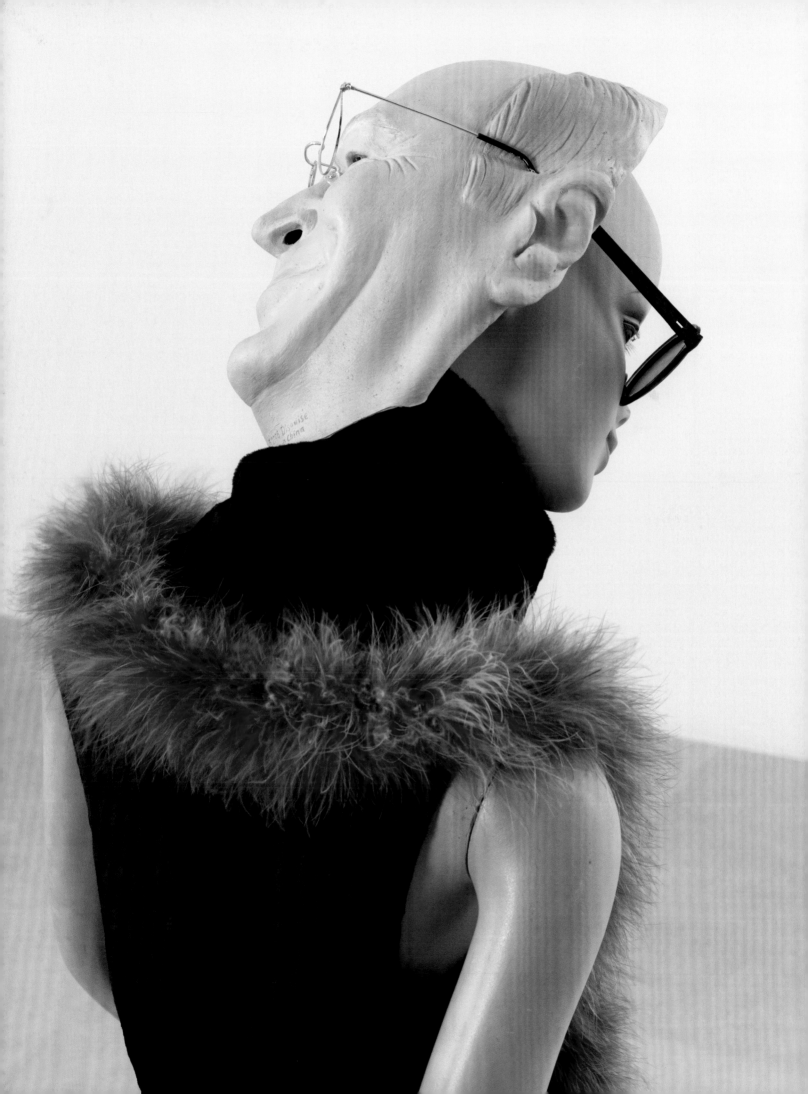

The Duck Hunter, 2012
Wood, polystyrene, cement,
acrylic, mannequin, Dick Cheney mask,
fabric, feather boa, sunglasses,
glasses, and ski pole
69 5/8 × 75 × 33 inches
176.8 × 190.5 × 83.8 cm

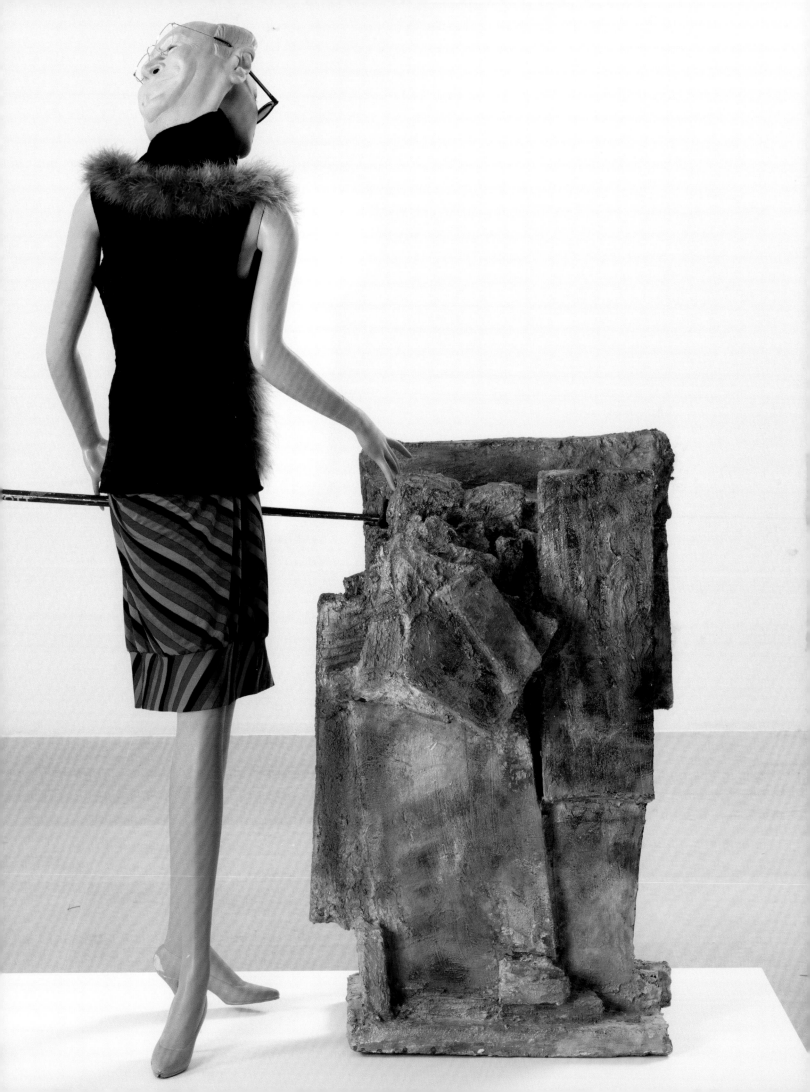